CUBISM
IN COLOR

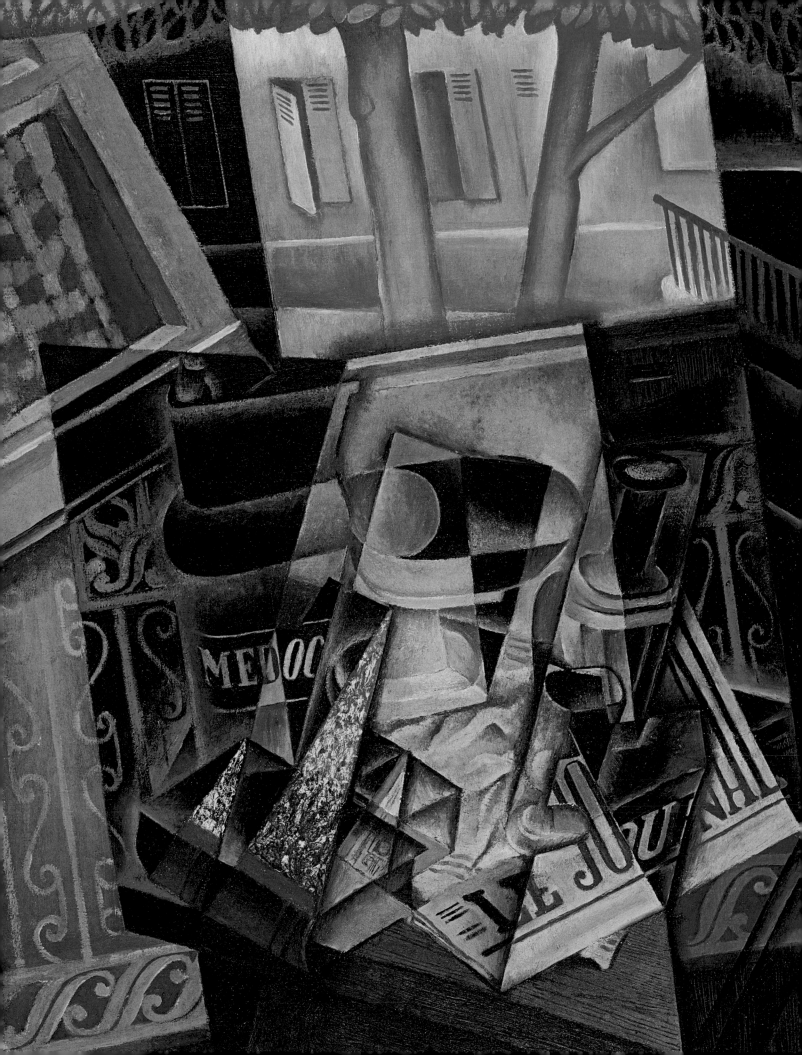

CUBISM IN COLOR

THE STILL LIFES OF JUAN GRIS

EDITED BY

Nicole R. Myers AND

Katherine Rothkopf

WITH CONTRIBUTIONS BY

Anna Katherine Brodbeck

Christine Burger

Harry Cooper

Paloma Esteban Leal

Nicole R. Myers

Katherine Rothkopf

THE BALTIMORE MUSEUM OF ART

DALLAS MUSEUM OF ART

DISTRIBUTED BY

YALE UNIVERSITY PRESS
New Haven and London

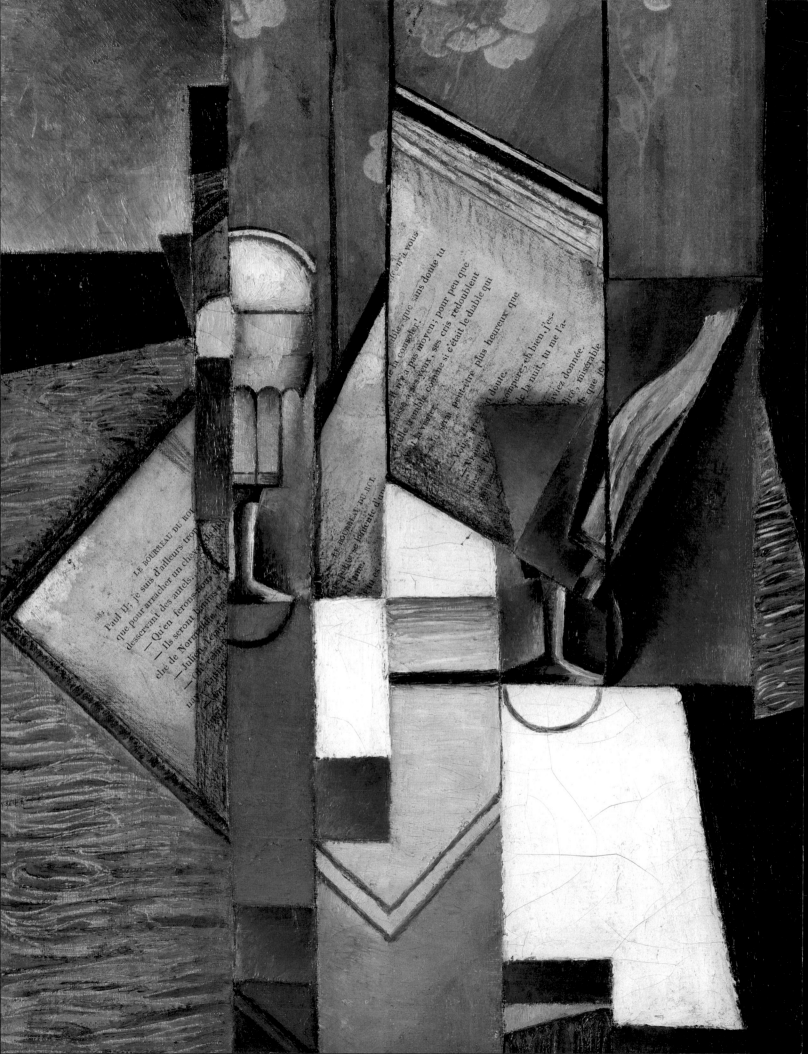

Contents

Directors' Foreword

AGUSTÍN ARTEAGA AND CHRISTOPHER BEDFORD

With *Cubism in Color: The Still Lifes of Juan Gris*, the Dallas Museum of Art (DMA) and The Baltimore Museum of Art (BMA) have joined forces to offer a new look at the Spanish artist's pioneering contributions to the Cubist movement by focusing on his fascination with subjects drawn from everyday life. The first monographic exhibition to be presented on Juan Gris (1887–1927) in more than thirty-five years in the United States, our project explores the transformation of his innovative aesthetic and his principal motifs over the course of his tragically short career.

Though credited alongside Pablo Picasso, Georges Braque, and Fernand Léger as a foundational contributor to the development of Cubism, Gris's unique and revolutionary approach has often been overlooked or downplayed in comparison to his better-known colleagues. Inspired by Picasso and Braque's early achievements, Gris's experimental and exquisite still-life compositions are distinguished by their vibrant colors, bold patterns, and constantly shifting aesthetic.

Focused in scale but large in scope, *Cubism in Color* traces the evolution of Gris's approach to still life through the careful selection of more than forty paintings and collages that span the artist's production from 1911 to 1927. The exhibition opens with Gris's earliest proto-Cubist paintings that are distinctive in their systematic geometry, crystalline faceting, and bright monochromatic palettes. By 1913, Gris had quickly progressed to combining Analytic Cubism, with its simultaneous viewpoints, and Synthetic Cubism, with its emphasis on flattened surfaces, in a series of brilliant paintings where superimposed planes of color and texture evoke a sense of space, volume, and energetic movement. This section of the exhibition, which extends through early 1916, features paintings and collages that frequently incorporate trompe-l'oeil and Pointillist techniques, and boast dazzling colors applied in daring and novel combinations.

From spring 1916 to 1919, Gris drastically reinvented his style, temporarily abandoning his radiant palette in favor of more somber earth tones. His

method of constructing his compositions shifted as well; the works became more simplified in their geometric structure as he sought to more fully integrate the still-life components with their backgrounds. His late production from 1920 to 1927 demonstrated a renewed interest in rich, vibrant hues and the still life set before an open window, an innovative motif he first introduced to Cubism in 1915. Notable for their harmonious, lyrical quality, these final works embody yet another revolutionary shift in Gris's artmaking practice as he increasingly relied on the geometric, abstract structure of his compositions to determine the still-life contents integrated seamlessly within them.

Cubism in Color: The Still Lifes of Juan Gris realizes the profound belief of its curators—the DMA's Nicole R. Myers, The Barbara Thomas Lemmon Senior Curator of European Art, and the BMA's Katherine Rothkopf, The Anne and Ben Cone Memorial Director of the Ruth R. Marder Center for Matisse Studies and Senior Curator of European Painting and Sculpture—in the value of finding works in their respective museums' collections to tell new stories about artists who have been underappreciated and are in need of reassessment. This collaboration began in 2017 when Katy approached Nicole about the possibility of teaming up. For Katy, the idea arose as part of an initiative to focus on Gris's work in the BMA's collection. Two outstanding Gris paintings in the BMA's holdings, *Bottle and Glass* (cat. 29) and *The Painter's Window* (cat. 40), are rare Cubist examples in the museum's collection, and Katy wanted to put them into context in a larger presentation of his work to better understand their origin. For Nicole, the exhibition offered an exciting opportunity for an in-depth exploration of the DMA's remarkable *Guitar and Pipe* (cat. 5) from the Eugene and Margaret McDermott Collection. This singular painting within Gris's oeuvre provided a new avenue to explore his innovative, yet relatively unknown creative process, prompting a fresh review of the artist's techniques across his entire production.

We congratulate Nicole and Katy for their tremendous partnership throughout this project. We also wish to acknowledge the project teams at both institutions who are thanked below; we are so grateful for their careful work on every aspect of this exhibition and catalogue. We would also like to thank Harry Cooper, Paloma Esteban Leal, and Anna Katherine Brodbeck for their insightful essays on Gris's work, the collecting history of his work in Spain, and his influence on modern and contemporary Latin American art, as well as Christine Burger for her entries in the catalogue section. Their contributions to the exhibition catalogue have made an important addition to the scholarship on this essential Cubist painter.

Several other partners played a vital role in bringing the catalogue to fruition. We thank the team at Lucia | Marquand for the book's engaging design, Martin Fox for his editing, and Patricia Fidler and Nicholas Geller at our distributor, Yale University Press.

This exhibition and catalogue are the result of invaluable assistance among staff at both institutions. At the Dallas Museum of Art, our heartfelt thanks go

to Jacqueline Allen, Director of Libraries; Selena Anguiano, Grants Manager, Institutional Giving; Jill Bernstein, Director of Communications and Public Affairs; Mary Ann Bonet, Director of Community Engagement; Cynthia Calabrese, Chief Development Officer; Giselle Castro-Brightenburg, Imaging Manager; Clara Cobb, Senior Marketing Manager; Lizz DeLera, Creative Director; Amanda Dietz Brooks, Exhibitions Manager; Danya Epstein, former Intern for European Art; Brad Flowers, Head Photographer; Taylor Glennon, Curatorial Assistant, European and Islamic Art; Laura Graziano, former Associate Registrar for Exhibitions; Jessica Harden, former Director of Design and Content Strategy; Laura Hartman, Paintings Conservator; Mike Hill, Senior Preparator; KC Hurst, Chief Marketing and Communications Officer; Lance Lander, Manager of Gallery Innovation and Technology; Jaclyn Le, Senior Graphic Designer; John Lendvay, Head Preparator; Stacey Lizotte, DMA League Director of Adult Programs; Martha MacLeod, Senior Curatorial Administrator; Skye Malish-Olson, former Exhibition Designer; Lillian Michel, Marketing and Communications Coordinator; Paul Molinari, Intellectual Property Administrator; Claire Moore, The Allen and Kelli Questrom Center for Creative Connections Education Director; Claudia Sánchez, Associate Registrar for Exhibitions; Emily Schiller, Head of Interpretation; Sarah Schleuning, Interim Chief Curator and The Margot B. Perot Senior Curator of Decorative Arts and Design; Alison Silliman, Director of Retail, Museum Store; Peter Skow, Spanish Language Editor and Translator; Isabel Stauffer, Director of Collections Management; Jenny Stone, Librarian; Sarah Sutton, Director of Development; Reese Threadgill, Manager of Corporate Giving; Veronica Treviño, Exhibitions Assistant; Queta Moore Watson, Senior Editor; Joni Wilson-Bigornia, Director of Exhibitions and Interpretation; Tamara Wootton Forsyth, The Marcus-Rose Family Deputy Director; and Eric Zeidler, Publications Manager, among many others. We are deeply indebted to the DMA's Board of Trustees, and we particularly acknowledge Board President Catherine M. Rose and Board Chair Bill Lamont for their stalwart support of the DMA and its exhibition program.

At The Baltimore Museum of Art we would like to thank Laura Albans, Assistant Curator of European Painting and Sculpture; Verónica Betancourt, Director of Interpretation; Andrea Boston, Digital Media Manager; Anne Brown, Senior Director of Communications; Katie Cooke, Curatorial Assistant to the Chief Curator; Elizabeth Courtemanche, Senior Director of Advancement; Raymond Cunningham, Exhibition Designer; Christine Dietze, Chief Operating Officer; Wyatt Esteves, Assistant Director of Exhibitions; Greg Ferrara, Director of Retail Operations; Meghan Gross, Manager of Digital Asset Services; Gamynne Guillotte, Chief Education Officer; Melanie Harwood, Senior Registrar; Colleen Hollister, Image Services and Rights Coordinator; Scott Homolka, Director of Conservation; Mitro Hood, Senior Photographer; Tim Hurlburt, Director of Security; Lindsey Lang, Senior Graphic Designer; Steve Mann, Senior Director of Exhibitions and Program

Alignment; Melanie Martin, Chief Innovation Officer; Saroyah Mevorach, Assistant Director of Advancement Events; Alexa Milroy, Director of Administration and Campaign Manager; Asma Naeem, The Eddie C. and C. Sylvia Brown Chief Curator; Jennifer Nelson, Publications Editor; Jessica Novak, Director of Content Strategy and Publications; Caitlin Perry-Vogelhut, Associate Registrar, Database Administration and Exhibitions; Caitlyn Reid, Assistant Registrar; Lauren Ross, Associate Conservator of Frames; Mary Sebera, The Stockman Family Foundation Senior Conservator of Paintings; Oliver Shell, Curator and Interim Department Head of European Painting and Sculpture; Olivia Tucker, Graphic Designer; David Verchomin, Director of Installation; Brandy Wolfe, Director of Grants and Sponsorships; and David Zimmerman, Installation Manager, among many others. Additionally, we would like to extend our gratitude to the BMA Board of Trustees and in particular Board Chair Clair Zamoiski Segal, for resolute support of the Museum and its Exhibition program.

We are deeply thankful for generous financial support from many sources, which has enabled us to undertake the scholarship and planning required to bring this ambitious project to fruition. Both institutions are very grateful for an indemnity from the Federal Council on the Arts and the Humanities, and we would like to particularly recognize Patricia Loiko, Indemnity Administrator at the National Endowment for the Arts. In Dallas, the exhibition is generously presented by Texas Instruments. Major support is provided by Gobierno de España / Acción Cultural Española and the National Endowment for the Arts. Exhibition support is provided by Ben E. Keith Company. Additional support is provided by The Robert Lehman Foundation. The Dallas Museum of Art is supported, in part, by the generosity of DMA Members and donors, by the citizens of Dallas through the City of Dallas Office of Arts and Culture, and by the Texas Commission on the Arts.

Without enthusiastic and supportive lenders, both public and private, no exhibition is possible. We extend sincere thanks to the lenders to this exhibition, listed on page 171. It is because of their incredible generosity that we are able to produce an exhibition and publication that introduce the fascinating work of Juan Gris to a new generation.

Agustín Arteaga
The Eugene McDermott Director
Dallas Museum of Art

Christopher Bedford
Dorothy Wagner Wallis Director
The Baltimore Museum of Art

Curatorial Acknowledgments

Exhibitions such as this are the result of the generosity and assistance of many individuals. We both have had great support from our directors, Agustín Arteaga and Christopher Bedford, who have been champions of this project from the start. We are extremely grateful for their enthusiasm and encouragement, as well as for the support of the leadership teams at our museums.

We are deeply indebted to our colleagues at the many museums and institutions that generously lent works of art to the exhibition: Janne Sirén, Albright-Knox Art Gallery, Buffalo, New York; Caitlin Haskell and James Rondeau, The Art Institute of Chicago; Bernard Blistène and Brigitte Leal, Centre Pompidou, Paris, Musée national d'art moderne/Centre de création industrielle; William M. Griswold and William Robinson, The Cleveland Museum of Art; Nannette V. Maciejunes, Columbus Museum of Art, Ohio; Rebecca R. Hart, Christoph Heinrich, and Timothy Standring, Denver Art Museum; Salvador Salort-Pons and Jill Shaw, Detroit Institute of Arts; Sabine Eckmann, Mildred Lane Kemper Art Museum, Washington University in St. Louis; Josef Helfenstein and Eva Reifert, Kunstmuseum Basel; Fabrice Hergott and Sophie Krebs, Musée d'Art Moderne de Paris; Fernando de Terán Troyano, Museo de la Real Academia de Bellas Artes de San Fernando, Madrid; Manuel Borja-Villel, Museo Nacional Centro de Arte Reina Sofía, Madrid; Paloma Alarcó and Guillermo Solana, Museo Nacional Thyssen-Bornemisza, Madrid; Katie Hanson and Matthew Teitelbaum, Museum of Fine Arts, Boston; Glenn D. Lowry and Ann Temkin, The Museum of Modern Art, New York; Harry Cooper and Kaywin Feldman, National Gallery of Art, Washington, D.C.; Matthew Affron, Timothy Rub, and Jennifer Thompson, Philadelphia Museum of Art; Susan Behrends Frank and Dorothy Kosinski, The Phillips Collection, Washington, D.C.; Luis A. Croquer, Rose Art Museum, Brandeis University, Waltham, Massachusetts; Brent R. Benjamin and Simon Kelly, Saint Louis Art Museum; Senator Manuel Cruz Rodríguez and Gloria Picado Moreno, Senado de España, Madrid; Danielle Carrabino and Jessica Nicoll, Smith College Museum of Art, Northampton, Massachusetts; Richard

Armstrong, Solomon R. Guggenheim Museum, New York; Laura Ramón Brogeras, Telefónica Collection, Madrid; Alex Nyerges, Virginia Museum of Fine Arts, Richmond; Stephanie Wiles, Yale University Art Gallery, New Haven, Connecticut; and the private collectors who wish to remain anonymous.

We are also thankful to our generous colleagues at museums, galleries, archives, and auction houses who supported this project by sharing research, advice, or assisting in various other ways. We wish to particularly acknowledge Laura Hartman and Mary Sebera at our own institutions, as well as Indira Abiskaroon, Natalie Alavi, Cindy Albertson, Julie Barten, Courtney June Books, Véronique Borgeaud, Emily Braun, Gabriel Catone, Christy Williams Coombs, Stephanie D'Alessandro, Julian Dawes, Ann Dumas, Isabelle Duvernois, Anna Erşenkal, Lily Goldberg, Michelle Harvey, Jodi Hauptman, David Horowitz, Margaret Huang, Pureza Villascuerna Ilarraza, Jay Krueger, Jillian Kruse, Douglas Lachance, Allison Langley, Anne Lemonnier, Camille Morando, Victoria Fernández-Layos Moro, Joan Neubecker, Chloe Nigro, Scott Niichel, Thomas Primeau, Cynthia Schwartz, Pam Skiles, Gail Stavitsky, Marcia Steele, Mary Welch, and Jason Wierzbicki.

This beautiful catalogue was produced by the DMA's publications department, overseen by Eric Zeidler, who managed the project with great skill, insight, and good cheer. Our sincere thanks also go to Martin Fox, who edited the publication with the utmost dexterity, Tom Eykemans at Lucia | Marquand for the book's elegant design, and the catalogue authors, whose contributions greatly enrich our knowledge of Gris's importance and impact. We would also like to acknowledge Laura Albans, Assistant Curator of European Painting and Sculpture at the BMA, who has greatly contributed to this exhibition since its inception. A special note of gratitude is also due to Christine Burger, Curatorial Research Assistant at the DMA, who provided research and support for both the exhibition and the catalogue with unwavering humor and enthusiasm.

Of course, major financial support is essential to realizing such an ambitious undertaking. We join our directors in thanking all of the exhibition's funders and express our deep appreciation for their generosity.

Nicole R. Myers
The Barbara Thomas Lemmon Senior Curator of European Art
Dallas Museum of Art

Katherine Rothkopf
The Anne and Ben Cone Memorial Director of the Ruth R. Marder Center for
Matisse Studies and Senior Curator of European Painting and Sculpture
The Baltimore Museum of Art

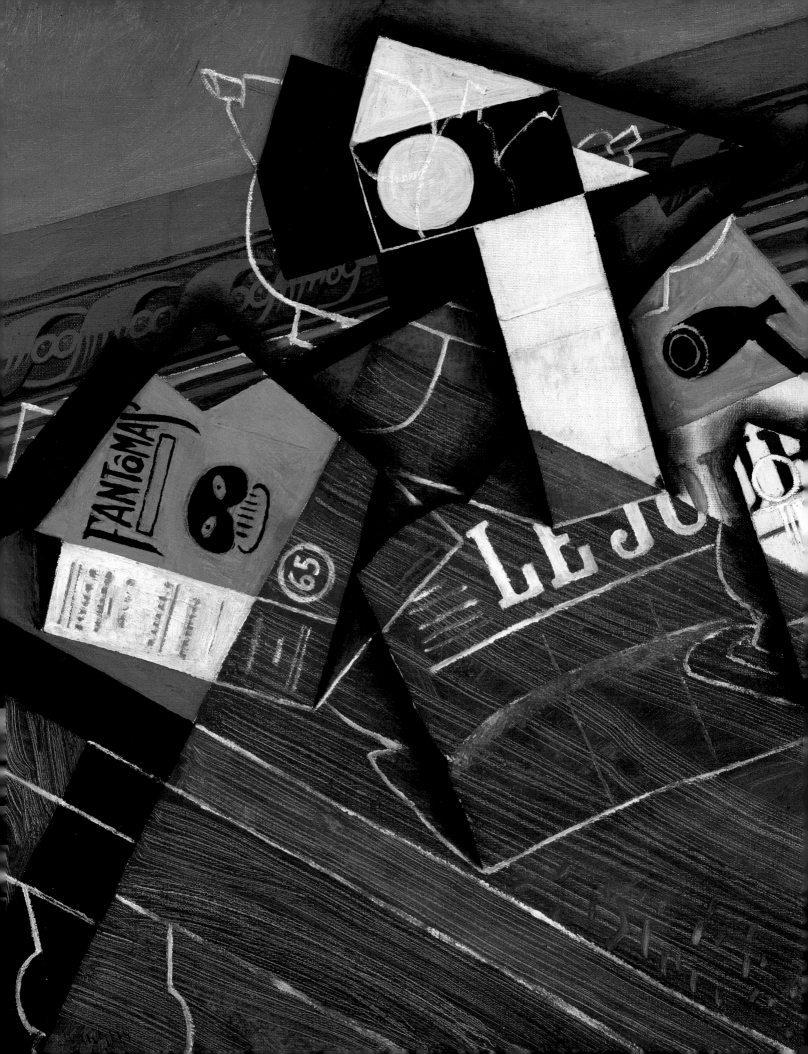

Decoding Gris

HARRY COOPER

Juan Gris is a fabrication. Born José Victoriano Carmelo Carlos González Pérez in Madrid in 1887, he first used the pseudonym on a bookplate he designed for a Spanish publishing firm in 1906, signing it simply "Gris."[1] Maybe he knew that he would be moving later that year to Paris, the center of the art world, for the name works in both French (with the "s" silent) and Spanish. But why Juan Gris in particular? A colorless name, a John Gray, to match his quiet personality and dedication to craft? Did he already know that his first paintings, four years ahead, would be distinguished by a steely gray palette ("gris" in both languages)? There is another possibility, one that has not been proposed before, namely that he combined the first two letters of his father's first name (Gregorio) with the first two of his mother's (Isabella), honoring them as he left behind the names they had given him. His new name was a cut-and-paste job, a clever first collage.

To enter the world of Juan Gris, especially that of his still lifes, his favorite genre, his bread-and-butter, is to err into a realm of artifice, a hall of mirrors (sometimes including real ones) in which reflection on art and depiction is endless, perception is deception, configuration is reconfiguration, and—to mix metaphors in a way that somehow seems appropriate—we are left unsure of where we stand, or sit, studying a fictive table upon which the elements and possibilities of representation have been spread out before us like a fan of cards (sometimes including depicted ones) whose suits, numbers, and faces we cannot quite recognize, at least not all at once. Oh, and it is also beautiful.

To thus emphasize the difficulty of Gris, the cultivated complexity of his work, is to go against the grain. Guillaume Apollinaire called him "the demon of logic" in 1912 and Gertrude Stein used the word "perfection" three times in her brief 1927 tribute.[2] The tenor of these views, whose dates nearly bookend his short painting career (he died at the age of 40 after a lingering illness), has persisted. In contrast to the radical inventors of Cubism, Georges Braque and especially Pablo Picasso, whom he called "dear master," Gris is often considered a conservative, for three main reasons: 1) his painstaking

composing, sometimes involving preparatory drawings, most of which he destroyed, and his use of mathematical formulas, leading to equally painstaking execution; 2) his respect for the object—the glasses, bottles, and guitars that he studied carefully, preserving their forms from the ruins of Picasso and Braque's Analytic Cubism; and 3) the fusion of these two, of compositional logic and representational clarity, in pictures of ideal, harmonious, satisfying, intelligent, tasteful, and classical unity and balance. (There, I have tried to capture all the clichés of the conservative view at once.)

One might well object that these two notions, Gris the radical and Gris the conservative, are not diametrically opposed. There is no necessary antagonism between complexity and clarity, uncertainty and balance, abstraction and depiction. Gris had to show us the object, and keep it in view, if we were to follow all the changes he rang on it—all the ways he broke it into its constituent parts, its primary and secondary qualities of texture, contour, volume, color, shadow, etc.—and then did or did not quite (there's the rub) reassemble it. Christopher Green, in a set of essays on Gris from 1992 that remains the most serious attempt at a full account of his art, says just this, describing how, in a 1913 painting of a man with top hat and cigar (fig. 39, p. 77), Gris "takes apart his smoker and puts him back together again."[3]

This idea of Cubism as a two-stroke engine, a rhythm of de- and reconstruction, was very much in the air at the time. The critic Maurice Raynal, reviewing the Salon de la Section d'Or in October 1912, the Paris exhibition that was one of Gris's first major showings, wrote of Cubism that its "analysis" of things into components was followed by "a synthetic task" leading to the creation of "a new whole."[4] This pseudo-Kantian language (*The Critique of Pure Reason* had begun by contrasting analytic and synthetic judgements) was soon applied to the history of Picasso and Braque's Cubism itself, periodizing it into Analytic (1908–12) and Synthetic (1912–14) phases. Daniel-Henry Kahnweiler, Gris's devoted dealer, friend, commentator, and biographer, even suggested that Gris was the first to use the term Analytic Cubism.[5] The division between the two phases was marked and precipitated by Braque's invention (quickly adopted by Picasso) of *papier collé* in 1912, by which he ushered pieces of the world into the work.[6] *Papier collé* (literally, paper pasted or collaged) helped the two artists find their way back from piles of illegible fragments to the recognizable object, albeit "recognized" not so much through perception as via a play of multivalent signs and divergent representational codes, literally re-cognized.

This periodization applies equally to Gris's career, with two caveats. First, there was a temporal lag of one or two years appropriate to his admitted status as an acolyte: he did not start painting until 1910 and did not fully embrace the use of collaged elements until 1913. Second, the divisions within his career are not nearly as sharp as those of the inventors of Cubism. As Green implies, Gris's work of 1913–16 straddles the Analytic and Synthetic modes: while certainly not as fracturing as Picasso and Braque had been in the first phase,

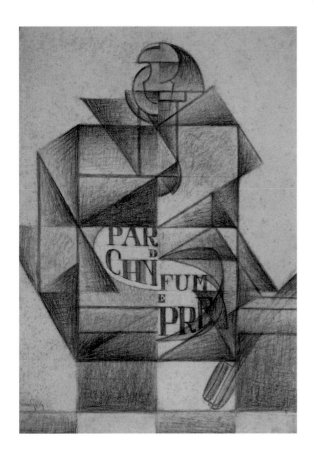

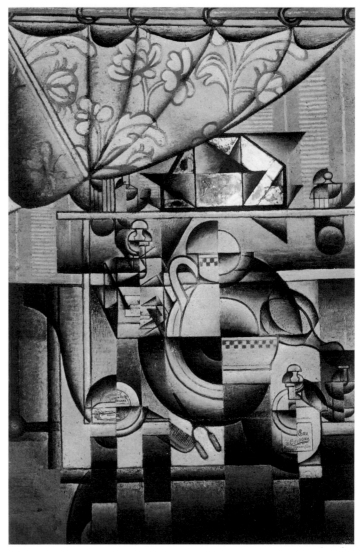

FIG. 1 *Parfum de Chypre,* 1911–12. Charcoal on paper. Private collection.

FIG. 2 *The Washstand,* 1912. Oil on canvas with pieces of paper and shards of mirror. Private collection.

he was also not as integrating as they were in the second. "To assemble figures or still-lives in different dialects," Green writes, "as Picasso did from 1912, is one thing: to take them apart again analytically, is another, with its own difficulties, above all the danger of disintegration into babble. Gris rarely, if ever, succumbs."[7] For Gris himself, synthesis seems to have loomed as a great goal, an unreachable promised land. As he wrote near the very end of his life, "To-day, at the age of forty, I believe that I am approaching a new period . . . a well-thought-out and well-blended unity. In short, the synthetic period has followed the analytical one."[8]

This two-stroke procedure, de/reconstruction, is on perfect display in a work by Gris from 1911–12 depicting a bottle of perfume on a checkered table or shelf with most of a toothbrush next to it (fig. 1). A rather large drawing (about 12 × 16 inches) beautifully shaded à la Seurat, this work has a lot to tell us not just about Gris's compositional methods but about his relationship to modernity, his interest in language, and what we might broadly call his poetics.[9]

It is a study for (or after?) the perfume bottle to left of center in the 1912 painting *The Washstand* (fig. 2), an ambitious work that caused a stir at the Section d'Or exhibition for its inclusion of actual shards of mirror at upper

right, on the top shelf. Like the painting, the drawing is Cubist through and through, from the sharp arrises or ridges and the arbitrary shadows of its facets to the double view of the stopper, seen both from above and the side. Another Cubist feature of the drawing, often seen in contemporaneous paintings by Picasso—if never so clearly—is the interaction of two grids, one diagonal and one horizontal-vertical, which combine in the drawing to suggest the cut glass and refractive depths of the bottle. What is pure Gris is the introduction of a third grid, the square checkerboard of the shelf, which blends or melts upward into the rectangular modules of the bottle in a moment of exciting confusion: such close clashing of similar systems will become a staple of Gris's still lifes.

The centerpiece of the drawing, however, is a label, or perhaps two, reading (at left) "PAR D CHY" and (at right) "FUM E PRE." Picasso and Braque had been playing language games already, starting most famously with the stenciled letters spelling BAL in the latter's painting *Le Portugais* (1911, Kunstmuseum Basel). Yet while they enjoyed chopping up words into suggestive bits—*journal* (newspaper) often becoming *jou* for example, suggesting both *jouer* and *jouir* (play and pleasure)—they never did anything as elaborate as what Gris did here. An attempt to read the two parts together yields only more nonsense: "PAR D CHYFUM E PRE." (*Par* and *pre*, or rather *pré*, are French words, but "chyfum" is not.) But a glance at the outer shape of the label reveals an oval that has been split down the middle into two halves which have been displaced in relation to each other.[10] A quick mental realignment, restoring the oval, makes the label legible: a cypress scent, *Parfum de Chypre* (Cypress Perfume). The drawing operates like a slide-rule but with letters instead of numbers. We just have to figure out how to use it.

Such an object, a *transpositeur*, had been invented in France in 1912 and patented the following year by Georges and Gabriel Lugagne. This portable "strip cipher" machine, with twenty separate alphabets sliding past two transparent ruled windows, could create powerful codes thanks to the large number of possible permutations (fig. 3).[11] While there is no evidence that Gris knew about this invention, it is tempting to think that his eager pursuit of modernity might have entailed an interest in cryptography, which was becoming ever more important in the age of wireless telegraphy and would figure crucially in the coming war.[12] In any case, Gris was likely aware that the mutual shifting of alphabets or other symbols, using simple machines made of strips or discs, had been the basis of cryptography since the time of Julius Caesar, hence the term "Caesar cipher." Perhaps

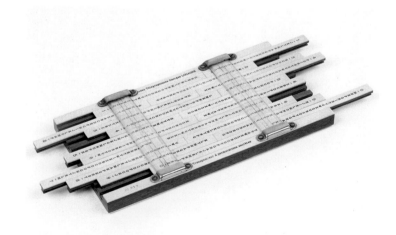

FIG. 3 Transpositeur. Crypto Museum, The Netherlands.

even includes the implied pun of *chiffre* (French for numeral or, more rarely, cipher) and *chypre*.

Disappointingly, the label on the bottle of perfume in the resulting painting, *The Washstand*, while also split and displaced, contains no legible words.[13] Indeed, Gris would never again resort to such an obvious demonstration of encoding and decoding, of verbal analysis and synthesis. (This is precisely what makes the drawing such a good demonstration, a key.) Still, Gris triggers the same deciphering impulse in us elsewhere in the same painting. The lower half is composed of some ten vertical strips that seem out of phase with one another, with predictable effects on the objects being depicted. It may not be possible to restore a seamless image through their virtual rearrangement, but we have an urge to try. In the upper half, in a clever reversal of this logic, the floral pattern on the curtain continues blithely across the gathered folds and swags, heedless of their complex topography. But the most radical reconfiguration of all is effected by the actual pieces of mirror on the top shelf, which the critics admired as a solution to the impossibility of representing a mirror with its changing reflections. Or as Gris reportedly said to Michel Leiris, "There is nothing to do but stick on a real piece [of mirror]."[14] What Gris did not mention was that the mirror, a mosaic of shards, breaks up the observer, who is thus incorporated into the Cubist image. It is deconfiguring.[15]

Before we proceed, a note on the title of the exhibition in which this work appeared: *La Section d'Or*, or The Golden Section. It refers to a ratio or progression of slightly more than 3:2 whose appealing harmony is thought to be underwritten by nature, as in the spiraling chambers of seashells. Starting in 1911, this was discussed in meetings at Jacques Villon's house in the Paris suburb of Puteaux with Raymond Duchamp-Villon and Marcel Duchamp (Villon's brothers) as well as Jean Metzinger, Albert Gleizes, and others—the so-called Puteaux Cubists. Gris's interest in this ratio was never orthodox, but it can be detected in *The Washstand* and in several paintings in the present exhibition (cat. 3, 5, 28, and 36), as well as *Man in a Café* (fig. 4), in which forms seem to spiral out from the coiled center of the man's face, growing ever larger.[16] The golden section is also present in *Parfum de Chypre*, for instance in the width of the bottleneck compared to the width of the rectangles on either side of it.[17]

Our drawing thus proposes two methods of composition, equally systematic: the eternally fixed golden section and the infinitely variable cipher. It would be hard to imagine two more different systems, and yet such are the tensions characteristic of this conservative-radical artist. He was the rare Cubist to have a foot in two opposed camps, showing with (and no doubt sometimes attending meetings of) the Puteaux Cubists, yet firmly allied with *"la bande à Picasso"* in the ramshackle Bateau-Lavoir building at 13 rue Ravignan in Montmartre where he lived for many years, from at least 1908 to the early 1920s, long after Picasso had gone on to better digs. (His alliance with the latter as opposed to the former group was cemented when he signed a contract with the Kahnweiler gallery in 1912, putting him in the company of Picasso and

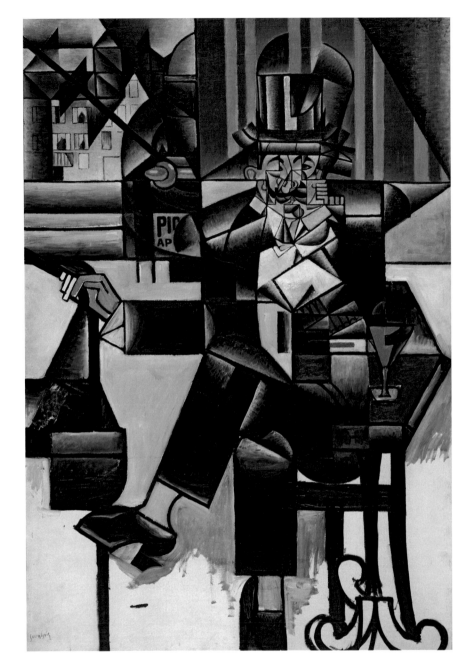

FIG. 4 *Man in a Café,* 1912. Oil on canvas. Philadelphia Museum of Art: The Louise and Walter Arensberg Collection, 1950-134-94.

Braque and exempting him, as the contract stipulated, from showing with the other Cubists in the annual salons.) And if the Puteaux group was enamored of the golden section, Picasso and many of the artists and poets around him were fascinated by the unstable, sliding, polysemic, differential aspects of language, verbal and visual. For Picasso, one might say, painting was a cipher with no one solution.[18]

Both principles, section and cipher, are at work in Gris's still lifes, but not usually at once. In *Still Life with Flowers* (cat. 3), likely shown at the Salon des Indépendants in March of 1912, where Gris also unveiled his magisterial *Homage to Picasso* (1912; Art Institute of Chicago), there is plenty of fodder for those seeking ideal proportions, whether in its triangles (the ratio was often applied to explain the Pyramid of Giza) or its rectangles. By contrast, the lesser-known but impeccably brushed *Jar, Bottle, and Glass* (cat. 1) has no

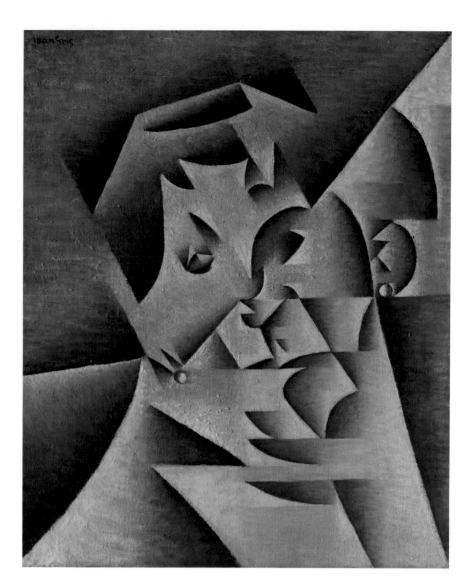

mathematical basis and little apparent stability. It has been sliced into strips by a diagonal windstorm that blows hot and cold, brown and gray, across the canvas with such force that the careful centering of its main diamond is easy to overlook, almost subliminal. An even less stable, more irrational work in the same moment and style is Gris's *Head of a Woman* (*Portrait of the Artist's Mother*) (fig. 5), in which a fairly legible upper half, depicting eyes and forehead, is divided from a totally deranged lower half by a jagged line extending from earring to earring.[19]

Of these two principles, fixed section and sliding cipher, it was the latter that won out in Gris's work for the rest of the decade. Eagerly picked up by Gris's colleagues, especially Jean Metzinger, the strip-and-slide method, to coin a term, was pushed further by Gris himself in 1913 as he turned fully to collage. *The Book* of 1913 (cat. 4) incorporates parts of an actual book, *Le Bourreau du Roi* (*The King's Executioner*), offering a page spread seen from above (the only way to see a page pasted onto a canvas) and divided into strips that almost give the illusion that we could operate the composition ourselves. The image also suggests a reading experience liberally interrupted by two different drinks (wine and beer?) whose glasses come between and in front of the pages. (The same two glasses appear in *Glasses, Newspaper, and Bottle of*

Wine (1913, Telefónica Collection, Madrid), in which the strip-and-slide method seems to reach a peak of complexity.) Perhaps Gris needed some extra alcoholic fortification to get through this piece of pulp fiction, which he must have picked up at one of the *bouquinistes* along the Seine. The novel is a historical potboiler written by Roland Bauchery in 1834 and set in the time of Louis XI. Page 282 of the book is at left and page 283, cut into two contiguous pieces, at right. Given Gris's penchant for punning, perhaps his attraction to this work was its title, for he has executed the book itself with a sharp blade.

Gris was at his most resistant to Picasso, and perhaps most himself, in collage. While he followed Picasso and Braque in often choosing newspapers and wallpapers or other decorative papers, what he did with them was different, in two ways. For Picasso, any applied material could serve any representational purpose: in his *Siphon, Glass, Newspaper, and Violin* of 1912–13 (fig. 6), pieces of newsprint may represent objects through their cut shapes (the siphon at left) or their printed contents (the vertically oriented words *prêt* and *prêts* suggest rising bubbles), or they may serve simply as grounds for drawing (the two pieces at right), or they may represent themselves (the neatly clipped title *Journal*).[20] For Gris—and in this he is more like Braque, more conservative—sheets of newspaper and pages of books represent themselves.[21] Semiotic play is limited to the words they contain, as in the title just mentioned (*Le Bourreau*) or the headline *ces exploreurs!* ("these explorers!") in *The Packet of Coffee* (fig. 7), which may refer to Picasso and Braque, the pioneers of Cubism.

Second, Gris's collages have a different material presence than either Picasso's or Braque's, which are very much works of paper and on paper: whether glued or lightly pinned, their papers (when not damaged or overconserved) retain their living, curling nature. By contrast, Gris's collages are typically mounted on canvas, the papers seemingly laminated into an image that may also contain oil paint, gouache, charcoal, crayon, and pencil. In effect, Gris reinscribes collage into the space of painting.[22] Whether this is a radical or conservative gesture—normalizing collage or subverting painting—can be argued either way. In any case, he certainly did not agree with Picasso about what the latter called, writing to Braque in 1912, no doubt with tongue partly in cheek, "our horrible canvas."[23]

There is another way that Gris departed in his collages from both Picasso and Braque, and that was in his use of the actual pages of books, a choice that is more significant than it might seem. (Books are as common in his collages as sheet music is in theirs.) Usually a Gris collage contains only one kind of reading matter, either a book or a newspaper, but in *Still Life: The Table* (cat. 11),

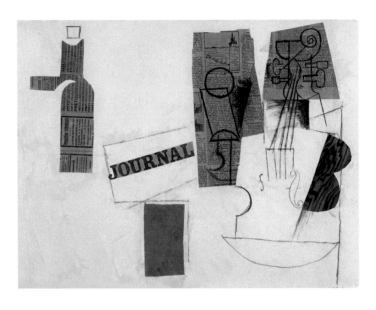

FIG. 6 Pablo Picasso, *Siphon, Glass, Newspaper, and Violin*, 1912–13. Pasted paper and charcoal on paper. Moderna Museet, Stockholm.

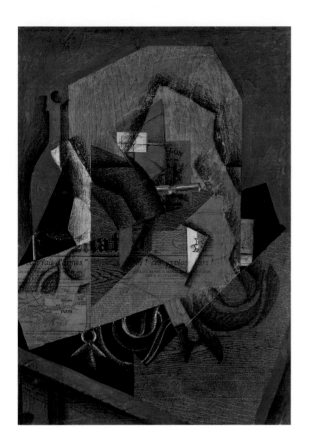

FIG. 7 *The Packet of Coffee,* 1914. Gouache, collage, and charcoal on canvas. Museum Ulm—Loan of the State Baden-Württemberg.

one of Gris's greatest collages, they are both present. The two elements have been identified as a section of the front page of *Le Journal* from May 18, 1914, and a page from chapter 30 of *L'Agent Secret,* the fourth of the Fantômas novels churned out in huge quantities by Pierre Souvestre and Marcel Allain.[24] Several commentators have weighed in on this collage over the years, often pointing out how both texts make reference to issues of reality, truth, and representation (the newspaper article concerns a popular book about "*le vrai et le faux chic,*" or true and false taste in fashion, while the Fantômas series is named after a criminal who is a master of disguise, as is Juve, the detective who pursues him). These issues figure in the collage itself, given its play of real and depicted objects, transparency and opacity, shading and shadows. But the collage also stages a very specific debate, I would suggest, between the relative claims of books and newspapers, a debate pursued by one of Gris's literary heroes, the French Symbolist poet Stéphane Mallarmé.

Gris was close to several poets: Apollinaire, whose poems he collaged into *The Watch* (1912, private collection, Cooper no. 27); Pierre Reverdy, whose poems he illustrated for an abortive collaboration; and the Chilean writer Vicente Huidobro, whose poetry he critiqued and even edited.[25] Kahnweiler reported that Gris's poetic obsessions as a reader were the seventeenth-century Spanish poet Luis de Góngora and Mallarmé, who had died in 1898.[26] Gris liked to recite lines from Mallarmé's poetry (not an easy feat), so it is reasonable to think he was acquainted with his essays as well, certainly the better-known ones.

In his 1895 essay "The Book: A Spiritual Instrument," Mallarmé claimed a "quasi-religious" significance for the fact that a book is a folded structure that can never be fully opened, in contrast to the "vulgar" display of the large newspaper sheet, which is only temporarily folded for convenience. The book's thickness was "a tiny tomb for the soul," the need to cut open its "virgin folds" a sacred sacrifice, and its shadowy gutters a repository for "fragment[s] of mystery."[27] Two years later he wrote and published what is arguably his magnum opus, *Un coup de dés jamais n'abolira le hasard* (*A Throw of the Dice Will Never Abolish Chance*), deploying typographical variety and the whiteness of the page to rebuke the "monotony" of newsprint. If it had not been clear in the essay how the "extraordinary intervention of folding or rhythm" of any book resulted in a "spacious mobility" and "play of elements," now, in Mallarmé's poem-book, which extended across ten pairs of facing pages, it was. While the primary reading of the poem is left to right (across the fold) and from the top down, there are many other possibilities: for example, the title can be derived by flipping through the book and reading only the largest type. Even Picasso, whose French was not nearly as good as Gris's, registered his appreciation of *Un coup de dés* in his punning 1912 collage *Un coup de thé* (A shot of tea), words that he

carefully cropped from the larger headline *Un coup de théatre* (A dramatic turn of events).

Turning back to *Still Life: The Table*, we can see how Gris, following Mallarmé, has provided the newspaper with a temporary fold between the J and the U of *Journal*—suggesting the name of the detective Juve from the Fantômas books—while he has elaborated the collaged page of the book by showing its thickness and shading one edge of the pages. (Not that that would have redeemed such a work of pulp fiction for Mallarmé; Gris was a member of the Society of the Friends of Fantômas founded by Apollinaire, which engaged in just the kind of slumming that Mallarmé would have disdained.[28]) Similarly, in his collage *The Book* of the previous year, Gris augmented the bird's-eye view of the actual book pages with a painted profile of the book, again showing its thickness and the flop of its pages.

Perhaps Mallarmé's thoughts on the book can even inform our reading of *Parfum de Chypre*, if we think of the label's axis of displacement as a fold across which mobility is possible. And perhaps the meaningless neologism that results, *chyfum*, can take its place with *ptyx*, a word that Mallarmé was proud of inventing (although he might well have known its Greek origin) out of the necessity to rhyme with Styx.[29] In the conclusion of his 1895 essay *"Crise de Vers"* (Crisis of Verse), Mallarmé celebrates "verse, which, out of several vocables, makes a total word, entirely new, foreign to the language, and almost incantatory. . . ."[30] Seen in this light, the drawing is far more than a study for a section of a larger painting: it is a machine for the creation of new words.

And yet if Gris was taken with Mallarmé's celebration of the book in all of its mysterious lability, he arguably makes equal claims for the newspaper, giving it pride of place in *Still Life: The Table* and clearly enjoying, in many collages, the flexibility it affords in cutting and folding, and the scope for word play. Even Mallarmé was sensible to the claims of newspapers as a form, offering "guarded admiration" of the possibilities.[31] Newspapers may have been depressing in their flattening of experience, but they were far easier to activate and operate than books, to decode and recode.

When Gris left collage behind in 1914, several years of extraordinary invention followed, often in works that took the look and lessons of collage into painting itself (just as Picasso and Braque were doing) as a kind of faux collage. In *Fantômas* (cat. 17), the confrontation of book and newspaper, indeed of a volume of *Fantômas* and an edition of *Le Journal*, is once again restaged, with no clear winner. Here the suggestion of an overlap between the two kinds of reading matter (see the wood-grained quadrilateral between the 65 and the L that could "belong" to either book or paper as well as table), which was absent from *Still Life: The Table*, presents the possibility of a tie or cohabitation. Gris has taken liberties with the book, replacing the realistic cover illustration that every volume would have had with a mask logo of his own invention, but he preserves the memorable calligraphy of the series title as well as the indication of the price (65 *centimes* in a white circle). Of course, he takes even

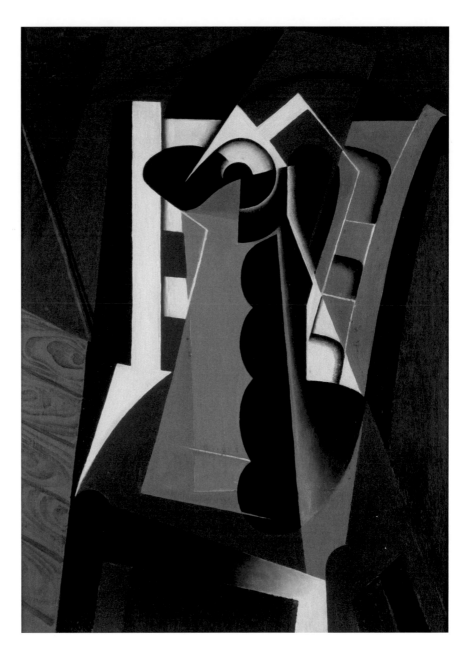

greater liberties with the entire still-life scene, as color, line, texture, and shadow interact to deliver a series of mobile pieces, ghostly contours, shocking transparencies (Gris clearly enjoyed showing off his faux-bois technique right through much of the newspaper), trompe-l'oeil details (the molding at the top of the wainscoting is, incredibly, done by hand), and formal rhymes (note how the shape of the pipe with its stem and bowl is picked up in several other places).

Kahnweiler writes that in their pictures "Gris and his friends . . . gave a great variety of information, derived from previous visual impressions, about a single object."[32] We might add that in Gris's work, and nowhere more than in *Fantômas*, the different types of information are carefully separated: contour, texture, shape, color, and pattern are all given through different means in a kind of conceptual layering that parallels the ambiguous spatial layering of the scene. It is up to us to figure out how to put the various codes together, to solve the "crime" that the artist has perpetrated on our normal habits of seeing. No

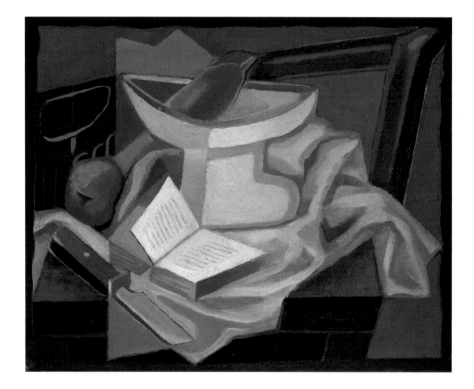

FIG. 9 *Still Life with Book*, 1925. Oil on canvas. Fine Arts Museums of San Francisco, Bequest of Mrs. Ruth Haas Lilienthal, 1975.3.3.

wonder the presiding spirit of the picture is Fantômas, a master of disguise and disappearance.

There is little room here to give more than an indication of the rest of Gris's career in still life. The year 1916 saw a delighted explosion of Pointillist color and patterning (cat. 19–23), which was followed by some of his most somber works, such as *Still Life with Newspaper* (cat. 25), and, in 1917, some of his most beautifully abstract works, for example *Still Life on a Chair* (fig. 8). What transpired in 1918 has often been understood as part of the larger so-called *retour à l'ordre* (return to order) in French art after the trauma of World War I, and there is much truth to this interpretation. Spatial ambiguity was reduced and compositional order became locked in as Gris turned to the look of bas relief, painting still lifes that seemed as if they had been carved from colored stone. Much of his work in the 1920s was taken up with the motif of an open window (cat. 36), which created an idyllic French Mediterranean setting for objects that often allegorized the arts to which Gris had been devoted: painting, poetry, and (to a lesser extent) music, with occasional hints of a newspaper peeking through.

At this point, several of the debates that we have traced within Gris's works—radical vs. conservative, newspaper vs. book, mobility vs. stability, doubt vs. certainty—seem to have been settled. Or have they? Almost every picture by Gris still contains moments of oddity or anomaly. In *Still Life with Book* (fig. 9), what jumps out of the picture is a heavy knife whose black handle, hilt,

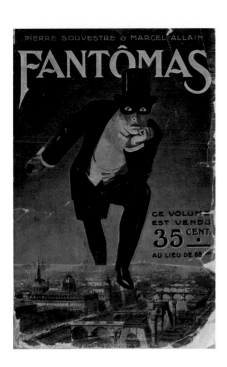

FIG. 10 Book cover of the first volume of the series *Fantômas* by Pierre Souvestre and Marcel Allain, Paris, éditions Fayard, 1911. Anonymous illustration.

and gray blade seem excessive for any task at hand, whether cutting the fruit in the bowl or opening up the pages of the book on the table. This imposing knife is a frequent feature of Gris's still lifes in his last years, morphing at times into a much sharper and pointier implement, more of a stiletto.[33] Might Gris have been inspired in this by the famous cover of the first volume of *Fantômas* (fig. 10), which shows the masked and top-hatted villain perching over Paris with a bloody dagger not quite concealed behind him? Might Gris have been thinking back to Mallarmé's declaration, on approaching a book, "I brandish my knife, like a poultry butcher"?[34] A line from Gertrude Stein's 1927 tribute to Gris, written in mourning for her friend, comes to mind: "And he liked a knife and all but reasonably."[35] Understanding Stein's phrase requires a double take. All but reasonably, not quite reasonably, slightly unreasonably? With her inimitable syntax, Stein captures the tensions that had marked Gris's art from the beginning. He had sliced his way through Cubism with a violent care that continues to leave us all but secure.

Notes

1. Juan Antonio Gaya Nuño, *Juan Gris* (Barcelona: Ediciones Polígrafa, 1986), 9. Also that same year Gris illustrated *Alma América*, a book of poems by the Peruvian poet José Santos Chocano, and signed one image "J. Gris." Mark Rosenthal, *Juan Gris* (Berkeley: University Art Museum, University of California, 1983), 149.

2. LeRoy C. Breunig, ed., *Apollinaire on Art: Essays and Reviews, 1902–1918* (New York: Viking Press, 1972), 254. Gertrude Stein, "The Life of Juan Gris / The Life and Death of Juan Gris," originally in *Transition*, July 1927, reprinted in Gertrude Stein, *A Stein Reader*, ed. Ulla E. Dydo (Evanston, IL: Northwestern University Press, 1993), 537.

3. Christopher Green, *Juan Gris* (London: Whitechapel Art Gallery, 1992), 30. He is describing *The Smoker* (1913). On Gris's possible knowledge of Locke's distinction between primary and secondary qualities, see Green, 39.

4. Cited in Green, *Juan Gris*, 31.

5. Daniel-Henry Kahnweiler, *Juan Gris: His Life and Work*, trans. Douglas Cooper (New York: Harry N. Abrams, 1968), 117.

6. See Green, "Synthesis and the 'Synthetic Process' in the Painting of Juan Gris 1915–1919," *Art History* 5 (March 1982): 87–105.

7. Green, *Juan Gris*, 40.

8. Quoted in Kahnweiler, *Juan Gris*, 204, citing Maurice Raynal, *Anthologie de la peinture en France de 1906 à nos jours* (Paris: Montaigne, 1927), 172.

9. Tantalizingly, Green (*Juan Gris*, 28, 38) reproduces the drawing on a full page but barely mentions it.

10. Interestingly, this is not true of the bottle as a whole, which retains its firm enclosing rectangle: the displacement is reserved for the label, as if to focus us on the linguistic work at hand.

11. See "Transpositeur," Crypto Museum, https://www.cryptomuseum.com/crypto/lugagne/transpositeur/index.htm. The device was powerful enough that it did not need to be updated until the 1930s. The ciphers of the Lugagne company were adopted in France for the transmission of civilian telegraphic messages.

12. A similar suggestion could be made about his choice of perfume. While the "cypress" scents, named after Cypress because of their Mediterranean constituents and associations, had been around for a long time, with nineteenth-century examples by Guerlain, they were regarded as especially forceful and modern and would soon become all the rage with perfumer François Coty's release of a *Chypre* in 1917.

13. Another label, on a bottle of eau de cologne at lower right, is legible but unscrambled, and in fact seems to be a collaged element.

14. Cited in Christine Poggi, *In Defiance of Painting: Cubism, Futurism, and the Invention of Collage* (New Haven, CT: Yale University Press, 1992), 17. See Kahnweiler, *Juan Gris*, 125.

15. I have never seen the work and verified its effects, as it has long been held in a very private collection.

16. See above all William A. Camfield, "Juan Gris and the Golden Section," *The Art Bulletin* 47 (March 1965): 128–34.

17. Of course, there are so many different proportions here it is hard to make too much of any one. Such has been the problem with all efforts to reduce Gris's compositions to a rule. As Rosenthal notes (*Juan Gris*, 34), "Gris never precisely duplicated the formula in his calculations . . . , perhaps leaving a final decision to intuition or aesthetic calculation."

18. The semiotic analysis of Picasso and Braque's Cubism, especially in its Synthetic phase, was established by Rosalind Krauss and Yve-Alain Bois. See above all Bois, "The Semiology of Cubism," and Krauss, "The Motivation of the Sign," in *Picasso and Braque: A Symposium*, ed. Lynn Zelevansky (New York: The Museum of Modern Art, 1992), 169–208 and 261–86. To do more than suggest a connection between the semiotic turn in Cubism and the cryptographic interests I am ascribing to Gris would require another essay.

19. See Harry Cooper, "The Matrix of Juan Gris's Cubism," in *Cubism: The Leonard Lauder Collection*, ed. Emily Braun and Rebecca Rabinow (New York: Metropolitan Museum of Art, 2014), 69–75.

20. Rosalind Krauss, *The Picasso Papers* (New York: Farrar, Straus & Giroux, 1998), 50.

21. "[B]ut whereas, with Picasso in particular, the newspaper was often used simply as a piece of material, with Gris the fragment of mirror represents a mirror, the printed book page is itself, and so is the piece of newspaper." Kahnweiler, *Juan Gris*, 125.

22. "On the other hand [in contrast to Picasso and Braque], Gris made use of it [*papier collé*] only in paintings." Kahnweiler, *Juan Gris*, 125.

23. Cited in Anne Umland, *Picasso: Guitars, 1912–1914* (New York: The Museum of Modern Art, 2011), 20.

24. See Sarah Moss, "'Le Vrai et le Faux' in Juan Gris's 'The Table' (1914)," *The Burlington Magazine* 63 (September 2011), 574–78, and, most recently, Emily Braun, "Juan Gris's Cubist Mysteries," in *Cubism: The Leonard A. Lauder Collection*, 125–35. Another essential essay in the same volume, focusing on materials, is Elizabeth Cowling, "Juan Gris: Four Collages," 116–25.

25. René da Costa, "Juan Gris and Poetry: From Illustration to Creation," *The Art Bulletin* 71 (December 1989): 674–92.

26. As told to John Golding, *Visions of the Modern* (Berkeley: University of California Press, 1994), 203. Kahnweiler (*Juan Gris*, 48) himself writes that Gris "worshipped" Mallarmé and liked to recite the sonnet "*Quelle soie aux baumes de temps* [What Silk of Balmy Time]," in particular its line "*La considérable touffe* [The considerable tuft]," which refers to the hair of a prince's beloved in which his cries are stifled. What Gris liked about the line, according to his friend Michel Leiris, the writer, was not its suggestive content but rather "the simple combination of a substantive and an epithet . . . the pure conjunction of two words irrespective of the image." In other words (perhaps), Gris enjoyed the blunt, collage-like conjunction of a highly abstract adjective with a forceful and concrete noun.

27. Mallarmé, "The Book as Spiritual Instrument," in his *Divagations*, trans. Barbara Johnson (Cambridge, MA: Harvard University Press, 2007), 226–30. Gris could not have known Mallarmé's unfinished *Le Livre* (*The Book*), which he worked on for decades but was not published in French until 1957. See Jacques Scherer, *Le "Livre" de Mallarmé* (Paris: Gallimard, 1957), and Stéphane Mallarmé, *The Book*, trans. with an introduction by Sylvia Gorelick (Cambridge, MA: Exact Change, 2018). This work was not a book so much as a plan for an ultimate book, *The Book*, and it was full of obscure formulas and diagrams that might well have fascinated Gris.

28. Kahnweiler, *Juan Gris*, 49, notes the artist's "strong taste for Fantômas." For more on this see Robin Walz, *Pulp Surrealism: Inso-lent Popular Culture in Early Twentieth-Century Paris* (Berkeley: University of California Press, 2000), especially chapter two, "The Lament of Fantômas: The Popular Novel as Modern Mythology." My thanks to Professor Walz for his help in identifying and understanding the books in Gris's collages.

29. While working on his "Sonnet in yx," Mallarmé wrote to a friend in 1868, asking him for assurance that the word "ptyx" did not exist in any language. See Dennis Duncan, "The Protean Ptyx: Nonsense, Non-Translation and Word Magic in Mallarmé's 'Sonnet en yx,'" Academia.edu, https://www.academia.edu/34742058/The_Protean_Ptyx_Nonsense_Non-Translation_and_Word_Magic_in_Mallarm%C3%A9s_Sonnet_en_yx.

30. Mallarmé, *Divagations*, 211. For a discussion of the role of new words in Cubism vis-á-vis Mallarmé and other writers, see Kahnweiler, *Juan Gris*, 185–86. Some commentators understand Mallarmé's phrase "a total word" to refer to the entire poem itself, so perhaps we would do better to consider Gris's *Parfum de Chypre* drawing as a machine for the creation of a new tableau or image.

31. Anna Sigridur Arnar, *The Book as Instrument: Stéphane Mallarmé, the Artist's Book, and the Transformation of Print Culture* (Chicago: University of Chicago Press, 2011), 228, quoted in Sarah Boxer, "Ripped from the Headlines," in *The Shock of the News*, ed. Judith Brodie (Washington, D.C.: National Gallery of Art, 2013), 133n17.

32. Kahnweiler, *Juan Gris*, 121.

33. See Douglas Cooper with Margaret Potter, *Juan Gris: Catalogue Raisonné of the Paintings*, 2nd ed., updated by Alan Hyman and Elizabeth Snowden vol. 2 (San Francisco: Alan Wofsy Fine Arts, 2014), nos. 471, 472, 475, 480–83, 497, 513.

34. Mallarmé, *Divagations*, 229.

35. Stein, *A Stein Reader*, 537.

"A Certain Professional Secret"

Juan Gris's Studio Practice

NICOLE R. MYERS

Gris's Progress

I am working quite a lot, but many things have been scrapped.
However I am making progress.

—JUAN GRIS[1]

Upon reviewing Juan Gris's first solo exhibition in 1919, Raymond Radiguet observed, "Juan Gris paints like all painters, that is to say on canvas or cardboard or wood. Did I say he is no different from the others? There is always a certain professional secret, many people would like to know it."[2] With this simple yet insightful commentary, Radiguet put his finger on an essential aspect of Gris's work that has received scant attention in the modest body of scholarship dedicated to this foundational member of Cubism—namely, the concept of Gris as a skilled draftsman and brilliant painter, as a beguiling virtuoso who concealed his methods even as he revealed them across the surfaces of his paintings. "The more we work on paintings by Gris, the more confusing we find him as a technician, no previous experience with his paintings ever seems to prepare us for the next one," noted the painting conservator Caroline Keck while examining *The Painter's Window* (cat. 40) in 1963. "I still do not understand the structure of this one and I know it rather intimately."[3]

So seamless are Gris's images, so finished and complete in their appearance, that they beg us to focus on the artist's aesthetic—which shifted dramatically over the span of his short career—rather than on how the works were made. Gris himself urged this chronological consideration of progress in his work, signing and dating the majority of his paintings from early 1913 until at least 1922 with both the month and year of their production. This unusual practice, unique among his peers, gives us an unprecedented view of Gris's artistic development, especially when coupled with his correspondence to his friends and his dealers, Daniel-Henry Kahnweiler and Léonce Rosenberg.

We can map the emergence of new ideas within his oeuvre with startling precision, in addition to the moment when certain lines of exploration fizzle out. The nervous, searching hope that his paintings showed steady progress is a constant refrain in Gris's letters, as are his frequent expressions of doubt and crises in confidence.[4] He often wrote to Kahnweiler that he had destroyed or abandoned works he felt were not good enough to send him, suggesting in turn that his dealer destroy any works he found unworthy of Gris's name.[5]

Underscoring this general sense of anxiety was Gris's conviction that his technical abilities lagged behind his conceptual ideas, a belief undoubtedly fostered by his brief period of formal training and rapid entry into the Parisian art scene. Writing to Kahnweiler in 1915, he exclaimed, "I think I have really made progress recently and that my pictures begin to have a unity which they have lacked till now. [. . .] But I still have to make an enormous effort to achieve what I have in mind. For I realize that although my ideas are well enough developed, my means of expressing them plastically are not."[6] He would repeat this sentiment shortly after the success of his one-man show at Rosenberg's Galerie de L'Effort Moderne in 1919.[7]

Gris's persistent doubts and self-deprecating comments give the impression that while the conceptual underpinnings of his work were solid, based as they were on clear and logical organizational systems, he was not a gifted painter. This view of Gris as the rigorous and austere doctrinaire of Cubism, in contrast to Pablo Picasso's irrational passion, Georges Braque's painterly refinement, and Fernand Léger's energetic modernism, set up a false dichotomy between Gris the Great Artist and Gris the Mediocre Painter. This current is reflected not only in Gris's writings but also in those of his earliest critics, such as Waldemar George and Maurice Raynal, as well as by Rosenberg.[8] Gris's openly deferential position vis-à-vis Braque and Picasso, in particular, both of whom he called *maître* until his death, only bolstered this perception that his was a lesser talent, deserving of the secondary role he has been allotted within Cubism. Surprisingly, even when it came to his skills as a colorist, one of the artist's most distinct and admired characteristics, Gris confessed, "This always worries me because it seems to me my weak point."[9]

One has only to look closely at his paintings, however, to see that this notion of Gris as an artist, not a painter, is a gross underestimation of his considerable talent. He was a master manipulator of materials who could achieve a stunning array of wide-ranging effects that oscillate between the subtlest of formal harmonies to the most jarring and dazzling.[10] Lauded for their legible and rational compositions, his "perfect" still lifes belie the considerable amount of labor that went into their creation, not only intellectual but also manual. While Gris's conceptual approach to painting has been the dominant topic of discussion from his earliest critics and biographers to scholars today, little has been written on how he actually made his paintings using the objects themselves as primary sources, from the techniques and materials he employed to how he devised his compositions, especially after 1913.[11] While the study that follows

is neither exhaustive nor definitive, its goal is to open new inquiries into Gris's production that extend beyond his aesthetic innovations and theories in order to consider what the paintings themselves have to tell us over the arc of his career.[12]

Gris the Painter

Well, it can't be helped! One must after all paint as one is oneself.
—JUAN GRIS[13]

It is difficult to know what exactly Gris's artistic education entailed before he left his native Madrid for Paris in 1906. Born in 1887, he enrolled at its Escuela de Artes y Manufacturas in 1902, where he received a craft-based arts education with secondary lessons in basic technical and scientific subjects. A gifted draftsman, he began publishing drawings in illustrated magazines that same year, a practice that allowed him to support himself for another decade. After only two years, Gris left the Escuela de Artes y Manufacturas to take private painting and drawing classes with the Spanish academicians José Moreno Carbonero and Cecilio Plá.[14] Little is known about their instruction, but presumably Gris's lessons lasted until his departure for Paris with the intent of continuing a career in the fine arts.

Almost immediately upon his arrival in 1906, Gris was introduced to Picasso, who became his close friend and helped him secure a studio in Picasso's building, the now famous Bateau-Lavoir at 13 rue Ravignan in Montmartre.[15] In the years leading up to World War I, the environment of the Bateau-Lavoir was intensely formative for Gris's artistic development. He would quickly meet and befriend Braque, as well as the writers Guillaume Apollinaire, André Salmon, and Max Jacob. Picasso's studio was a training ground of sorts into the theories of avant-garde practice, and Gris had a front-row seat to the development of *Les Demoiselles d'Avignon* (1907, The Museum of Modern Art) and Analytic Cubism—a term first coined by Gris, per Kahnweiler—as it was conceived by Picasso and Braque in the crucial period between 1910 and 1912.[16] Notably, Gris's first documented oil painting dates to 1910. It is likely that Gris destroyed much of his earliest work, as there is a considerable gap between his arrival in Paris and the work he chose to signal his debut as a painter four years later.[17] We are thus left to imagine what practical lessons he may have received from time spent with Picasso and others at the Bateau-Lavoir. Its conditions were rather squalid—its tenants had no gas, no electricity, no internal plumbing, and Kahnweiler would describe it as being so filthy and "unhygienic" that it was unsuitable both for Gris's infant son, born in 1909, and for the artist himself when his health began to fail in 1919.[18] Nevertheless, Gris lived and worked in this studio until 1922, the year he rented a three-room apartment near Kahnweiler in Boulogne-sur-Seine that served as his home base until his death in 1927.

There are few accounts of Gris's studio practice from those who knew him, and it is only due to his prolonged sojourns away from Paris and the resulting correspondence that we get snippets of the artist's routines and working methods. We learn that he frequently oscillated between periods of depressed inactivity and bursts of energy during which he worked on multiple paintings, sometimes juggling up to ten canvases at once.[19] We learn that he thought of his paintings as series, exhausting certain lines of thinking or formal explorations in discrete groups that he dispatched to his dealers.[20] We learn that during his travels Gris maintained a mobile studio, buying supplies from local vendors and/or having them shipped to him, which sometimes caused delays in his work as he impatiently awaited their arrival.[21]

While sometimes Gris bought commercially prepared, pre-primed canvases,[22] he also stretched and prepared his own supports, faithfully adhering to standard French canvas sizes throughout his career.[23] In at least one instance, *Bottle and Glass* (cat. 29), Gris crudely stitched together three small scraps of canvas to produce a standard size 10 *Marine* format, a reflection of his tendency not to waste materials, as evidenced by the great number of canvases and even one panel that he reused between 1913 and 1916.[24] Notably, though Gris occasionally lamented the lack of coal, gas, and tobacco during the course of the First World War, he never mentioned difficulty in obtaining painting supplies, nor can wartime privations be linked to his near-exclusive production of collages in 1914 or predominant use of wood panel supports in 1917, as has been suggested.[25]

Virtually nothing is known about the paint Gris used and whether he mixed his own pigments, but he was an expert in manipulating its properties to produce a wide range of desired optical and textural effects. There is a common refrain in the narrative of Cubism that Picasso, Braque, and Gris sought to eliminate any traces of their individual hands, bestowing upon their paintings and collages a machine-made appearance to underscore their break with traditional modes of illusionistic representation and to stress the conceptual origins of the movement.[26] Discussing Gris's paintings and collages from 1910 to 1921, Christopher Green asserted, "Although presented proudly as fine art, not the work of an artisan, they are commonly anonymous in technique and their anonymity can always be read as the mark of the 'personality' in them, of Gris."[27] Yet, one of the most distinctive features of his production is the lavish, painstaking, and personalized attention he bestowed upon the surfaces of his paintings.

In every phase of his career, Gris deliberately underscored the presence of his hand in the making of his works, producing astonishingly tactile paintings whose subtlety is often lost in reproduction. He used a diversity of mark-making techniques to suggest the different textures, materials, and surfaces of his subjects, and varying conditions of atmosphere and light within his still-life settings. In his earliest paintings Gris applied thick paint, often wet into wet, with a variety of brushstrokes to construct geometric forms

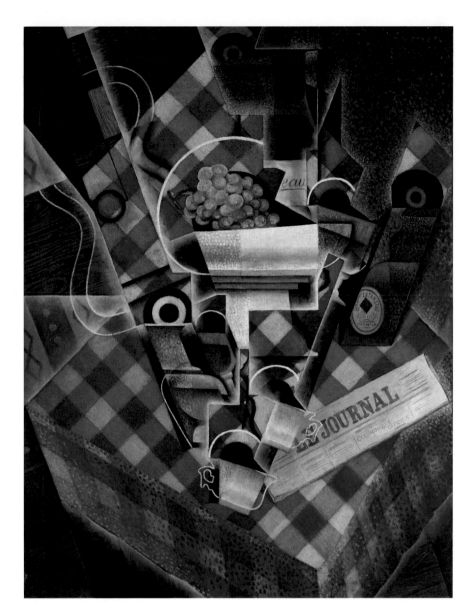

FIG. 11 *Still Life with Checked Tablecloth*, 1915. Oil and graphite on canvas. The Metropolitan Museum of Art, Leonard A. Lauder Cubist Collection, Purchase, Leonard A. Lauder Gift, 2014 (2014.463).

that are distinguished by their individual textures and are often delineated by visible paint ridges that challenge the overriding flatness of his proto-Cubist aesthetic (cat. 1–2).[28] In 1912–13, he began adapting the divisionist brushwork of the Impressionists and Neo-Impressionists (cat. 3), producing textured patterns of broken and stippled brushstrokes that unify the surface while signifying light and atmospheric conditions that culminate in his brilliant Pointillist series of 1916 (cat. 19–23).[29]

Not long after Picasso and Braque introduced collage in their work in 1912, Gris followed suit by incorporating playing cards, pieces of wallpaper, pages from books, and even mirror shards in his paintings (cat. 4 and 6; see also fig. 2, p. 15). Perhaps it was this investigation of unconventional materials that ushered in his mature period around 1913, a foundational year marked by great technical experimentation that extended through 1917. Continuing in the footsteps of his proclaimed masters, Gris deftly employed trompe-l'oeil techniques to mimic the appearance of stone and wood surfaces. Using a variety of tools, he pushed and pulled paint to denote different types of wood surfaces, sometimes molding patterns into thick patches of paint with a brush or metal comb (cat. 5b and 14; see also fig. 43, p. 81), and other times dragging bristles through a sheer, fluid layer of paint to expose the canvas or ground layer below (cat. 17). Between 1913 and 1915, he experimented with incising compositional elements into wet paint, using a sharp tool, the back of the brush, and sometimes pencils to scratch in or imprint various details, most often in the lettering or column breaks of journal mastheads. In *Still Life with Checked Tablecloth* (fig. 11), one of his largest and most ambitious paintings to date, Gris meticulously etched a cross-hatched pattern into each square of the tablecloth to create a witty illusion that pits the painted fabric against the woven fabric support.[30] In search of novel effects, he may also have employed less conventional tools, such as a rag, sponge, palette knife, and even his finger to apply or modulate paint layers.[31]

Complementing this variety of mark-making was that of Gris's paint finishes. At times he used a higher-opacity, pigment-rich paint—probably produced by adding dry pigments or draining oil from his mixtures, or even letting them dry out on the palette before use[32]—to create a matte effect that was enhanced by his sporadic use between 1911 and at least 1915 of absorbent, unprimed canvas supports, some of which have remained unvarnished.[33] Gris's desire to add greater realism and tactility to his paintings would lead to a brief period (1913–15) during which he added sand, ash, or even sawdust to his paint mixtures (cat. 14–15, see also fig. 43, p. 81). In other paintings, he isolated areas of thick, glossy impasto, perhaps an attempt to emphasize a certain compositional element or color contrast as in the neon pink and green triangles in the foreground of *Still Life before an Open Window, Place Ravignan* (cat. 13). While Kahnweiler contended that this "solidification" of color was intended to minimize the slick appearance of oil paint and thus restrict the possibility of virtuosic handling, Gris's contrasts between textured and smooth, opaque and transparent, and matte and glossy paint applications produce quite the opposite effect.[34] Sensuous and seductive, these demonstrations of his technical mastery give clarity to his abstracted images by distinguishing the various components of his fragmented subjects while unifying the composition through alternating and repeating surface effects.

Gris's delight in investigating the physical properties of his materials extended beyond his techniques to encompass his choice of supports. At times Gris used cardboard or laminated paperboard, either as a backing for some of his *papier collés* in 1914 or in a small series of paintings from 1915 in which thick applications of paint with sand and sawdust may have necessitated a more stable support (cat. 14–15). Most unexpected, however, was his near total adoption of thin plywood panels from June 1916 through December 1917. As Gris explained to Rosenberg, "one decidedly paints better on wood than on canvas."[35] In some of his first panel paintings, Gris incorporated areas of exposed wood graining into the composition as a stand-in for wall paneling, flooring, or tabletops, much like collage, as seen in *Playing Cards and Siphon* (fig. 12). More typically, Gris covered the surface of his panels with smooth applications of paint that complement, in their precision, the aesthetic of flat interlocking forms that dominate his style in this period.

Unlike his works on canvas, which were typically painted in reserve and allowed slivers of canvas to remain visible along the contours of his forms, Gris's panel paintings were often built up in thin, successive paint layers that produce an almost enamel-like appearance even when the faint texture of the wood grain shows through in thinly painted areas.[36] Perhaps to counter this effect, Gris began adding texture to his panels in 1916 by embedding inclusions within the paint, eventually covering the entire surface, and continuing the practice from his return to painting on canvas in 1918 up through 1920 (cat. 27, 29–31, and 35).[37] Gris's renewed interest in manipulating the material properties of oil paint to produce varied surface effects was likely the result of his

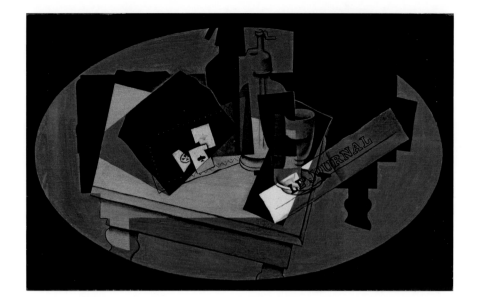

push to balance the mechanical aspect of his process, which he considered too meticulous and severe, with the "sensitive and sensuous qualities" he had been seeking to develop in his painting since late 1915.[38]

This impulse to incorporate a more painterly aesthetic into his works became a matter of contention in the summer of 1918. Writing to Rosenberg of his recent work from July of that year, Gris happily confided, "I find them better painted, that's to say painted in a more supple and lively manner. [...] I'm sick of spreading colors in a cold and mechanical manner and I'd like to be able to brush [*brosser*]."[39] These private musings found their way to the critic Louis Vauxcelles, who promptly published a denouncement of Gris's painterly drive as antithetical to Cubism.[40] Yet for Gris, who defended himself against this accusation, the Cubist aesthetic was a state of mind and thus open to any technique that could express what was for him its "very profound," "very human," and contemporary nature.[41] His desire "to brush," to give license to both sensuous shape and color, is beautifully evoked in the works that followed, such as *Still Life with a Bottle of Bordeaux* from August 1919 (cat. 32). Deceptively simple in appearance, the canvas features an almost velvety-looking surface created by his layered, painterly application of rich color.

In what would be his final period of production in the 1920s, Gris's bold experimentation with varied surface textures was generally replaced with a smoother application of opaque paint that leaves little trace of the artist's hand, as seen for example in *Le Canigou* (cat. 36). The culmination of a series that marked his return to the theme of the still life before a window in 1921, *Le Canigou* presents itself as a postcard, the picturesque scene depicted as a silhouetted vignette against a white field with the name of the snow-capped mountain painted like printed text along the top. Perhaps this is where we can apply Green's notion of anonymity to Gris's painting, for if it ever existed, surely it is manifested in this presentation of the painting like a photograph. That is not to say that Gris abandoned the pursuit of surface effects altogether, but his explorations in the 1920s were more nuanced, as color, rather than texture or facture, became the dominant element in creating a unified and balanced composition. In *The Painter's Window*, for example, Gris subtly modulated the colors of certain passages through scumbling, as seen in the sky and tablecloth, adding both depth and tonal richness (cat. 40). And though his style

became more homogenous in this period, Gris made subtle changes to his techniques, such as using a colored preparatory layer, to impart an overall warmness or coolness to his paintings.[42]

Gris's Process

> Gris might well say to me: 'When I take my brush, I do not know
> what is going to happen...' I don't believe it, I cannot believe it...
> Gris knows very well where he's going.
>
> <div align="right">—LOUIS VAUXCELLES[43]</div>

Apart from discussions of Gris's use of the golden section in 1912–13, most considerations of his artistic process focus on theory, and in many respects we have the artist to thank for that. Gris guarded his "professional secret" closely, revealing very little about his art making, whether in public or in private. Compelled to defend Cubism's validity, it was only in the early 1920s that he began publishing his philosophies and processes, elaborating in a handful of texts what he identified as a quintessential aspect of his practice, a process he called the deductive method.[44] First recounted in 1921 by Amédée Ozenfant in *L'Esprit Nouveau*, Gris's initial thoughts on the subject are among his most clear, concise, and repeated:

> I work with the elements of the intellect, with the imagination. I try to make concrete that which is abstract. I proceed from the general to the particular, by which I mean that I start with an abstraction in order to arrive at a true fact. . . . Cézanne turns a bottle into a cylinder, but I begin with a cylinder and create an individual of a specific type: I make a bottle—a particular bottle—out of a cylinder. . . . That is why I compose with abstractions (colors) and make my adjustments when these colors have assumed the form of objects. For example, I make a composition with a white and a black and make adjustments when the white has become a paper and the black a shadow: what I mean is that I adjust the white so that it becomes a paper and the black so that it becomes a shadow. This painting is to the other what poetry is to prose.[45]

Kahnweiler elaborated on this so-called deductive method in his 1946 biography, detailing it as a multistepped process that began on paper rather than oil on canvas as intimated by Gris. Kahnweiler noted that Gris's point of departure was a kind of automatic drawing in which a proportion, such as the golden section, provided the springboard for the creation of an abstract armature. He would then transpose and translate the rhythm of the drawing into "colored architecture" on canvas, "qualifying" the painted forms by giving them the properties of recognizable objects. Although the process started with a conscious choice vis-à-vis the geometric catalyst for the composition,

Kahnweiler and Gris both stressed the role played by imagination, creativity, and automatism in the painting's final appearance.[46]

Gris's invention and proclaimed use of the deductive method, which Kahnweiler stated began around 1920, dominates most writing on the artist's work regardless of when it was made. Nevertheless, there has yet to be an adequate demonstration of the actual practice in his paintings. In their foundational texts, both Mark Rosenthal and Christopher Green have observed the contradiction between Gris's written theories and what we see in his paintings, arguing for example that Gris's frequent and intentional repetition of the same subjects from canvas to canvas, or the critical roles played by specific objects as compositional elements within his still lifes, could not possibly have resulted strictly from abstract formal relationships.[47] While Rosenthal denies the practice altogether, Green claims that Gris used the deductive method in his paintings sporadically and at least in part beginning around 1917. The key, he argued, was Gris's development of a greatly simplified style consisting of flat shapes in a limited palette that lent themselves to pictorial rhyming, such as the repetition of parallel lines that simultaneously signify text on a newspaper, scores on a music sheet, and the strings of a guitar as exemplified in paintings like *Guitar and Fruit Dish on a Table* from 1918 (cat. 30). For Green, this increased interchangeability of a limited repertoire of multivalent forms opened up a number of possibilities to Gris as he created the abstract geometric armatures that structure his compositions.[48]

Like Picasso and Braque, Gris certainly reveled in the exploration of such playful formal metaphors, using, for example, the same size of circle to denote both the opening and the foot of a glass as early as 1913. It was only in 1919, however, that he recognized a turning point in how he conceived of his paintings and outlined a new direction for his work. He explained to Kahnweiler,

> I would like to continue the tradition of painting with plastic means while bringing to it a new aesthetic based on the intellect. [. . .] For some time I have been rather pleased with my own work because I think that at last I am entering on a period of realization. [. . .] I have also managed to rid my painting of a too brutal and descriptive reality. It has, so to speak, become more poetic. I hope that ultimately I shall be able to express very precisely, and by means of pure intellectual elements, an imaginary reality.[49]

Gris's publications on his artistic process make clear that the deductive method was the means by which he could achieve this goal. From 1920 forward, he certainly believed he was using some form of it or, perhaps more accurately, he strove to use it as the organizational logic of his paintings. But whether Gris ever succeeded in applying it, either in part or in whole, is incredibly difficult to ascertain. In addition to there being a general lack of conservation technical studies on his paintings, which undoubtedly would illuminate key aspects of his artistic process, Gris destroyed almost all of his

preparatory drawings and instructed Kahnweiler and his wife Josette to burn those that remained upon his death.[50] Gris's desire to suppress the evidence of his creative process seems in itself one of the most telling signs that he may not have been practicing what he preached.

Nevertheless, in spite of this crucial missing material, it is hard to imagine that Gris did not start with a general sense of what he wanted to paint beforehand, if not an even more specific plan to achieve it, when we study his paintings. Returning to *Guitar and Fruit Dish on a Table*, visual analysis reveals that the entire composition adheres closely to two underlying grid structures intersected by diagonals that together determine the shape and placement of every major compositional element within the painting (fig. 13). Rather than the composition having been inspired by a simple geometrical proportion or abstract rhythm that in turn served as the springboard for the application of colored forms, its precise and formal complexity strongly suggests that it was based on a meticulously executed drawing in which predetermined objects were either subordinated to or plotted along the gridded structure. Indeed, the grid is an ideal mechanism for the precise transfer and scaling of a design from paper to canvas. That more detailed plans had been worked out on paper and/or canvas well before colored forms were introduced is supported by the existence of graphite or charcoal underdrawings in every phase of Gris's production, beginning to end. Infrared reflectography (IR), as well as close visual analysis of paintings created throughout his career, consistently reveal a range of underdrawings either carefully drawn or barely sketched, from major organizational structures to the placement of a few prime objects or lines, whether on canvas, cardboard, or wood panel.[51]

Setting aside for now the question of Gris's practical application of the deductive method, what is more significant in his production is the crucial role that drawing played in his process, especially as he developed increasingly complex organizational systems to structure his paintings. Gris's roughly

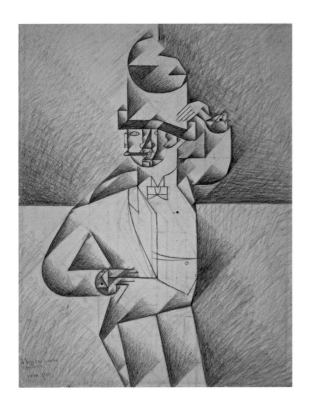

FIG. 14 *Man in a Café*, 1911–12. Conté crayon on laid paper. Philadelphia Museum of Art: A. E. Gallatin Collection, 1952-61-42.

130 known drawings and his lifelong production of illustrations for various publications attest to the central role that drawing consistently held within his practice. As Christian Derouet has noted, Cubism was one among many avant-garde movements that denied the importance of drawing, which smacked of the academy and its emphasis on preparatory studies.[52] We have only to consider Kahnweiler's self-interested role in diminishing its importance within Gris's production in favor of constructing a narrative that culminates in spontaneous abstraction, an irony underscored by his own admission that he had seen and helped destroy the preparatory drawings that were key to the so-called deductive method. Scholars such as Green have picked up this narrative, insisting on the separation of Gris's drawing practice from his painting, especially after 1913, even as the opposite is revealed through his artwork and correspondence.[53] This false dichotomy stems from an inability to reconcile the naturalistic drawings that begin reappearing in his work in 1916 with the abstract style he was developing concomitantly. Yet drawing and painting were deeply interconnected in Gris's process.

This interconnection is most obvious in his early works from 1910 to 1913, the period from which the largest number of studies and preparatory drawings survive. For example, at least four large-format drawings exist that trace Gris's development of the head and torso of the protagonist in *Man in a Café* (1912; fig. 4, p. 18). The earliest of these sketches reveals a process of multiple adjustments and erasures (fig. 14), with Gris increasing the boldness of the contours he settled on as the image took its desired appearance, a practice he continued until his death. During this early period, Gris almost always started his drawings with some kind of organizational system that either covers the surface of the page or governs (or is generated from) the individual objects depicted.[54] While sometimes he started his drawings by dividing the blank page into quadrants along its vertical, horizontal, and/or diagonal axes (perhaps a remnant of his academic training), other times he used a mathematical proportion, such as the phi ratio (golden section), as the basis for his compositional structure. The existence of holes in at least one surviving study reveals the use of a compass or geometric divider to construct his forms. On another, Gris jotted down the geometric formula he deployed to establish his proportions.[55]

The same methods that Gris applied to his drawings can be found in his paintings, especially as revealed in *Guitar and Pipe* (cat. 5a) and by several abandoned compositions that grace the versos of finished paintings and collages between 1913 and 1917 (cat. 5b).[56] Using charcoal or graphite, Gris outlined the underlying geometric structure and subjects of his composition, often making adjustments to the placement and proportions of the various elements. This preliminary drawing served as a general guide as Gris painted blocks of the design in reserve, often leaving areas of canvas and charcoal

drawing visible at their junctures, a technique evident on both the recto and verso of *Guitar and Pipe*.[57] Infrared photography of *Guitar and Pipe* reveals that Gris played around with the placement of the table—one of its former locations can be seen lurking below the paint surface on the lower-left side—in addition to drawing in several other compositional elements, such as the guitar's right profile, that were eliminated during the painting process (fig. 15). For though Gris produced drawings on paper to serve as studies for his paintings and collages in this period, the multiple changes and sketchy quality of the lines in his underdrawings suggest he may have been working out large parts, or entire compositions, directly on the support.[58] And as would be the case throughout his career, Gris responded intuitively to the aesthetic demands of each painting, never hesitating to stray from his initial plan to balance form and color as the image came into focus.[59] Indeed, significant areas of underdrawings can be seen below thin layers of paint in

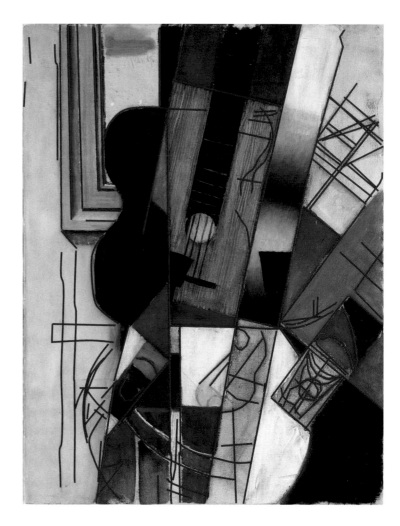

FIG. 15 Infrared photograph of *Guitar and Pipe*, 1913 (cat. 5a), with overlay tracing the preliminary charcoal underdrawing.

other paintings from 1913, such as *Violin* (cat. 8) and *Still Life with a Guitar* (Metropolitan Museum of Art, New York), begging the question as to whether Gris intended these phantom images to be seen as yet another surface variation in the overall scheme.[60] It is tempting to view the presence of isolated or scattered pinholes observed on *Violin*; *Still Life: The Table*; and *Newspaper and Fruit Dish* (cat. 8, 11, and 20) as indications that Gris also relied on tools like a compass, geometric divider, or even strings tacked to the surface of his supports to aid in the precise transfer or construction of his underdrawings onto his supports, though more research in this area is necessary.[61]

As Green has observed, this method of drawing, adjusting, and selecting what to include and what to erase in the final design, whether on paper or canvas, was an important part of Gris's creative process that was honed through his production of *papiers collés* in 1914.[62] Restoration of *Flowers* (fig. 35, p. 68) and *Book and Glass* (1914, The Museum of Modern Art), for example, revealed precise and detailed underdrawings whose various components find their exact equivalents in the pieces of cut-out paper, as well as the drawn and painted elements that cover them, in the finished composition.[63] In addition to using rulers, protractors, and triangles to produce his mindbogglingly complex *papiers collés*, Gris must have also used tracing paper to transfer the design of the underlying drawing to the surface.[64] Gris described using tracing paper to transfer and adjust a drawn design intended for print, so it is highly probable that he also used it to refine compositions from drawing to drawing, as

FIG. 16 *Man Sitting in an Armchair* (recto), 1923. Graphite on paper. Centre Pompidou, Paris, Musée national d'art moderne/Centre de création industrielle.

FIG. 17 *Seated Harlequin*, 1920. Graphite and ink on paper. Tate, London, Presented by Gustav and Elly Kahnweiler 1974, accessioned 1994.

well as from drawing to painting, as he decided which contours or structures to include in his final design and which to omit.[65] The exceptional existence of two almost identically scaled drawings related to *Seated Harlequin* (1920, Los Angeles County Museum of Art)—one a study executed in graphite with a drawn gridded armature (fig. 16), the other a contour drawing of the final composition executed in graphite and ink (fig. 17)—demonstrates what this process might have entailed. Likely using tracing paper, Gris flipped the orientation of the sketch in the contour drawing, which in turn matches the orientation of the composition in the painting.

When Gris resumed oil painting in 1915 after a year of collage, the sketchy quality that previously characterized his underdrawings was replaced by a more refined method in which major compositional elements were blocked in with a sure hand from what was likely a drawn study.[66] Infrared imaging of *Fantômas*, for example, reveals a developed underdrawing with no adjustments that matches the finished image on the surface with only minimal deviations (fig. 18; see also cat. 17). Remarkably, even the placement of the most spontaneous-seeming passages, such as the wet-into-wet demarcation of the columns of the journal, was established first in the underdrawing. Not long after he painted *Fantômas*, Gris felt his work had become too painstaking in its execution. "Sometimes I feel that my way of painting is wholly mistaken," he wrote to Kahnweiler in late 1915. "I find my pictures excessively cold. But Ingres too is cold, and yet he is good. [. . .] Seurat also, although I dislike the meticulous element in his pictures almost as much as in my own!"[67] Disillusioned with his approach, Gris turned to the French masters he admired for guidance, studying black-and-white reproductions of still-life and figure paintings by Cézanne, Corot, Chardin, and Ingres, among others, sent to him as postcards by friends.[68] Gris tried to unlock the geometric underpinnings that structured the various masters' compositions by drawing organizing lines

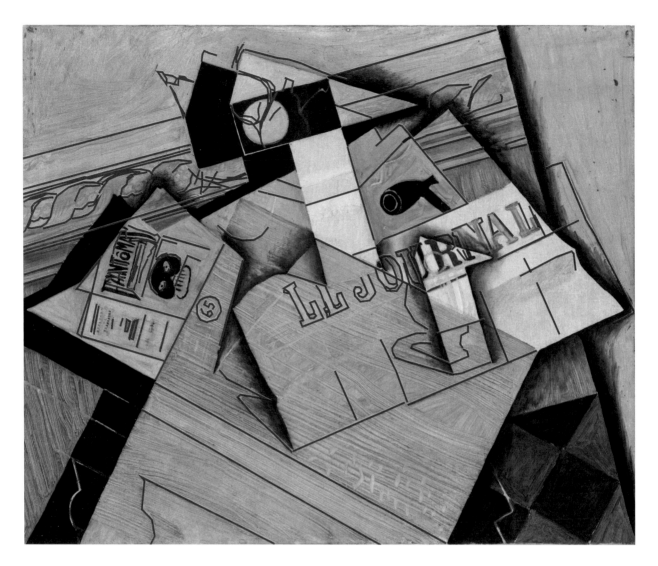

FIG. 18 Infrared image of *Fantômas*, 1915 (cat. 17), with overlay tracing preliminary underdrawing.

over the images on his postcards with a straightedge.[69] We see him trying to determine whether Chardin, Ingres, and Cézanne used the golden section and what, if any, system dictated the placement of strong obliques within their compositions.

Just as in the beginning of his career, it was Cézanne's example that set Gris on a new aesthetic path.[70] In a few drawings, as well as a painting, all of which copy passages in the earlier artist's works, Gris returns to the construction of form through faceted or overlapping planes composed of light, medium, and dark shades. The approach is volumetric, rather than linear, and by reducing his subjects to a limited range of tonal values, Gris found new means of merging figure with ground (fig. 19).[71] This mode of drawing was crucial to Gris's development of an abstract lexicon for the depiction of still-life objects that ushered in a more truly Synthetic style in his paintings beginning in 1916. The emergence of highly schematized glasses and bottles rendered in white and black in paintings such as *The Coffee Mill* (cat. 24), *Still Life with Newspaper* (cat. 25), *The Sideboard* (cat. 27), and *Chessboard, Glass, and Dish* (cat. 28) is undoubtedly the result of Gris's experiments with charcoal and graphite on paper.

Accompanying this aesthetic shift was an expansion of the systems he used to structure his paintings. As James Mai brilliantly discovered, Gris began

FIG. 19 *Still Life with Bottle,* 1916. Chalk and paint on paper. Collection Kröller-Müller Museum, Otterlo, The Netherlands.

experimenting in 1917 with different symmetry transformations, combining bilateral reflective symmetry with changes in proportion, scale, or position.[72] An example of these transformations can be seen in *Chessboard, Glass, and Dish* (fig. 20), which Gris divided into quadrants along its vertical and horizontal axes, a common practice in this period. The background is composed of black and ochre planes that mirror one another through bilateral reflective symmetry with glide transformation along the horizontal axis (the top and bottom are symmetrical, with the left to right orientation reversed in the lower half). Similarly, bilateral reflective symmetry along the vertical axis defines the relationship of the still-life elements on the table, with a reduction in scale between the compotier and glass.

As seen in paintings like *Chessboard, Glass, and Dish,* Gris still turned to mathematical proportions like the phi ratio as a point of departure for the scale and placement of his still-life elements between 1916 and 1919.[73] More often than not, however, it is difficult to discern what systems underlie his compositions in this middle period of his career. This may be because Gris began to develop compositions in which the objects themselves largely determine the compositional armature rather than the other way around. And this new mode of working may well have stemmed from his dedicated drawing practice in 1918. As Gris wrote to Paul Dermé from Beaulieu that spring, "Work goes ahead and I paint for eight or nine hours each day, except for two hours which I spend drawing from nature."[74] This comment has been invoked by those who argue for the separation of painting from drawing in Gris's practice, yet a rare pairing from July of that year reveals just how closely interdependent these practices were.[75] Gris transposed the central still-life elements of an incredibly naturalistic contour drawing into *Pipe, Tobacco Pouch* (1918, private collection, Cooper no. 270), a highly Synthetic painting composed of interlocking blocks of opaque color. It is the placement and contours of the individual objects that determine the angled planes that connect and fuse figure with ground. As with many works of this period, the dynamic still-life elements in the painting are treated as a vignette, set off against a stable background composed of simple geometric planes organized along vertical and horizontal axes.[76]

Many of the paintings Gris produced between 1916 and 1920 bear the marks of considerable *pentimenti,* the artist's changes frequently visible in specular light, which resulted from his refinement of color and form during the painting practice. For example, Gris painted over a series of parallel lines in the upper-left corner of *Still Life with Guitar,* perhaps an allusion to wall molding that mirrors the strings of the guitar below (cat. 35). Gris relied more and more on the potential of such pictorial metaphors to create the rhythm that unified the composition beyond a strict mathematical or symmetrical system. Green identifies this period as the beginning of Gris's application of the deductive method, and the presence of *pentimenti* would seem to point to the adjustments that the artist describes in his writings as he "qualified" subjects suggested by "the quality or the dimensions of a form or a color."[77] Nevertheless, in

spite of this apparent spontaneity, traces of underdrawings are present in *The Coffee Mill* (cat. 24), *Chessboard, Glass, and Dish* (cat. 28), and *Bottle and Glass* (cat. 29).[78] In *Still Life with a Bottle of Bordeaux* (cat. 32), a painting whose formal harmonies rely largely upon the repetition of rhyming forms, infrared imagery reveals a precise underdrawing that blocks in major compositional elements, such as the undulating form of the green tablecloth, as well as loose, curvilinear lines near the bottle that did not make it into the final image.

Perhaps unsurprisingly, Gris's last phase of production was ushered in by a new aesthetic that announced itself first in drawing. Likely inspired by Picasso's 1916 line drawings, which were themselves inspired by Ingres, Gris began his own production of naturalistic drawings in 1919–20 that emphasize the integrity of his subjects, whether figures or still-life objects, through sharply defined contours and minimal modeling (fig. 21).[79] Gris's renewed emphasis on line and legibility in drawing found its parallel in his paintings from 1920 on, culminating in his creation of solid objects that abut, rather than interpenetrate, in the years just prior to his death. As Gris's declining health now prevented him from painting for long stretches at a time, drawing remained the constant in his practice.[80]

It was in this period that Gris described his method of composing paintings in a semi-automatic manner starting with abstract, colored forms. Yet, analysis reveals that his compositions were much more rigorously planned and complex than Gris proclaimed or than has previously been thought. Writing to Ozenfant in 1921, Gris asserted: "I don't deny that I passed on the 'golden section' to some nice young fellows who needed something to guide them in their work, but I had other methods of composition. [...] I wonder whether you have noticed that the majority of my latest things done here are on M shapes?

FIG. 20 *Chessboard, Glass, and Dish*, 1917 (cat. 28), with overlay illustrating three symmetrical systems that structure the composition. The solid white and yellow contours show bilateral reflective symmetry with glide transformation along the horizontal axis. The blue contour demonstrates bilateral reflective symmetry along the vertical axis, while the red contours indicate that same system with a change in scale.

FIG. 21 *Still Life*, 1920. Pencil on paper. Centre Pompidou, Paris, Musée national d'art moderne/Centre de création industrielle.

Well, this has nothing whatever to do with the 'golden section'. It's done with a very strict use of means."[81] The canvases in question were a series of standard *Marine* (M) size 40 paintings that resume the theme of a still life before an open window, the motif that Gris first introduced to Cubism in 1915. In spite of his protest, the main linear axes and proportions within paintings such as *The Open Window* (fig. 36, p. 75) and *Le Canigou* (cat. 36), two of the most celebrated in the series, are determined by the golden section, which lends itself almost perfectly to the *Marine* format as Ozenfant clearly noticed.[82]

It is sometimes stated that in this period Gris frequently used a three-to-five ratio, a slight variation on the golden section or phi ratio, though it is not clear if he truly did this, intentionally or not.[83] Over the course of the 1920s, Gris increasingly treated the central still-life elements of his pictures as integral groups, frequently using a variety of framing techniques to set them off like vignettes against solid-colored backgrounds, typically white, black, or red. When in use, the phi ratio often aligns perfectly with the primary outer vertical axes that delineate the vignettes, as seen for example in *The Mandolin* (1921, private collection, Cooper no. 364), *Le Canigou*, and *The Open Window*, among others.

Nevertheless, these vignettes would increasingly follow their own organizational logic, which Gris hinted at when he teasingly mentioned to Ozenfant that in fact other modes of composition were at play in these works. As Mai detected in *Le Canigou*, and as can also be observed in *The Mandolin* and *The Cloud* (1921, Hamburger Kunsthalle) that preceded it, Gris also deployed a reflective symmetry transformation with enlargement/reduction along the vertical axis that bisects the table. The formal rhyming one sees in *Le Canigou* between the shapes of the white mountain peaks and blue shadow on the guitar's side, between the rectangle of the door on the right and the brown rectangle that comprises the left side of the table, are reflective symmetry transformations with a change in scale (fig. 22).[84] Amazingly, Gris reveals nothing of this incredibly complex system within his correspondence, simply noting to Kahnweiler, "generally speaking, the canvases on which I am working are well composed."[85] Gris undoubtedly worked out such compositions beforehand, transferring the design to an underdrawing on the canvas. During his stay in Bandol, the local butcher's son served a short stint as his studio assistant and helped prepare *The Open Window*. "The large picture is sketched out and it won't be bad," he wrote to Kahnweiler in January 1921, "The work was done by my pupil, a boy of eleven who is astonishingly gifted and says he only wants to do that sort of painting."[86] Gris may have worked out preliminary

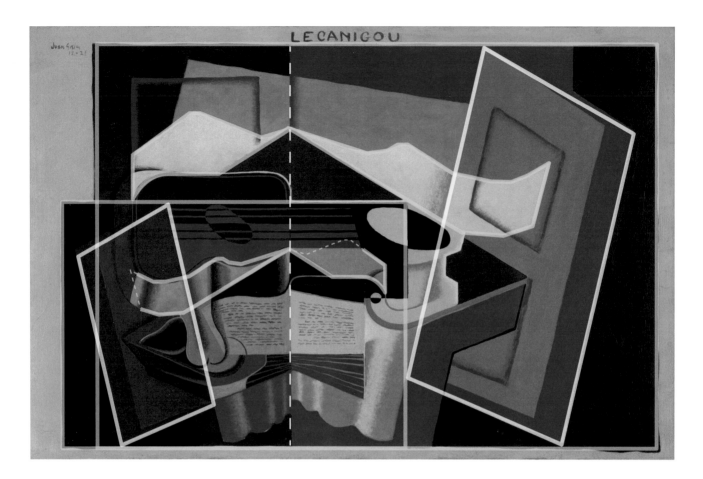

FIG. 22 *Le Canigou*, 1921 (cat. 36), with overlay showing reflective symmetry transformation along a vertical axis (whose placement aligns with the golden section) with a change in scale.

studies for these compositions on graph paper, a method he used in the 1920s to compose his set designs for the Ballets Russes (fig. 23), in order to accurately reduce or enlarge his repeating forms.

Gris probably also used gridded or graph paper to aid in the production of his astonishingly novel compositions in the last three years of his life. Beginning in 1924, he developed a system of reflective symmetries along the diagonal axes of his paintings, adjusting the proportion of the symmetrical shapes to account for the rectangular format of the canvas.[87] In the earliest examples of this new compositional mode, Gris relied intuitively on color to explore formal affinities and produce symmetries between objects and space either in part, as seen in the mirrored shapes of the pink head and shoulder in *Woman with Clasped Hands* (1924, Ikeda Museum of 20th Century Art, Japan), or in their entirety, as in *Violin and Book* (1924, private collection, Cooper no. 455). As Gris honed this compositional device, he narrowed down his selection of still-life objects, developing a lexicon of key subjects—table, window, stringed instrument, bottle, compotier with fruit, journal, books of sheet music—based on shared formal affinities derived from their most essential characteristics, such as the bowtie shape of a guitar or fruit dish.

It was through his drawing that Gris became intimately familiar with his subjects' properties, both linear and volumetric. As Ozenfant observed while watching him draw, Gris seized upon shared structural components between objects, exaggerating and repeating their forms so that they fit together like puzzle pieces.[88] Most viewers of Gris's late paintings pick up on this rhyming aspect—described by critics and scholars alike as a lyrical or poetic counterbalance to the severe mathematical structures of his earlier work—without

FIG. 23 Study for *Les Tentations de la Bergère*, c. 1923. Crayon on paper. Private collection.

FIG. 24 *Sketch* (verso), 1923. Graphite on paper. Centre Pompidou, Paris, Musée national d'art moderne/Centre de création industrielle.

ever noticing the rigorous geometric principles that govern the majority of them. Indeed, Gris's construction of objects through the repetition of basic rectilinear or curvilinear forms aided him in building up symmetrical compositions along their diagonal axis, as demonstrated in an incredibly rare sketch from 1923 (fig. 24). Along a diagonally plotted line within a faint rectilinear grid, Gris bisects a square overlaid with a bowtie shape, perhaps a translation of the sketch of an open book below it.

Gris's later works are often thinly painted and exhibit minimal *pentimenti*, a reflection of the careful plan worked out before setting brush to canvas. As he did throughout his career, he began with an underdrawing, establishing the placement of compositional elements and organizing lines that guided his symmetries.[89] For example, in addition to the contours that define objects like the window in *The Painter's Window*, infrared reflectography of the painting reveals a line that cuts across the lower part of the compotier and continues along the top of the four of diamonds playing card.[90] Visible only in IR, the underdrawn line finds its symmetrical counterpart in the painted line that defines the right side of the guitar's bridge. Though in the beginning Gris's symmetries are relatively straightforward and easy to spot, he became incredibly adept at complicating or concealing their guiding lines, which are often hiding in plain sight. The symmetries within *The Painter's Window* are not constructed within individual objects, but are formed by joining the outer contours of grouped objects as well as disparate compositional elements, such as the grey shadow of the guitar's sound hole and the metal nib and tip of the paint brush (fig. 25). The only significant compositional change that Gris made during the painting process was to the shape of the upper-left side of the green tablecloth.[91] Having originally angled it more

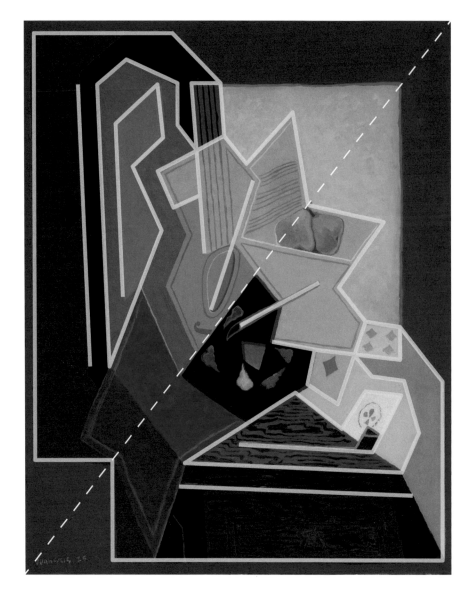

to the left, Gris adjusted the position downward to create a more symmetrical relationship with its counterpart on the upper-right side of the tablecloth.

In spite of Gris's insistence regarding his use of the deductive method, the "professional secrets" hidden in his paintings, only briefly elucidated in this study, tell a more complicated story. As his close confidant, Maurice Raynal, claimed in 1923, "Gris must have a subject and it is from the subject that he makes his painting,"[92] an assertion borne out by close analysis of works across his career. Yet, to the degree that Gris distorted his subjects' formal properties to fit the symmetrical armatures in the 1920s, to the degree that he built a set number of rhyming objects by deducing them from their most basic geometric components, the closer we come to the spirit of the artist's intent when he said: "Cézanne turns a bottle into a cylinder, but I begin with a cylinder and create an individual of a specific type."[93] Gris's last paintings continue the clever conceptual game he set out at the beginning of his career, an intellectual exercise of hide and seek, continuity and disruption, integrity and fragmentation, that challenges both artist and viewer in every phase of his production. But it was only through his incredible virtuosity, his mastery of materials and process, that he achieved the ultimate balance between poetry and prose, color and line, theory and practice—that Gris the Painter became Gris the Artist.

Notes

This essay would not have been possible without the generous collaboration and contributions of many individuals. I would like to recognize and thank Laura Hartman, Paintings Conservator, Dallas Museum of Art, and the following colleagues for dedicating their time and resources, in addition to providing technical data, imaging, and photographs related to paintings by Gris in their respective collections: Cindy Albertson, The Theodor Siegl Conservator of Modern and Contemporary Paintings, Philadelphia Museum of Art; Courtney Books, Assistant Paintings Conservator, Saint Louis Art Museum; Harry Cooper, Senior Curator and Head of Modern Art, National Gallery of Art, Washington, D.C.; Isabelle Duvernois, Painting Conservator, Metropolitan Museum of Art; Anna Erşenkal, Graduate Intern in Paintings Conservation, Philadelphia Museum of Art; Jay Krueger, Head of Painting Conservation, National Gallery of Art, Washington, D.C.; Douglas Lachance, Technician, Painting Conservation, National Gallery of Art, Washington D.C.; Allison Langley, Head of Paintings Conservation, Art Institute of Chicago; Joan Neubecker, Conservation Technician, Cleveland Museum of Art; Thomas Primeau, Conservator of Works of Art on Paper, Philadelphia Museum of Art; Cynthia Schwartz, Senior Associate Conservator of Paintings, Yale University Art Gallery; Mary Sebera, The Stockman Family Foundation Senior Conservator of Paintings, The Baltimore Museum of Art; Pam Skiles, Senior Paintings Conservator, Denver Art Museum; Marcia Steele, Interim Chief Curator, Cleveland Museum of Art; Julia Welch, Curatorial Research Fellow, Art of Europe, Museum of Fine Arts, Boston; Jason Wierzbicki, Conservation Photographer, Philadelphia Museum of Art. I would also like to thank Christine Burger for her insights and research assistance and Jaclyn Le for the overlays illustrating Gris's dynamic symmetry.

1. Gris to Kahnweiler, January 14, 1915, letter XXVIII, in Douglas Cooper, trans. and ed., *Letters of Juan Gris [1913–1927]. Collected by Daniel-Henry Kahnweiler* (London, 1956), 23.

2. Raymond Radiguet, "Allusions," *Sic* 42–43 (March 30–April 15, 1919): 330, [340]. Cited in Christian Derouet, ed. *Juan Gris, Correspondances avec Léonce Rosenberg, 1915–1927*, Les Cahiers du Musée national d'art moderne (Paris: ADAGP, 1999), 98. Author's translation.

3. Caroline Keck, Preservation of Paintings, Report to The Baltimore Museum of Art, #622906 "The Painter's Window," January 1963, The Baltimore Museum of Art, Painting Conservation file.

4. See, for example, letters XXVIII, XXXI, XL, LXXI, LXXX, LXXXI, and CXII in Cooper, *Letters of Juan Gris*.

5. See, for example, letters CI, CII, CXII, CXIII, CXIV CIV, CXV, and XXXV in Cooper, *Letters of Juan Gris*.

6. Gris to Kahnweiler, March 26, 1915, letter XXXI, Cooper, *Letters of Juan Gris*, 25.

7. "I find that, whereas I may have control over my feelings and my mind, I do not always have the same control over the tip of my brush. My work in its present stage can be compared with those pictures of Seurat in which the severity and the emptiness are the result of inexperience and not of incompetence." Gris to Kahnweiler, September 3, 1919, letter LXXXI, Cooper, *Letters of Juan Gris*, 66–67.

8. Christopher Green, Christian Derouet, and Karin von Maur, *Juan Gris* (London: Whitechapel Art Gallery, 1992), 14–15, 19–21; Christian Derouet, "Le cubisme 'bleu horizon' ou le prix de la guerre. Correspondance de Juan Gris et de Léonce Rosenberg, 1915–1917," *Revue de l'Art* no. 113 (1996): 52.

9. Gris to Kahnweiler, January 8, 1920, letter LXXXVIII, Cooper, *Letters of Juan Gris*, 73.

10. My thanks to Jay Krueger and Isabelle Duvernois for drawing my attention to Gris's expert handling of paint with examples in their respective care.

11. William Camfield, John Willats, and most recently James Mai are notable and groundbreaking exceptions. Christopher Green also gives extensive consideration to Gris's techniques, particularly his use of the deductive method, though his discussions tend to rely more on theory than technical observations. See William Camfield, "Juan Gris and the Golden Section," *The Art Bulletin* 47, no. 1 (March 1965): 128–34; John Willats, "Unusual Pictures: An Analysis of Some Abnormal Pictorial Structures in a Painting by Juan Gris," in "Psychology and the Arts" special issue, *Leonardo* 16, no. 3 (Summer 1983): 188–92; James Mai, "Juan Gris's Compositional Symmetry Transformations," *Bridges 2012: Mathematics, Music, Art, Architecture, Culture* (2012): 283–90; Christopher Green, "Synthesis and the 'Synthetic Process' in the Painting of Juan Gris 1915–19," *Art History* 5, no. 1 (March 1982): 87–105. See also Green in Green, Derouet, and Maur.

12. The observations and hypotheses set forth in this essay, which span a period of 1911 to 1927, are drawn from data culled from Douglas Cooper's catalogue raisonné, the artist's correspondence, close visual analysis, and technical conservation information and imaging. This study limits itself to paintings in which oil paint is the predominant medium.

13. Gris to Kahnweiler, December 14, 1915, letter XL, Cooper, *Letters of Juan Gris*, 33.

14. Paloma Esteban Leal, *Juan Gris. Painting and Drawings 1910–1927*, 2 vols. (Madrid: Museo Nacional Centro de Arte Reina Sofía, 2005), 1:233–34.

15. The exact date of when Gris began his residency in the Bateau-Lavoir is not known, though most accounts confirm it was by 1908. Esteban Leal, *Juan Gris. Painting and Drawings*, 1:29; Green, Derouet, and Maur, 16.

16. Daniel-Henry Kahnweiler, *Juan Gris: His Life and Work*, trans. by Douglas Cooper (New York: Harry N. Abrams, 1968), 117.

17. Mark Rosenthal, *Juan Gris* (New York: Abbeville Press, 1983), 12. Christian Derouet, "Experimentation with a Return to Representation in Gris's Drawings," in *Juan Gris. Painting and Drawings 1910–1927* 1:116, claims that Kahnweiler asked Gris to "weed out" his weaker early work when they signed their exclusive contract in 1913.

18. *Juan Gris. Painting and Drawings*, 1:119; Kahnweiler, *Juan Gris*, 33.

19. See for example, letters XXXVII, CVII, CLII, and CCXII in Cooper, *Letters of Juan Gris*.

20. Cooper, *Letters of Juan Gris*, 189, letter CCXXIV; see also 2, 3, 101, letters III, IV, and CI.

21. Cooper, *Letters of Juan Gris*, 80, 125, 173, 179, 197.

22. Examination report of Juan Gris's *Table at a Café* (cat. 2), dated May 16, 2005, Conservation Department, Art Institute of Chicago. A photograph of the verso of *Table at a Café*, taken before it was lined, shows the canvas stamp of Léon Besnard, a Parisian art supplier located at 60 Rue de la Rochefoucauld in Paris, who sold products by Lefranc et Cie from 1902 until at least 1912. The canvas and stretcher are also stamped with "8F," a standard canvas size for a no. 8 *Figure* format. My thanks to Allison Langley, Head of Paintings Conservation, Art Institute of Chicago, for providing technical images and an examination report for *Table at a Café* (email to author November 26, 2019). See entry on "Besnard, L.," in Pascal Labreuche, *Guide Labreuche: Guide historique des fournisseurs de matériel pour artistes à Paris 1790–1960*, https://www.labreuche-fournisseurs-artistes-paris.fr/fournisseur/besnard-l.

23. For example, the absence of canvas stamps, visible either on the verso or documented in photographs before lining of *The Cup* (1914, sold via Sotheby's Nov. 2, 2005, see Cooper no. 98), *Newspaper and Fruit Dish* (1916, Solomon R. Guggenheim Museum, cat. 20), *Newspaper and Fruit Dish* (1916, Yale University Art Gallery, cat. 21), and *Lamp* (1916, Philadelphia Museum of Art, cat. 22), suggests the likelihood that Gris cut and stretched them in the studio. See Curatorial object file [53.1341], Solomon R. Guggenheim Museum, for imagery of the versos of the Guggenheim, Yale, and Philadelphia paintings. In a letter to Kahnweiler from Collioure dated July 8, 1914, (letter VII, Cooper, *Letters of Juan Gris*, 5), Gris mentions the use of a dedicated room to prepare canvas.

Though Gris employed standard canvas sizes from his first recorded oil paintings forward, the contract he signed with Rosenberg, which lasted from April 1916 until September 1921, established fixed prices based on support size with an agreed-upon maximum, an arrangement that sometimes constrained his production. In order to please Rosenberg, Gris consciously sent him a selection of formats that tended to range from small to medium, with preference given to canvas sizes 30, 25, and 10. Based on feedback from Rosenberg, Gris produced smaller format paintings in the fall of 1916, and then larger ones several months later, including *The Sideboard* (1917, The Museum of Modern Art, cat. 27). Rebuked by Rosenberg, Gris wrote in anger, "You are mistaken to believe that it is by hunger that I make large paintings. I prefer to languish in misery than to do anything against my nature. If I made paintings of these formats it is because I felt the need for my development, just as in other series I feel [the need] to make small pictures." Letters 65 and 92, Derouet, "Le cubisme," 41, 60. Author's translation.

Although these circumstances were perhaps not ideal, Gris saw the challenge of painting to specific formats as a positive in his development, boasting to Amédée Ozenfant in 1921, "Today, *mon cher ami*, you can believe me when I say that not only do I know the attributes of every size and shape of canvas—F, P or M—but that I can produce to order a composition to suit any given area." Gris to Ozenfant, March 25, 1921, Cooper, *Letters of Juan Gris*, 105–6, letter CXXIV.

24. The seams, which run horizontally across the support, are visible on the recto in specular light as well as in x-ray and a photograph of the verso before it was lined. My thanks to Mary Sebera for providing the imagery and confirming these observations.

At least 15 of Gris's paintings and *papier collés* bear abandoned sketches, paintings, and/or collages on their versos (Cooper nos. 30, 43, 44, 57, 67, 90, 94,

99, 102, 127, 141, 164, 176, 179, and 229). Others were painted over compositions on the recto, such as *Lamp* (1916, Philadelphia Museum of Art, cat. 22) and possibly *Still Life before an Open Window, Place Ravignan* (1915, Philadelphia Museum of Art, cat. 13). An underlying composition can be seen in x-radiographs of the latter; however, as the painting is lined, further examination is needed to determine whether the image was painted on the recto or verso. See Conservation object files [1950-134-96, 1950-134-95], Philadelphia Museum of Art.

25. See for example letters 75 and 121 in Derouet, *Juan Gris, Correspondances*, 47, 74. Derouet, "Le cubisme," 51, suggests that Gris may have elected to use lightweight wood supports as shipping to his dealers from afar was difficult during the war, but Gris in fact began using panels while still in Paris.

26. See, for example, Kahnweiler, *Juan Gris*, 124–26, and Green, Derouet, and Maur, 87.

27. Green, Derouet, and Maur, *Juan Gris*, 87.

28. Examination report of Juan Gris's *Table at a Café*, dated May 16, 2005, Conservation Department, Art Institute of Chicago.

29. Gris gives a further nod to Georges Seurat, the originator of the Pointillist technique whom he deeply admired, in his sporadic pairings of contrasting complementary colors, such as red/green and purple/yellow, in order to signify Seurat color theories in relation to the optics of vision. Camfield, "Juan Gris and the Golden Section," 129–130n9, notes that Seurat was admired by the Puteaux Cubists, whom Gris frequented in his early years, for his application of the golden section in paintings like *Circus Sideshow (Parade de cirque)* (1887–88, Metropolitan Museum of Art). As Dan Heenan observed, Gris adopted the *Marine* format used for *Circus Sideshow (Parade de cirque)* in a series of paintings from 1920 and 1921 that are structured in part by the golden section, perhaps uncoincidentally. Letter from Dan Heenan to Steve Nash, May 10, 1975, Fine Art Collection Documentation Files, Albright-Knox Art Gallery. My thanks to Holly Hughes, Godin-Spaulding Curator and Curator for the Collection, Albright-Knox Art Gallery, for bringing this letter to my attention.

30. Isabelle Duvernois, conversation with the author, Oct. 23, 2019.

31. Gris may have wiped away paint with a rag or his finger to produce the small vertical marks on the tabletop in *Fantômas* (cat. 17). Laura Hartman, Painting Conservator, Dallas Museum of Art, has observed the possibility that paint was applied by a rag in *Guitar and Pipe*, technical examination, February 2019. Cynthia Schwarz posits that the stippled texture of the white newspaper in *Newspaper and Fruit Dish* (cat. 21) might have been produced using something like a rag or a sponge, emails to the author, November 18, 2019, and February 18, 2020. The latter provides a playful counterpoint to the network of hand-painted Pointillist dots that dominate the painting's surface. Courtney Books notes the possible use of a palette knife in smooth passages of *Still Life with Guitar* (cat. 35), in emails to author, November 22, 2019, and January 12, 2020.

32. My thanks to Laura Hartman and Courtney Books for discussing these techniques with me in conversation and email. A condition report dated December 17, 1971, for *Houses in Paris* (1911, Solomon R. Guggenheim Museum), records that Gris was thought to have applied the paint in a "near-dry state." Curatorial object file [48.1172.33], Solomon R. Guggenheim Museum, accessed October 24, 2019.

33. Unprimed canvases were used, for example, in *Houses in Paris* (1911, Solomon R. Guggenheim Museum), *Guitar and Pipe* (1913, Dallas Museum of Art, cat. 5), *Violin* (1913, Philadelphia Museum of Art, cat. 8), *Still Life with a Guitar* (1913, Metropolitan Museum of Art), *Still Life before an Open Window, Place Ravignan* (1915, Philadelphia Museum of Art, cat. 13), and *Still Life with Checked Tablecloth* (1915, Metropolitan Museum of Art). See condition report, *Houses in Paris*, December 17, 1971, curatorial object file [48.1172.33], Solomon R. Guggenheim Museum, accessed October 24, 2019; Laura Hartman, Dallas Museum of Art, technical examination, February 2019; Anna Erşenkal, email to author, December 23, 2019; condition assessments in the conservation object files [1952-61-34, 1950-134-95], Philadelphia Museum of Art, accessed Nov. 5, 2019; and Isabelle Duvernois, conversation with author, October 23, 2019.

Violin and *Guitar and Pipe* remain unvarnished, and according to conservation records at the Solomon R. Guggenheim Museum, *Houses in Paris* appears to have been unvarnished at the time of its acquisition in 1948; email from Indira Abiskaroon to author, February 27, 2020. This was likely Gris's preference and practice throughout his career. Isabelle Duvernois notes that *Still Life with Checked Tablecloth* was probably also originally unvarnished. The only mention of varnish in Gris's correspondence dates to October 11, 1920, when he mentions applying it selectively to passages of paint to maintain the desired balance of tones and saturation in a picture. See letter XCIX, Cooper, *Letters of Juan Gris*, 82.

34. Kahnweiler, *Juan Gris*, 126.

35. Derouet, *Juan Gris, Correspondances*, 30–31, letters 39 and 41. It is not known whether Gris bought large sheets of plywood that he cut down to standard sizes or whether he bought them commercially prepared.

36. See for example *Pitcher and Glass on a Table* (1916, Pinakothek der Moderne, Munich) or *Chessboard, Glass, and Dish* (1917, cat. 28). This may have been a desired textural effect, as noted by Anna Erşenkal, who observed that Gris does not appear to have applied a traditional opaque ground layer before paint application in *Chessboard, Glass, and Dish*. Email to author, December 23, 2019.

37. Per Laura Hartman and Courtney Books, the inclusions may have been produced by incorporating flecks of semi-dry paint on his palette into fresh paint. Gris also incorporated unidentified mixed media and wax in *Open Window* (1917, Philadelphia Museum of Art).

38. Gris to Kahnweiler, September 3, 1919, letter LXXXI, Cooper, *Letters of Juan Gris*, 66; Gris to Kahnweiler, December 14, 1915, letter XL, Cooper, *Letters of Juan Gris*, 33.

39. Gris to Rosenberg, July 10, 1918, letter 130, Derouet, *Juan Gris, Correspondances*, 79. Author's translation.

40. Pinturicchio [Louis Vauxcelles], "Perplexité," *Le Carnet de la semaine* no. 167 (August 18, 1918): 7, cited in Derouet, *Juan Gris, Correspondances*, 81n1.

41. Gris to Rosenberg, August 22, 1918, letter 134, Derouet, *Juan Gris, Correspondances*, 80–81. Author's translation.

42. Kahnweiler, *Juan Gris*, 133–34, recalled this change in technique in Gris's paintings from the 1920s, noting that some of these experiments with grounds led to cracking. See also letters CLXVI and CLXI in Cooper, *Letters of Juan Gris*, 141, 145. Courtney Books has observed what appears to be a warm, light-colored preparatory layer in *Still Life with Guitar* (1920, Saint Louis Art Museum, cat. 35). Email to author, November 22, 2019.

43. Pinturicchio [Louis Vauxcelles], "Mort de quelqu'un," *Le Carnet de la semaine* no. 408 (April 1, 1923): 8, cited in Green, Derouet, and Maur, 82, 90n44.

44. These included *L'Esprit Nouveau* (1921), *Der Querschnitt* (1923), and the *Transatlantic Review* (1924), which published the lecture Gris delivered in 1923 to the Society of Philosophical and Scientific Studies at the Sorbonne. See Kahnweiler, *Juan Gris*, 192–204, for a complete transcription of Gris's writings.

45. Vauvrecy [Amédée Ozenfant], *L'Esprit Nouveau*, no. 5 (1921): 533–34, cited in Kahnweiler, *Juan Gris*, 193.

46. Kahnweiler, *Juan Gris*, 146.

47. Rosenthal, *Juan Gris*, 128; Green, "Synthesis and the 'Synthetic Process,'" 89–90.

48. Green, "Synthesis and the 'Synthetic Process,'" 97–99, 101; Green, Derouet, and Maur, 52.

49. Gris to Kahnweiler, August 25, 1919, letter LXXX, Cooper, *Letters of Juan Gris*, 65. The resumption of his correspondence with Kahnweiler in August, after nearly four years of silence during the war, prompted Gris to take stock, particularly as it came on the heels of his solo exhibition of paintings from 1916–1918 at Rosenberg's Galerie de L'Effort Moderne. The exhibition had affirmed Gris as a "classical" painter in opposition to newer abstract movements like Dada, which he adamantly opposed for having departed too far from reality.

50. Kahnweiler, *Juan Gris*, 146; Green, "Synthesis and the 'Synthetic Process,'" 101.

51. In addition to traces of charcoal or graphite visible to the eye in areas of unpainted canvas or below thin layers of paint observed by the author in numerous paintings between 1912 and 1925, underdrawings can also be seen in infrared imagery of *Table at a Café* (1912, Art Institute of Chicago, cat. 2), recto and verso of *Guitar and Pipe* (1913, Dallas Museum of Art, cat. 5a–5b), *Violin* (1913, Philadelphia Museum of Art, cat. 8), the abandoned painting on the verso of *Still Life: The Table* (1914, Philadelphia Museum of Art, cat. 11), *Ace of Clubs and Four of Diamonds* (1915, The National Gallery of Art, Washington, D.C., cat. 14), *Fantômas* (1915, The National Gallery of Art, Washington, D.C., cat. 17), *The Coffee Mill* (1916, Cleveland Museum of Art, cat. 24), *Chessboard, Glass, and Dish* (1917, Philadelphia Museum of Art, cat. 28), *Bottle and Glass* (1918, The Baltimore Museum of Art, cat. 29), *Still Life with a Bottle of Bordeaux* (1919, Denver Art Museum, cat. 32), and *The Painter's Window* (1925, The Baltimore Museum of Art, cat. 40). My thanks to Laura Hartman for reviewing these infrared images with me.

52. Derouet, "Experimentation with a Return," 1:117.

53. Green, Derouet, and Maur, 18, 76–77.

54. Green, Derouet, and Maur, 38.

55. Green, Derouet, and Maur, 41. The drawing with mathematical figures is reproduced in *Juan Gris, Peinture et Dessins* (Marseille: Musées de Marseille—Réunion des musées nationaux, 1998), 19, as *Still Life, Habana*, 1911–1912, charcoal on paper, Galerie Louise Leiris, Paris.

56. See, for example, the versos of *Violin* (1913, Philadelphia Museum of Art, cat. 8), *Still Life: The Table* (1914, Philadelphia Museum of Art, cat. 11), and *The Bottle of Claret* (1913, private collection, Cooper no. 43).

57. Douglas Cooper, with Margaret Potter, *Juan Gris Catalogue Raisonné*, 2nd ed., updated by Alan Hyman and Elizabeth Snowden 2 vols. (San Francisco: Alan Wofsy Fine Arts, 2014), places *Guitar and Pipe* as the first painting executed in 1913, presumably in January or February of that year (Cooper no. 30). However, the style of the abandoned painting on the verso is very similar in palette, composition, and subject to *The Guitar*, a collage that is signed and dated May 1913 in the collection of the Centre Pompidou, Paris, Musée national d'art moderne/Centre de création industrielle (Cooper no. 42). The verso was probably painted at that time, with the recto being executed in the summer, probably around July 1913, as it closely relates to *Guitar and Glass*, signed and dated July 1913, in the collection of the Art Institute of Chicago (Cooper no. 45).

58. Laura Hartman, conversations with the author, December 10 and 11, 2019.

59. Rosenthal, 29, 34.

60. Isabelle Duvernois, conversation with the author, October 23, 2019.

61. Mary McCampbell recorded the presence of a pinhole on the top-left edge of *Newspaper and Fruit Dish* (cat. 20) in a condition report dated February 26, 1955, Curatorial object file [53.1341], Solomon R. Guggenheim Museum. Infrared reflectography of *Still Life: The Table* reveals two pinholes on the recto's upper-left corner; imaging conducted by Jason Wierzbicki in presence of Thomas Primeau and the author on November 5, 2019. *Violin* has a series of pinholes visible in the upper-right (up to eight), lower-right, and lower-left corners of the recto, in addition to holes along the right edge (see condition assessment, Conservation object file [1952-61-34], Philadelphia Museum of Art). As both *Still Life: The Table* and *Violin* are double-sided, the pinholes might correspond to tack holes from the canvas supports' original orientation on the stretcher, exposed when Gris removed the canvas, turned it over, and restretched it. Anna Erşenkal, email to author, December 23, 2019. Both works appear to be on their original stretchers; *Still Life: The Table* retains its Kahnweiler label and stamp recording its stock number. Nevertheless, the placement of two (possibly three) pronounced holes several inches from the tacking margins in the pattern of the wallpaper in the upper-right section of *Violin* suggest a different purpose.

62. Green, Derouet, Maur, 40–42. Derouet, "Experimentation with a Return," 119–20, also observes the importance of repetition, adjustment, and transfer in Gris's drawing process.

63. Images of these underdrawings are reproduced, respectively, in Cooper, with Margaret Potter, *Juan Gris Catalogue Raisonné*, 1:95, p. 175, and Emily Braun and Rebecca Rabinow, eds. *Cubism: The Leonard A. Lauder Collection* (New York: The Metropolitan Museum of Art, 2014), 133.

64. Elizabeth Cowling, "Juan Gris: Four Collages," in Braun and Rabinow, 116.

65. Gris to Rosenberg, October 7, 1918, letter 143, Derouet, *Juan Gris, Correspondances*, 86; Green, "Synthesis and the 'Synthetic Process,'" 42; Esteban Leal, *Juan Gris. Painting and Drawings*, 1:119. On Gris's use of hidden line elimination, among other translation and denotation systems, see Willats, "Unusual Pictures ," 190.

66. Supporting this hypothesis is the minimal presence of underdrawing and *pentimenti* in *Still Life with Checked Tablecloth* (1915, Metropolitan Museum of Art), one of Gris's largest and most technically complex paintings. These absences strongly suggest that the composition was worked out first in preparatory drawings that are among the many missing today. Isabelle Duvernois, conversation with the author, October 23, 2019.

67. Gris to Kahnweiler, December 14, 1915, letter XL, Cooper, *Letters of Juan Gris*, 33–34.

68. Several are reproduced in Christian Derouet, *Juan Gris, Correspondance, Dessins 1915–1921* (Paris: Musée national d'art moderne, Centre Pompidou, 1990). Kahnweiler, *Juan Gris*, 133, notes that during the last years of Gris's life, his studio was decorated entirely with reproductions of works by French painters—Fouquet, Le Nain brothers, Boucher, and Ingres—as can be seen in a photograph taken shortly after his death. Image reproduced in Emmanuel Bréon, *Juan Gris à Boulogne* (Paris: Herscher, 1992), 77.

69. Green, Derouet, and Maur, 60.

70. Green, Derouet, and Maur, 63; Derouet, "Experimentation with a Return," 123.

71. Green, Derouet, and Maur, 39; Esteban Leal, *Juan Gris. Painting and Drawings*, 1:26.

72. Mai, 288.

73. Green, Derouet, and Maur, 32.

74. Gris to Paul Dermé, May 13, 1918, letter LXVI, Cooper, *Letters of Juan Gris*, 53.

75. Green, Derouet, and Maur, 76–77.

76. Rosenthal, 11, observes this stylistic device, in which a sinuous outline encircles compositional elements in a vignette, in Gris's early illustration work in 1906 for *Alma América*, a book of poetry by José Santos Chocano.

77. "The quality or the dimensions of a form or a color suggest to me the appellation or the adjective for an object. I never know in advance the appearance of the object represented." Juan Gris, *Der Querschnitt*, nos. 1 and 2 (Summer 1923): 77–78, cited in Kahnweiler, *Juan Gris*, 194.

78. See note 51 above. An underdrawing may also be present in *Still Life with Guitar* (1920, Saint Louis Art Museum, cat. 35), email from Courtney Books to author, November 22, 2019.

79. Picasso's line drawings were published in *L'Élan* in 1916. Derouet, "Le cubisme," 48.

80. See, for example, letter XCVI, Cooper, *Letters of Juan Gris*, 80.

81. Gris to Ozenfant, c. March 25, 1921, letter CXXIV, Cooper, *Letters of Juan Gris*, 105–6.

82. Katy Kline, "Juan Gris," in Steven A. Nash, Katy Kline, Charlotta Kotik, and Emese Wood, *Albright-Knox Art Gallery: Painting and Sculpture from Antiquity to 1942* (New York: Rizzoli International Publications, 1978), 371, 371n2.

83. See for example Rosenthal, 106.

84. Mai, 288–89. *The Mandolin* (Cooper no. 364) from February 1921 may be the first M format canvas to deploy this reflective symmetry translation with change in scale.

85. Gris to Kahnweiler, January 15, 1921, letter CVIII, Cooper, *Letters of Juan Gris*, 89–90.

86. Gris to Kahnweiler, January 21, 1921, letter CIX, Cooper, *Letters of Juan Gris*, 90. It would be interesting to conduct infrared imagery on this painting and others from this series. For example, graphite lettering can be seen below the painted letters in *Le Canigou* (cat. 36), and it is likely that IR would reveal additional underdrawing.

87. Mai, 289–90.

88. Ozenfant recalled the following in his published memoir: "In his drawing he accentuated the squareness of the shoulders of the wine bottle, making them into right angles; to make these fit snugly with the roundness of the carafe, he changed its convex bottom and round opening into two triangles, thereby creating a common factor which he repeated three times. And so the two became one. One entity made up of two forces merged together through consonance. But poor carafe!" Cited in Esteban Leal, *Juan Gris. Painting and Drawings*, 1:126.

89. Precise linear underdrawings can be easily seen below thin paint layers in *Woman with Clasped Hands* (1924, Ikeda Museum of 20th Century Art, Japan) and *The Jug* (1924, private collection, Cooper no. 490).

90. My thanks to Mary Sebera for coordinating and sharing this imagery with me.

91. This change is visible in x-radiography and specular light. A minor artist's change is visible in the upper-right quadrant, where Gris originally painted a diagonal line through the red border from the window's upper-right corner to the upper-right corner of the canvas, as if painting a miter on a frame.

92. Cited in Rosenthal, 141.

93. Cited in Kahnweiler, *Juan Gris*, 193.

The Early Reception of Juan Gris in America

KATHERINE ROTHKOPF

It's grand to see a painter who knew what he was doing.

—PABLO PICASSO[1]

Juan Gris's achievements and contributions to the advancement of modern art were extraordinary. Over the course of a short career in France spanning about seventeen years, he went from being an ardent admirer of Paul Cézanne's work to becoming a Cubist innovator with significant changes to his style every year or two. Unlike his contemporaries Pablo Picasso, Georges Braque, and Fernand Léger, Gris is not well known in the United States today despite his great accomplishments. His works are well represented in American museums, but monographic exhibitions of his paintings and collages are few and far between. Why are some artists considered essential to tell the story of art in the early twentieth century and others less so?

As with many other European modernists, Gris's work was embraced early on by a small but dedicated group of individuals. His early reception in America is the story of supportive galleries and dedicated collectors. When surveying the list of Gris paintings that are owned by American museums today, the majority were donated by private collectors, with institutions making purchases on very rare occasions. This fact prompts the following inquiry into Gris's early reception in America, in order to learn more about how the arts community would have been able to first discover his work and appreciate his many contributions to art making during the first half of the twentieth century. This essay will focus on early gallery and museum exhibitions, important art dealers, and key American collectors of Gris's work, who generously shared their collections with the wider public during this early period.

The writer and collector Gertrude Stein was one of Gris's first American patrons, although she lived most of her adult life in Paris.[2] They first met in 1910, and four years later she began to buy examples of his work from his dealer Daniel-Henry Kahnweiler, with whom she shared an enthusiasm for

FIG. 26 *Self-Portrait No. 1* (detail), 1909–10. Charcoal on cream laid paper. Philadelphia Museum of Art, 125th Anniversary Acquisition. Gift of The Judith Rothschild Foundation, 2007-46-7.

the young Spanish artist. Stein later wrote about his contributions to modern art by stating that "... cubism is a purely spanish [sic] conception and only spaniards [sic] can be cubists and that the only real cubism is that of Picasso and Juan Gris. Picasso created it and Juan Gris permeated it with his clarity and his exaltation."[3] She continued, "... americans [sic] can understand spaniards [sic]. That they are the only two western nations that can realise abstraction."[4] Her Gris holdings would have been on view in her Paris apartment, where she hosted frequent gatherings for writers, artists, and other culturally interested guests, so they would have been seen by many Americans and Europeans.

After the outbreak of World War I in 1914, the French government determined that Kahnweiler, as a German citizen, was an enemy of the state, and thus justified seizing the contents of his gallery. He relocated to Switzerland later that year and did not return to France until 1920. Four auctions of Kahnweiler's holdings were later held in Paris with about 3,000 works sold, including many by Gris. Stein was able to acquire more examples by the Spanish painter in the 1920s after Kahnweiler returned to Paris and opened a new gallery—Galerie Simon. The friendship between Stein and Gris grew closer in the 1920s, as they spent more time together. Stein wrote a word poem about him in 1924, in which she described him as a "perfect painter."[5] After his death in 1927, she wrote a tribute to him as well.[6]

Early Gallery and Museum Exhibitions

Gris's first monographic exhibition was held in Paris in 1919 at the Galerie de L'Effort Moderne, run by Léonce Rosenberg, who had taken over as the Spanish artist's dealer during Kahnweiler's exile in Switzerland. This was one of several one-person shows of Gris's work held in the French capital during these early years. His work began to appear in galleries in New York in the 1910s as well, with early mentions of his inclusion in shows at the Modern Gallery in 1916 and 1918,[7] and in the *First Annual Exhibition of the Society of Independent Artists* in New York in 1917.[8] Despite the fact that Gris was first on Picasso's list of suggested European artists to be included in the Armory Show of 1913, the exhibition which introduced audiences in New York, Boston, and Chicago to contemporary art, Gris did not show his work in New York until later in the decade.[9] He therefore was not a victim of the overwhelmingly negative response to Cubism, and to modern art in general, from critics and the general public during that fateful exhibition and its immediate aftermath. Gris began to receive mentions in American art magazines in the late teens, such as *Arts & Decoration* and *The Soil*.[10] In 1921, Gris was even included in a group show of living artists in New York at Wanamaker's Department Store, along with other Post-Impressionist, Cubist, and Futurist painters.[11]

His work continued to be presented in group shows throughout the 1920s, including outside of New York, such as at the Worcester Art Museum in 1921

in an exhibition of "ultra" moderns that was drawn from the collection of the Société Anonyme.[12] Katherine Dreier, Marcel Duchamp, and Man Ray had founded the Société Anonyme in 1920 in New York to make contemporary art available to the American public, and the Worcester exhibition was the first venue of several in the collection's tour through the United States.[13] Gris's work was included in an exhibition at the Omaha Society of Fine Arts in early 1924, alongside examples by Picasso, Cézanne, Charles Demuth, and Max Weber, among others.[14]

In 1926–27, the Société Anonyme hosted a major show of international modern art at the Brooklyn Museum. More than 48,000 visitors attended during its planned run, leading the organizers to extend the exhibition by a week.[15] Gris's works owned by the Société Anonyme were included and earned special mention in the Brooklyn Museum's publication: "They can draw. They can paint. Technique is at their finger tips [sic]. Complete command of material is everywhere evident, perhaps rising to its most subtle expression in the abstractions of Juan Gris, the two compositions of Picasso, and Pevsner's head of a woman carved from glistening wood in planes that are like the taut wings of a flock of blackbirds flying high in the air."[16] Also in 1927, Gris was included in a group show at Wellesley College's art museum, entitled *Progressive Modern Painting*.[17] The college had recently hired Alfred H. Barr, Jr., as associate professor, who went on to teach the first modern art history class in the United States and later became the first director of The Museum of Modern Art in New York.[18]

Gris's first American solo exhibition was held in New York at De Hauke & Co. in November 1930. He had been included in a Cubism show at the same gallery in April 1930. The earlier show was hailed as the first major exhibition of Cubism since the Armory Show: "NEW YORK is having an exhibition of Cubism. Not since the Armory Show in 1913 has anyone had the temerity, or the energy, to gather a group of pictures which adequately represent the movement. Cubism, although at present in eclipse, is certainly one of the most important phases of twentieth century painting, both intrinsically and fo[r] its disciplinary effect on subsequent work, and all thanks are due M. de Hauke and his assistants for giving us this belated chance to find out 'what it's all about.'"[19]

In 1932, the Marie Harriman Gallery in New York hosted a one-person show, featuring twenty-one oil paintings and eleven watercolors and drawings, with all of the paintings from American collections (fig. 27). Only one work was already owned by a museum—the Columbus Gallery of Fine Arts (now known as the Columbus Museum of Art)—and two were from the Société Anonyme. In his review of the show for *The New York Times*, Edward Allen Jewell was mainly positive, although he spent most of his review trying to decipher how to define Gris's artistic output.[20]

Gris's debut at The Museum of Modern Art (MoMA) in New York took place with one work included in the *Summer Exhibition* of 1933, featuring examples of European modern art mostly from private collections, which was

then extended and enlarged into another exhibition in October of the same year.[21] In an article for *The Bulletin of the Museum of Modern Art* about the exhibition, Alfred Barr expressed his enthusiasm for the Cubist examples included, as well as his feeling that their work is no longer unknown or unusual: "The most striking room in the exhibition is unquestionably the group of 'Abstract' paintings. Most of us are by this time fairly familiar with the Cubism of Picasso and Juan Gris, Braque and Léger."[22] In 1934, Gris's work was included in an exhibition celebrating the fifth anniversary of the museum, followed by another *Summer Exhibition* in 1935.[23]

As time passed after his death in 1927, Gris's importance as a pioneering modernist painter was seen in museums throughout the United States. In the 1930s, his work was included in group exhibitions in both large city institutions and college galleries in Chicago; Philadelphia; San Francisco; Hartford, Connecticut; Cambridge, Massachusetts; Bennington, Vermont; Toledo, Ohio; and Poughkeepsie, New York, among others. In 1935, the dealer Howard Putzel in San Francisco hosted a small Gris show, which then traveled to the Julien Levy Gallery in New York and to The Arts Club of Chicago, giving the artist exposure across the country.[24]

In 1936, MoMA organized *Cubism and Abstract Art*, the first major museum exhibition in the United States that included Gris. This massive show was comprised of 386 works and included examples of many schools of contemporary art at one time. It presented four paintings, one collage, and one sculpture by Gris. By comparison, there were twenty-nine works by Picasso, but only nine by Braque, and five by Léger. The extensive catalogue included a very positive description of Gris's collages, and he was commended, along with his colleagues Picasso and Braque, for his experimental work in this new medium: "In the years 1912–14 Picasso, Braque, Gris and the others rivalled each other in the variety and originality of their *collages*, combining the pasted materials with drawing and painting. . . . During the years of Synthetic Cubism, Gris held his own even against Picasso and Braque, achieving a series of *collages* and painted compositions unsurpassed in precision and refinement."[25] Although the more conservative art critics did not wildly praise the show, it did make a major statement about the future of European modernism in the United States.[26]

The Jacques Seligmann Gallery in New York hosted a Gris exhibition in 1938, displaying twenty-seven works, mostly from private collections. The catalogue featured an essay that had originally been published in 1927 by Gris's friend Gertrude Stein, who described his life and death in her typical rolling prose.[27] The following year, The Arts Club of Chicago held its own Gris show, repurposing the biographical notes, quotes, and text by Stein from the Seligmann show, but with a total of thirty-four works.

Three more monographic gallery exhibitions were held in the 1940s in New York, including two important shows at the Buchholz Gallery, headed by Curt Valentin. One of Gris's great admirers and promoters, Valentin played

FIG. 28 Cover of the Buchholz Gallery exhibition brochure, *Juan Gris*. March 28–April 22, 1944.

a major role in placing works by the Spanish Cubist in private collections throughout the United States in the 1940s and early 1950s. Valentin first showed Gris's work in a group show in 1940, alongside paintings and drawings by Braque, Paul Klee, and sculpture by Henri Laurens.[28] In the 1944 Gris exhibition, Valentin borrowed works from private collectors and art dealers as well as from the Albright Art Gallery (now known as the Albright-Knox Art Gallery), Buffalo; MoMA; and the Smith College Museum of Art, Northampton, Massachusetts. The show consisted of twenty-nine paintings and eleven works on paper (fig. 28).

The Buchholz Gallery organized two more Gris exhibitions—one in 1947, the other in 1950. In the catalogue for the 1947 exhibition, Valentin stated that most of the paintings in the show had not been presented in an exhibition in the United States before, and MoMA and the Smith College Museum of Art were the only museum lenders.[29] It featured nineteen paintings, one collage, five drawings, and four lithographs. As Valentin wrote in the press release for the 1947 show about Gris: ". . . his work, starting with the inception of cubism, developed rapidly, and today we look back on the painting of Juan Gris, who was little recognized during his life-time, as one of the most important and creative oeuvres of the twentieth century."[30] In the catalogue for his 1950 exhibition, Valentin again mentioned that many examples included had not been seen in shows in America before, and none are identified as being owned by museums. The exhibition consisted of thirty-three paintings and collages, twelve drawings, and an unidentified number of lithographs.[31] Thanks to Valentin's determination and support, the Buchholz Gallery played a prominent part in furthering Gris's reputation in both the United States and Europe.

Private Collectors and American Museums

The first works by Gris to enter a museum collection in America were five early still lifes donated to the Smith College Museum of Art in 1921 and 1923 by the art dealer Joseph Brummer (including cat. 19). Although it is unclear why Brummer chose to give those works to the small liberal arts college, they would have been considered a very unusual gift to a college art museum at a time when modern art was not widely understood or accepted (fig. 29).[32] By the next decade, these works were of interest to the Fogg Art Museum at Harvard University, which borrowed two of them at some point during 1936–37.[33] Curt Valentin was eager to include several examples from Smith in his ambitious Gris show at the Buchholz Gallery in 1944—a time when there were not many paintings by the artist in public collections in the United States.[34]

Of the American private collectors who acquired works by Gris during the first half of the twentieth century, some purchased them abroad, usually in Paris. Others, particularly in the years surrounding World War II, bought them in galleries in New York and other larger American cities. Although he chose not to donate many of his more than 2,500 works of art to a museum, as he was

concerned about the reception of a major gift of contemporary art at that time, the American collector John Quinn purchased at least six works by Gris of the highest quality during the early years of the twentieth century, with four of them now in the collections of the Philadelphia Museum of Art, a promised gift to the Metropolitan Museum of Art, MoMA, and the National Gallery of Art (cat. 14).[35] Pittsburgh collector G. David Thompson also acquired a remarkable collection of modern art, including twelve works by Gris that spanned the entirety of the artist's short career. Thompson wanted to create an arts center for his vast collection in his native city, but when those plans did not materialize, he sold most of his collection. *Mandolin and Fruit Dish* (cat. 39), now in the collection of the Museum of Fine Arts, Boston, was once owned by Thompson.[36] Other major collectors of Gris's paintings and collages during the first half of the twentieth century included Leigh and Mary Block; curator and museum director James Johnson Sweeney; Walter P. Chrysler, Jr.; Ralph F. Colin; Earl Horter; artist George L. K. Morris; David Rockefeller, and Herbert and Nanette Rothschild, among many others.

Albert Eugene Gallatin played an essential role in furthering Gris's reputation in the United States. Gail Stavitsky has thoroughly documented how as both a major collector and the director of the first public institution of modern art in New York, Gallatin was in a unique position to promote and provide access to artists whose work could not be seen anywhere else in the city.[37] He provided an opportunity for local artists to see works by Cubist and abstract artists close to their own homes, and he also offered classes on modern art (fig. 30).[38]

Gallatin began making frequent trips to France in the 1920s, where he spent time with dealers, collectors, and artists. He took advantage of opportunities to meet those who specialized in Cubism, such as Daniel-Henry Kahnweiler, and visited with Picasso as well.[39] In his own writing, Gallatin was disdainful of the lack of availability of contemporary work in American museums.[40] This desire to educate the public about modern art prompted Gallatin to create his own museum in 1927 at New York University (NYU), where he was a trustee. Initially named the Gallery of Living Art, it was located in the South Study Hall of the university's Main Building and featured changing exhibitions, which were often based on Gallatin's own collection of Cubist art.[41] In the

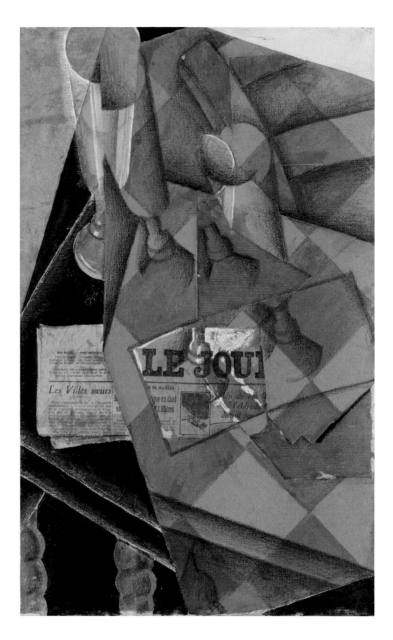

FIG. 29 *Glasses and Newspaper*, 1914. Gouache, conté crayon, and chalk on paper. Gift of Joseph Brummer, Smith College Museum of Art, Northampton, Massachusetts, SC 1921.8.2.

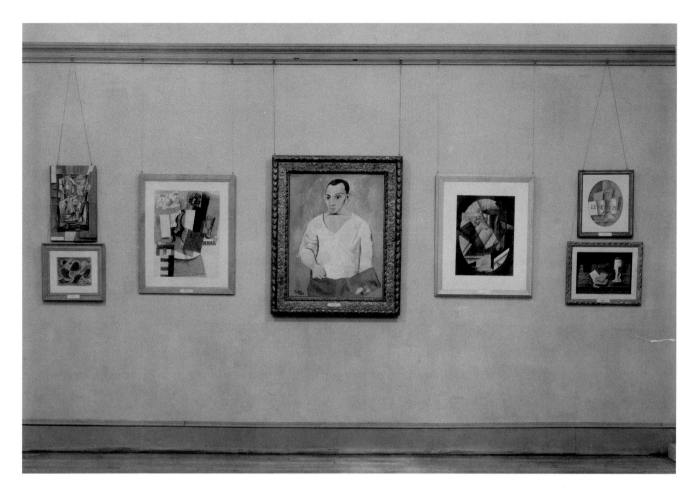

essay for the catalogue for the opening show, he described the mission of the new venture as: "The Gallery of Living Art has been founded in order that the public may have an opportunity of studying the work of progressive twentieth century painters. It is a permanent collection, which will be added to from time to time."[42] The inaugural show included twenty-one works by Americans and thirty-seven by European modernists, including a painting by Gris from 1923.[43] In her positive review of the new venture for *The New York Times*, art critic Elizabeth Cary commented, "Gris is another good painter who likes the clean path of abstraction."[44] Newspapers and journals from all across the country wrote about Gallatin's new endeavor.[45]

Gallatin also wrote about his burgeoning museum in *The Art News* in November 1927: "I am interested in good pictures, whatever their source and while we shall make every effort to encourage American art there will be no nationalistic propaganda. . . . We shall be especially interested in seeking out young men who have not yet been generally recognized. . . . Therein lies the sport of collecting. New York needs a place where the best contemporary work can be seen. . . ."[46] Gallatin added two more Gris works to his holdings in the summer of 1930, a drawing of a *Man in a Café* (fig. 4, p. 18) and the watercolor *The Table* (1916), which were both featured in his 1930 exhibition.[47] In the catalogue for the show, Gallatin noted that private collectors were traditionally the pioneers who bought avant-garde works, as "[e]xtremely few museums have ever bought good contemporary paintings."[48] In 1931, the gallery was praised by the future museum curator James Johnson Sweeney for displaying the fullest representation of Cubism in America. Sweeney went on to describe Gris as

"... fundamentally the puritan, the calculator, the unbending, self-disciplining craftsman."[49] Gallatin purchased two more works by Gris in 1932, including *Still Life: The Table* of 1914 (cat. 11) and *Still Life with a Glass* of 1917.[50]

In 1932, after meeting the French artist Robert Delaunay in Paris, Gallatin began to collect works by artists from other movements.[51] His interest in Gris and the Cubist circle continued to dominate, however, with Gallatin quoted in *The New York Times* in 1932 as saying that the "... outstanding and essential figures of today" were Picasso, Braque, Gris, and Léger.[52] By the following year, his enthusiasm for abstraction rivaled his earlier interest in Cubism, but he still considered Picasso, Gris, Braque, and Léger "... as the most weighty figures in contemporary painting" and "....Gris, whose importance as yet is fully recognized by comparatively few connoisseurs, by virtue of the purity of his painting no doubt one day will be considered, in certain of his paintings, the equal of Picasso, in his Cubist and more abstract work."[53]

In early 1935, Gallatin reinstalled the collection, and a new wave of positive responses from critics reiterated Gris's importance to the collection and the story of modern art in general. Henry McBride in *The New York Sun* acknowledged that although Picasso, Gris, Léger, and Braque were still yet to be fully recognized by the art community, Gallatin's institution certainly considered them to be the pillars of modern art.[54]

After the purchase of Picasso's masterpiece *Three Musicians* (1921) in 1936, Gallatin changed the name of his institution from Gallery of Living Art to the Museum of Living Art and published a new catalogue. He pointed to the importance of the founding members of the Cubist circle, and mentioned Gris as part of the great Spanish artistic tradition, one that "... has produced men of burning genius."[55] Gallatin's interest in Gris's work continued to thrive as his museum reached its tenth anniversary, with two works from 1916 purchased during the summer of 1937 while Gallatin was in Paris.[56] The following year, he wrote an article about his museum and abstract art, in which he praised Gris's works, mentioning that perhaps "posterity will judge certain of them, especially those painted about 1913–16, to be the greatest of all cubist pictures."[57] His enthusiasm for Gris and his colleagues Picasso and Miró can be found in the 1940 catalogue for the Museum of Living Art, where Gallatin recognizes those artists as being part of the long artistic tradition in Spain, which "... of all countries is the richest in the raw material of art, her painters strongly individualist but giving a forceful impression of their country, that they possess genius rather than talent and that improvisation plays a most important role in their work."[58]

In 1942, the university informed Gallatin that they needed the space where his museum was housed for the library, and the Museum of Living Art was forced to close.[59] After much consideration, Gallatin decided to loan his collection of about 170 works to the Philadelphia Museum of Art (PMA) in 1943, with the understanding that if his holdings were still on loan upon Gallatin's death, they would be acquired by the PMA. His personal scrapbooks are

filled with newspaper articles from the New York and Philadelphia regions both decrying the decision of NYU, and celebrating Philadelphia's triumph.[60] The move also prompted national publications to discuss the collection's relocation as well, such as in an article in *The Art News* summarizing the importance of Gallatin's many achievements, including his superior Gris collection: "Where Gallatin feels that Picasso, Braque, and Léger have, in their recent work, gone either soft or flashy, Gris is an artist who to the end maintained the pure high line he admires. He bought Gris from 1927 on, generally at auction to the minimum competition with the result that the Gris group in the Museum of Living Art is a particularly fine one."[61]

After the collection moved south, the PMA organized an inaugural show of Gallatin's holdings, which allowed many more works to be on view than had been possible at the NYU museum. The Gallatin collection was the focus of an entire edition of *The Philadelphia Museum Bulletin*, with multiple works from the collection mentioned in the text and illustrated, including Gris's *Violin* (cat. 8).[62] Gallatin also played a role in suggesting that works owned by Walter and Louise Arensberg come to Philadelphia as well, where the two collections could create an "unrivalled" view of modern art.[63] The Arensbergs began collecting modern art after seeing the Armory Show in New York in 1913, becoming friends and patrons of some of the most important artists of the period. In 1938, they purchased five important paintings by Gris (including cat. 13,

22, and 28), which span the years 1912 to 1917, a significant portion of the artist's career.[64] By the early 1940s, they started to seek a museum to house their artworks, and eventually chose the PMA, the gift arriving in Philadelphia in 1950. The museum created a suite of galleries featuring the Gallatin collection, which opened in April 1954, followed by another suite of galleries for the Arensberg collection in October 1954.[65] With the two collections combined, the PMA had become a center for modern art with one of the strongest, and certainly the largest and most comprehensive, collections of works by Gris in America (fig. 31).[66]

Duncan Phillips, who had founded the Phillips Memorial Art Gallery (now known as The Phillips Collection) in 1921 in Washington, D.C., as the first museum of modern art in the United States, bought his first work by Gris in 1930, *Abstraction* of 1915 (cat. 15). In 1932, he installed it in a small exhibition entitled *American and European Abstractions* alongside works by Picasso, Braque, Arthur Dove, and Karl Knaths.[67] That same year, Gris's *Still Life with Newspaper* (cat. 25) was included in the large *International Exhibition of Modern Art* organized by the Société Anonyme at the Brooklyn Museum, a painting that would eventually be purchased by Phillips from Katherine Dreier in 1950.

Ferdinand Howald of Columbus, Ohio, was another early collector of Gris's work. His interests ranged from Old Master paintings to Middle Eastern and Italian plates to American modernism, but his most important purchases were by French artists of the nineteenth and twentieth century. According to an essay written by Mahroni Sharp Young on Howald's collecting habits, when Gertrude Stein came to Columbus, she called Howald's holdings ". . . the finest collection of modern art she had ever seen in the United States."[68] Both his Gris works (one of them cat. 6) were bought in 1927, the year of the artist's death, and were donated to the Columbus Gallery of Fine Arts (now known as the Columbus Museum of Art) before Howald's death in 1934.[69]

The Museum of Modern Art began acquiring works by the Spanish Cubist in the 1930s and 1940s by both gift and purchase, with three major additions coming from the bequest of Anna Erickson Levene in memory of Dr. Phoebus Aaron Theodor Levene. The artist George L. K. Morris, who briefly owned Gris's *Guitar and Pipe* (cat. 5), probably donated it to MoMA in 1935. The painting, which had once been owned by Marcel Duchamp, appeared in many exhibitions and publications produced by the museum before it was deaccessioned from the collection in 1968. Fortunately, it was soon acquired by Eugene and Margaret McDermott, collectors of Impressionist and modern art, who donated the work to the Dallas Museum of Art in 1998. The Solomon R. Guggenheim Foundation in New York made some early acquisitions as well.[70] Installations of modern art started to appear in important American museums throughout the country during the 1940s, with the opening of the National Gallery of Art in Washington, D.C., in 1941, and Katherine Dreier's donation of the Société Anonyme to the Yale University Art Gallery that same year.[71] Both

the City Art Museum of St. Louis (now known as the Saint Louis Art Museum) and the Washington University Museum in St. Louis (now known as the Mildred Lane Kemper Art Museum) purchased examples by Gris (including cat. 35) in the 1940s at a time when most museums were only acquiring works by the artist as gifts, thus making important statements about the institutions' interest in modern art. T. Catesby Jones, who had started collecting Cubist works in 1924, made a significant gift of his collection when he bequeathed it (including cat. 12) to the Virginia Museum of Fine Arts upon his death in 1946, thus adding important examples of Gris's work to the Mid-Atlantic region.[72]

Saidie Adler May, a collector born in Baltimore, purchased two important paintings by Gris (cat. 29 and 40) in 1938 and 1940. Unlike the better-known Baltimore collectors Claribel Cone and Etta Cone, who favored works by Henri Matisse and Picasso and displayed their holdings in their Baltimore apartments, May saw her role as one of an advocate for The Baltimore Museum of Art (BMA), often sending her acquisitions directly to the museum after purchase. She was also generous with gifts to MoMA, the Fine Arts Gallery of San Diego (now known as the San Diego Museum of Art), and other institutions, but her relationship with the BMA was the deepest and most profound. May seems to have consciously planned her modern art acquisitions with the Cone sisters in mind, making sure the two eminent Baltimore collections of contemporary art would complement one another rather than overlap. She steered the BMA's future holdings toward a broader view of modernism with a focus on abstraction and Surrealism.[73]

In choosing to purchase Gris's 1918 *Bottle and Glass*, May added a prime example of his mid-career oeuvre, just as his interest in Pointillism was starting to wane in favor of a fascination with interlocking planes and a more muted palette. She purchased it from Galerie Simon in Paris in 1938. It was sent to the BMA just after its acquisition and was included in an exhibition of May's collection that same year. Since May did not have a permanent residence from 1928 until her death in 1951, she often sent her purchases directly to the BMA for exhibition and storage. In 1940, she added *The Painter's Window* of 1925

to her burgeoning collection. It is considered one of the great paintings from the end of the artist's career, featuring many of the motifs that he had included in his still lifes for more than a dozen years, set on a tabletop before an opaque window. By including an artist's palette and brush, this painting can be seen as an autobiographical statement by Gris, a sort of self-portrait in the genre and format with which he was most comfortable.

In 1944, Curt Valentin requested both of her paintings by Gris for his show at the Buchholz Gallery, writing, "It would be very difficult for me to make the exhibition as important as I want without your pictures."[74] In 1941, after the death of her sister Blanche Adler, a collector in her own right, May funded a room for members at the BMA in her sister's memory. Much like Gallatin's Museum of Living Art, the Members' Room at the museum was a place within a larger institution for May to display her own collection of modern art, occasionally adding in loans from other places (fig. 32). She served as curator from afar, sending letters to the director and curator with ideas for exhibitions and installations. After hosting a very successful exhibition of the work of Surrealist artist André Masson in 1941 (his first in the United States), May requested a show of nineteenth-century and early twentieth-century artists to be installed in the Members' Room, including Gris's work.[75] Her Gris paintings were also included in other modern exhibitions and installations at the museum in the 1940s.

In 1948, the Buchholz Gallery compiled a list of all the known paintings and drawings by Gris in America (in advance of Gris's first monographic museum exhibition in the United States held at the Cincinnati Art Museum). About 115 works are included, with more than half of them owned by private collectors.[76] This document provides an important map of where interest in Gris had taken hold in private collections, with most works located in New York and its surroundings, but with additional recognition in California, Oregon, and Chicago, as well as Ohio, Pennsylvania, Rhode Island, Vermont, Virginia, Upstate New York, and Florida.

The Cincinnati Art Museum hosted Gris's first monographic museum show in the United States in 1948, more than twenty years after his death (fig. 33). It featured sixty-four works, including paintings, drawings, collages, and lithographs with about one-third of the works already owned by museums or on long-term loan to museum collections. In the introduction to the catalogue, Edward H. Dwight laments Gris's less-than-stellar reception in America, wondering why he was recognized later than he deserved. He posits that perhaps it was because Gris's work was often used to explain the tenets

FIG. 33 Cover of Cincinnati Art Museum exhibition catalogue, *Juan Gris*. April 30–May 31, 1948.

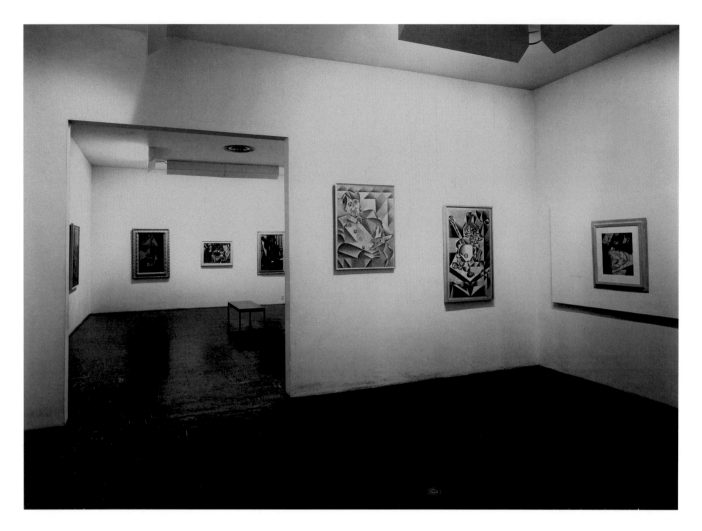

FIG. 34 Soichi Sunami, *Installation view of the exhibition, "Juan Gris."* April 8, 1958–April 15, 1958; May 12, 1958–June 1, 1958. The Museum of Modern Art Archives, New York, IN630.1. See *Still Life with Flowers* (cat. 3) to the right of the painting on the right side of the doorway.

of Cubism; it never was fully appreciated for its own beauty and complexity. Also, because of his short career, there were not as many works created, and his contemporaries, namely Picasso and Braque, lived long lives with many changes of styles and motifs.[77]

The same year, Gris was featured in *Picasso, Gris, Miró: The Spanish Masters of Twentieth Century Painting*, a major touring exhibition held on the West Coast of the United States at the San Francisco Museum of Art (now known as the San Francisco Museum of Modern Art) and the Portland Art Museum. Twenty-three works by Gris were included, and the catalogue featured important essays by Daniel-Henry Kahnweiler, Man Ray, and Donald Gallup, who discussed the intertwined relationships between Gertrude Stein, Picasso, and Gris.[78]

In 1958, MoMA organized a major Juan Gris retrospective, which traveled to the Minneapolis Institute of Arts, the San Francisco Museum of Art, and the Los Angeles County Museum (fig. 34). Curated by James Thrall Soby, the show featured sixty-three paintings and twenty-seven gouaches, drawings, and prints from his short but productive career.[79] Again, it featured many more works owned by private collectors than museums. In a list prepared for the 1958 show, forty-two American collectors of Gris's work were identified.[80] Of that group, thirteen were museums. In the 128-page catalogue, Soby discusses the originality of Gris's color in his essay, and notes that perhaps Gris's work is less well known and admired since so many catalogues about

Cubism have black-and-white illustrations. Given the monochromatic palette often used by Picasso and Braque, such publications helped spread their fame, but in the case of Gris, Soby argues that his work needs to be seen in color and in person to be truly understood and admired.[81] Soby also addresses the negative response to Gris's work produced after 1920, theorizing that the combination of his chronic illness as well as his design work for the theater might have made him less focused on his easel paintings.[82] He also suggests that since Gris remained a Cubist into the 1920s, while Picasso and Braque had moved on to other interests, he no longer had his Cubist friends from the previous decade working in the same style.[83] The exhibition and accompanying catalogue were well received by *The New York Times* critic Howard Devree, who stated that Gris's work "...warrants his inclusion in the first rank of cubist artists..."[84]

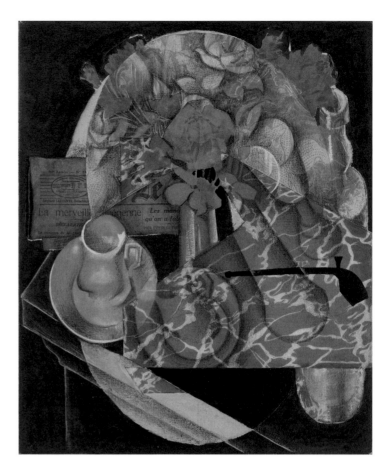

FIG. 35 *Flowers*, 1914. Conté crayon, gouache, oil, wax crayon, cut-and-pasted printed wallpapers, printed white wove paper, newspaper, white laid and wove papers on primed canvas; subsequently mounted to a honeycomb panel. Promised Gift from the Leonard A. Lauder Cubist Collection to the Metropolitan Museum of Art, New York.

Despite the interest in Gris during the run of the MoMA exhibition and the broad recognition of his importance visible in museum exhibitions and collections around the country, it took twenty-five years for the next major monographic museum show to be mounted in the United States. In 1983, the University of California Art Museum at Berkeley organized a major retrospective, which traveled to the National Gallery of Art, Washington, D.C., and the Solomon R. Guggenheim Museum, New York. Featuring more than ninety works, this show provided a new audience with a fresh view of Gris as one of the most essential members of the Cubist circle. As John Russell noted in his review for *The New York Times*: "A great Gris stays with us forever. It stands for an imaginative energy, a multiplicity of lucid statement and an apparently limitless invention. It also stands for a depth and strength of color that on the whole were excluded from Cubism. Where Picasso and Braque in the heroic years worked by taking color out, Gris worked by putting it in."[85]

Unlike his colleagues Picasso, Braque, and Léger, Gris's oeuvre has not been explored by theme or examined in slices or chapters of his output until now. In more recent years, the enthusiastic collecting of his work by the New York businessman and philanthropist Leonard Lauder has reenergized the attention paid to him by scholars and visitors alike (fig. 35). For more than forty years, Lauder has amassed an incredible collection of Cubist art, focused on the works of Picasso, Braque, Léger, and Gris. With already completed gifts as well as future gifts promised to the Metropolitan Museum of Art and the creation of the Leonard A. Lauder Research Center for Modern Art at the museum, Lauder's generosity and vision will encourage more exhibitions and programming in the future. His extraordinary contribution to the recognition and understanding of Gris's achievements will continue for generations to come.

As Daniel-Henry Kahnweiler wrote about his friend Juan Gris in 1948, "Time will, I am sure, increase more and more the reputation of this modest genius, who received so little encouragement during his all too short life, but who never despaired."[86]

Notes

1. Pablo Picasso, quoted in Daniel-Henry Kahnweiler, *Juan Gris: His Life and Work*, trans. Douglas Cooper (New York: Harry N. Abrams, 1968), 192.
2. For more information on Stein and Gris, see Janet C. Bishop, et al., *The Steins Collect: Matisse, Picasso, and the Parisian Avant-Garde* (San Francisco: San Francisco Museum of Modern Art, 2011).
3. Gertrude Stein, *The Autobiography of Alice B. Toklas* (New York: Vintage, 1990), 91.
4. Ibid.
5. Gertrude Stein, "Juan Gris," *Little Review*, Autumn and Winter, 1924–1925, 16.
6. Gertrude Stein, "The Life of Juan Gris. The Life and Death of Juan Gris," *Transition*, July 1927, 160–162.
7. "Back Matter," *Arts & Decoration* 6, no. 4 (1916): 196; and "Calendar of New York Special Exhibitions," *American Art News* 16, no. 24 (1918): 6.
8. Paloma Esteban Leal, *Juan Gris: Paintings and Drawings, 1910–1927* (Madrid: Museo National Centro de Arte Reina Sofía, 2005), 280.
9. Pablo Picasso, "List written by Pablo Picasso of European artists to be included in the 1913 Armory Show," 1912. Walt Kuhn, Kuhn family papers, and Armory Show records, 1859-1984. Archives of American Art, Smithsonian Institution.
10. Willard Huntington Wright, "The New Painting and American Snobbery," *Arts & Decoration (1910–1918)* 7, no. 3 (1917): 130; and R. J. Coady, "The Indeps," *The Soil* 1, no. 5 (1917): 207.
11. "Wanamaker's Plans Big Modernist Show," *American Art News* 20, no. 5 (1921): 3.
12. "Worcester Museum Has 'Ultra' Show," *American Art News* 20, no. 5 (1921): 1 and 7.
13. For more information about this exhibition, see "Modern Art at MacDowell Club," *American Art News* 20, no. 30 (1922): 2; and "Modernism and Abstraction," Worcester Art Museum, https://www.worcesterart.org/exhibitions/past/modernism_history.html, where it is discussed as one of the earliest shows of modern art seen at the museum.
14. "Omaha," *The Art News*, 22, no. 19 (1924): 11.
15. For more information about the exhibition, see "International Exhibition of Modern Art Assembled by Société Anonyme," Brooklyn Museum, https://www.brooklynmuseum.org/opencollection/exhibitions/1082.
16. "Société Anonyme's Exciting Show," *The Brooklyn Museum Quarterly* 14, no. 1 (1927), 21.
17. "Exhibitions, Learning Resources – Museum," Wellesley College Archives, http://academics.wellesley.edu/lts/archives/10S_Exhibitions.html.
18. For more information about Wellesley College's art museum and Alfred Barr, see "History," Davis Museum at Wellesley College, https://www.wellesley.edu/davismuseum/about-davis/history
19. "Current Exhibitions of Interest," *Parnassus* 2, no. 4 (1930): 3.
20. Edward Alden Jewell, "The Abstract Art of Juan Gris," *The New York Times*, February 6, 1932, 23.
21. For more information about these two exhibitions, see "Summer Exhibition: Painting and Sculpture," and "Modern European Art," The Museum of Modern Art, https://www.moma.org/calendar/exhibitions/1709 and https://www.moma.org/calendar/exhibitions/1875.
22. Alfred H. Barr, Jr., *The Bulletin of the Museum of Modern Art*, 1, no. 2 (Oct. 1933): 1.
23. "Modern Works of Art: 5th Anniversary Exhibition," The Museum of Modern Art, https://www.moma.org/calendar/exhibitions/1711; and "Summer

Exhibition: The Museum Collection and a Private Collection on Loan," https://www.moma.org/calendar/exhibitions/1710.

24. According to correspondence in the Julien Levy Gallery Records in the archives at the Philadelphia Museum of Art, Howard Putzel had the exhibition on view in San Francisco before offering it to the Julien Levy Gallery in New York in January 1935. Letter from Howard Putzel to Julien Levy, January 7, 1935, Series I. Correspondence, Julien Levy Gallery Records, Box 21, folder 33. Philadelphia Museum of Art, Library and Archives.

 According to the Julien Levy Gallery Records, the dates of the Levy venue were October 15–31, 1935. Exhibition postcard, Series I. Correspondence, Julien Levy Gallery Records, Box 21, folder 33. Philadelphia Museum of Art, Library and Archives.

 According to The Arts Club of Chicago, the Chicago venue dates were December 13–30, 1935. "Exhibition List," The Arts Club of Chicago, https://www.artsclubchicago.org/exhibitions/exhibition-list.

25. Alfred H. Barr, Jr., *Cubism and Abstract Art* (New York: The Museum of Modern Art, 1936), 82.

26. For more information, see Gail Stavitsky, "The Development, Institutionalization, and Impact of the A. E. Gallatin Collection of Modern Art," Ph.D. dissertation, New York University, May 1990, 301–302.

27. Gertrude Stein, "The Life of Juan Gris," 160–62.

28. Curt Valentin Papers, I.[87], The Museum of Modern Art Archives, New York.

29. *Juan Gris*, Buchholz Gallery, New York, April 1–26, 1947.

30. Undated press release from the Buchholz Gallery for the 1947 Juan Gris exhibition, Valentin, I.[42] 2 of 3. The Museum of Modern Art Archives, New York.

31. *Juan Gris*, Buchholz Gallery, New York, January 16 through February 11, 1950.

32. According to Danielle Carrabino, Curator of Painting and Sculpture at the Smith College Museum of Art, in an email to the author, dated September 4, 2019, there is not any evidence of a familial or personal connection known between Brummer and Smith College. Brummer had successfully sold a number of works to the college over the years, and he must have felt they were deserving of such strong examples of Analytic Cubism. It is unclear if the Gris works were on view in the museum galleries soon after they were donated, or if it took some time to have them installed. Smith owned Cooper nos. 66, 69 (since deaccessioned), 88, 157, and 165.

33. The Fogg Art Museum borrowed two works by Gris from the Smith College Museum of Art for an installation in 1936–37. Edward W. Forbes, "[Report of the Fogg Art Museum, 1936–37]," *Annual Report (Fogg Art Museum)*, no. 1936/1937 (1936), 21.

34. Letter from Curt Valentin to Jere Abbott, Director of the Smith College Museum of Art, February 10, 1944. Valentin, I.[42] 1 of 3. The Museum of Modern Art Archives, New York.

35. Douglas Cooper, with Margaret Potter, *Juan Gris Catalogue Raisonné*, 2nd edition, updated by Alan Hyman and Elizabeth Snowden, vol. 1 (San Francisco: Alan Wofsy Fine Arts, 2014), nos. 25, 61, 91, and 132.

36. For more information about the collectors and dealers of Cubism, see "Index of Historic Collectors and Dealers of Cubism," Metropolitan Museum of Art, https://www.metmuseum.org/art/libraries-and-research-centers/leonard-lauder-research-center/research/index-of-cubist-art-collectors.

37. Gail Stavitsky, "The Development, Institutionalization, and Impact of the A. E. Gallatin Collection of Modern Art," Ph.D. dissertation, New York University, May 1990.

38. Stavitsky, 1.

39. Stavitsky, 73–76.

40. A. E. Gallatin, *Charles Demuth* (New York: W. E. Rudge, 1927), viii–xiv, as cited in Stavitsky, 82.

41. For more information on the history of the Gallery of Living Art, please see "A. E. Gallatin and the Museum of Living Art," Grey Art Gallery, New York University, https://greyartgallery.nyu.edu/2016/05/e-gallatin-museum-living-art.

42. New York University, *Gallery of Living Art*, Catalogue of Opening Exhibition, December 13, 1927–January 25, 1928, [1], quoted in Stavitsky, 134.

43. Stavitsky, 138.

44. Elizabeth L. Cary, "Gallery of Living Art and American Print Makers; Two Novel Enterprises; A Few Confessions of Faith—Water Colors And Paintings in Oil Shown Together," *The New York Times*, December 18, 1927, Section X, 12.

45. Scrapbooks of news coverage of the opening of the Gallery of Living Art are included in the A. E. Gallatin papers housed at the Philadelphia Museum of Art, Library and Archives.

46. "Modern Art for New York University," *The Art News*, 26 (November 5, 1927), 239, quoted in Stavitsky, 93.

47. Stavitsky, 187.

48. *Gallery of Living Art* (New York: New York University, 1930), 3, quoted in Stavitsky, 183.

49. James Johnson Sweeney, "Four Cubists Featured in Gallery of Living Art," *Chicago Evening Post*, July 17, 1931, microfilm 1293, frame 629, quoted in Stavitsky, 195.

50. Stavitsky, 198.

51. Stavitsky, 10.

52. "At the Gallery of Living Art," *The New York Times*, December 4, 1932, Section X, 9, quoted in Stavitsky, 204.

53. A. E. Gallatin, "The Plan of The Gallery of Living Art," *Gallery of Living Art* (New York: New York University, 1933), 2, quoted in Stavitsky, 256.

54. Henry McBride, *The New York Sun*, January 26, 1935, quoted in Stavitsky, 277.

55. A. E. Gallatin, "The Plan of the Museum of Living Art," *Museum of Living Art, A. E. Gallatin Collection* (New York: New York University, 1936), 2, quoted in Stavitsky, 314.

56. Gallatin purchased *Coffee Pot*, 1916, and *Dish of Fruit*, 1916. Stavitsky, 365.

57. A. E. Gallatin, "Abstract Painting and the Museum of Living Art," *Plastique* 3 (Spring 1938), 9, quoted in Stavitsky, 374.

58. A. E. Gallatin, "The Plan of the Museum of Living Art," 5, quoted in Stavitsky, 391.

59. Stavitsky, 408.

60. The A. E. Gallatin Papers are housed at the Philadelphia Museum of Art, Library and Archives.

61. Rosamund Frost, "Living Art Walks & Talks," *The Art News*, February 15–28, 1943, 28, partially quoted in Stavitsky, 449.

62. *The Philadelphia Museum Bulletin*, 38, no. 198 (May 1943).

63. Letter from Gallatin to Kimbell, January 16, 1949, Philadelphia Museum of Art, Library and Archives, quoted in Stavitsky, 459–60.

64. The Arensbergs owned five works by Gris: Cooper nos. 25, 131, 166, 219, and 226.

65. Stavitsky, 482–86.

66. The Philadelphia Museum of Art owns thirteen paintings and collages by Gris: Cooper nos. 25, 44, 90, 131, 166, 204, 208, 219, 226, 229, 264, 437, and 602.

67. "Chronology," Phillips Collection, https://www.phillipscollection.org/sites/default/files/attachments/chronology.pdf.

68. Mahonri Sharp Young, introductory essay to From the Collection of Ferdinand Howald, The Columbus Gallery of Fine Arts, Columbus, Ohio, October 10–December 31, 1969, unpaginated.

69. Ibid.

70. Cooper nos. 214 and 237 were acquired in the late 1930s.

71. Stavitsky, 449.

72. "Index of Cubist Art Collectors," The Metropolitan Museum of Art, https://www.metmuseum.org/art/libraries-and-research-centers/leonard-lauder-research-center/research/index-of-cubist-art-collectors/jones. For more information about Jones, see Matthew Affron, John B. Ravenal, and Emily H. Smith, eds., Matisse, Picasso, and Modern Art in Paris: The T. Catesby Jones Collections at the Virginia Museum of Fine Arts and the University of Virginia Art Museum (Charlottesville: University of Virginia Press, 2009), 46–48.

73. For more information on Saidie Adler May, see Susan Helen Adler, Saidie May: Pioneer of 20th Century Collecting (Baltimore, 2011).

74. Letter from Curt Valentin to Mrs. Saidie A. May, February 10, 1944, Valentin, III.D.1, The Museum of Modern Art Archives, New York.

75. Letter from BMA Director Leslie Cheek to Saidie Adler May, November 8, 1941. Saidie A. May Papers, Correspondence, November–December 1941, Box 3, The Archives and Manuscripts Collections, The Baltimore Museum of Art.

76. "Paintings and Drawings by Juan Gris in the United States," c. 1948, Valentin, I. [45]. The Museum of Modern Art Archives, New York.

77. Edward H. Dwight, introduction to A Retrospective Exhibition of the Work of Juan Gris, 1887–1927, The Cincinnati Modern Art Society at the Cincinnati Museum of Art, April 30–May 31, 1948, unpaginated.

78. Picasso, Gris, Miró: The Spanish Masters of Twentieth Century Painting (San Francisco: San Francisco Museum of Art, 1948).

79. Juan Gris, The Museum of Modern Art, (April 8–June 1, 1958). Since the catalogue for the show does not include a checklist, these numbers are from the press release. "Juan Gris Retrospective at the Museum of Modern Art," The Museum of Modern Art, https://www.moma.org/documents/moma_press-release_326124.pdf.

80. James Thrall Soby Papers, I.116, The Museum of Modern Art Archives, New York.

81. Soby, 32.

82. Soby, 96. "It is only fair to add, however, that Kahnweiler's opinion about Gris' final works was shared by the late Curt Valentin, who did so much to further the artist's fame in this country and was obviously one of the most sensitive and dedicated dealers of our time. It is shared by Douglas Cooper, whose Gris collection is one of the finest in existence and who has long been engaged in compiling a catalogue raisonné of the painter's works. While paying full tribute to Gris' earlier masterworks, Cooper concludes: 'It is only in 1920 that Gris at last seems in full possession of his resources.'" Source of quote: Douglas Cooper, Juan Gris ou Le Goût du solennel (Geneva: Skira, 1949), unpaginated. Soby translation.

83. Soby, 110.

84. Howard Devree, "Art: Juan Gris Display," The New York Times, April 8, 1958, 26.

85. John Russell, "Art View; Juan Gris: The Other Cubist," The New York Times, October 23, 1983, Section 2, 29.

86. Daniel-Henry Kahnweiler, "Juan Gris," in Picasso, Gris, Miró: The Spanish Masters of Twentieth Century Painting (San Francisco: San Francisco Museum of Art, 1948), 73.

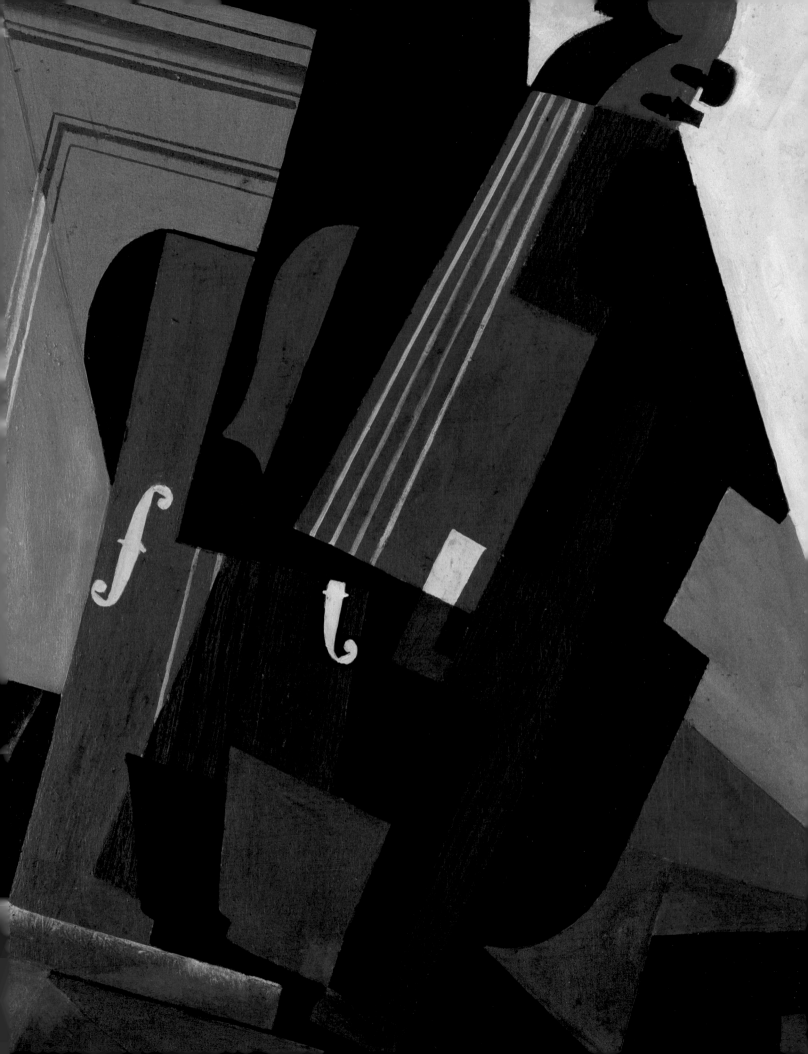

Juan Gris in
Spanish Collections

PALOMA ESTEBAN LEAL

The history of art collecting in Spain extends back to the sixteenth century, when the great royal collections were first amassed, along with those held by the Church and the aristocracy. Over time, these would be in part incorporated into the holdings of some of the best museums in Spain, most notably the Prado. By the seventeenth century, the reign of Philip IV (1621–1665) coincided with the liveliest period of collecting in both Spain and Europe as a whole, as the monarchy and nobility competed to acquire great works of art, particularly those by the most famous creators of the time.

As noted in a recent study, between the late-eighteenth and early-nineteenth centuries—despite the ongoing pastime of collecting among the aristocratic elite, and perhaps driven by the creation of the Prado Museum in 1819—a new trend in collecting emerged, centered around the rising bourgeoisie and its more eclectic tastes.[1] At the same time, patronage of the arts more traditionally exercised by the monarchy experienced a substantial decline, a phenomenon to which another significant fact could be added—the power exerted by the political classes, which, using dire economic circumstances as a justification, began to transfer to the museums their former function of supporting the arts and the associated practices of collecting. We should mention a third factor that contributed considerably to the detriment of nineteenth-century collecting, the episode known as the Confiscations of Mendizábal—a process of forced expropriation of ecclesiastical assets that resulted in vast collateral damage, most significantly in the disappearance and/or destruction of countless artworks belonging to the Church. The only exceptions to this situation might be found in Catalonia and the Basque Country, the peninsular territories where the industrial revolution had firmly taken root, thereby allowing for the rise of important collectors such as Frederic Marès, Francesc Cambó, and Eduardo Toda Güell, who were partly responsible for the flourishing of various art movements, such as Catalan Modernism.[2]

Within the framework of the twentieth century, the Spanish Civil War (1936–39) certainly represented another marked setback in the policies of protecting and promoting art and, consequently, of the practice of collecting. Only the appearance of some galleries in Madrid and Barcelona in the 1940s and 1950s would partially mitigate the bleak cultural panorama in Spain at this period. At the same time, public collecting, linked mainly to museums, would gradually emerge, a phenomenon from which private collecting would also benefit. With the reestablishment of democracy, by the 1980s the art market began to experience a new dynamism that would inevitably favor the creation of new museums and public art spaces, a process fostered by the Spanish Ministry of Culture, as well as autonomous governments, municipalities and councils, and foundations linked to financial institutions.

However, modern and contemporary artists—including such luminaries as Pablo Picasso and Juan Gris—tended to be largely overlooked within the broader framework of Spanish collecting, due both to the absence of a truly entrenched public tradition of collecting and the lack of social recognition among private collectors. In this context, the letter sent by the painter Benjamín Palencia in the 1930s to Ricardo Gutiérrez Abascal, the director of the Museo de Arte Moderno in Madrid[3] and a prominent art critic and journalist also known by his pen name, Juan de la Encina, is particularly illuminating:

> By procrastinating for so long on matters pertaining to art, everything has been lost, and the worst part is that what is now being achieved will also be lost. You know better than anyone about attempting to organize a prestigious museum of new art in Spain, with authentic artistic values [. . .] the same thing will happen to them as with the Impressionists, with Picasso and with Juan Gris: while there is no foreign museum or collection in which they are not represented with decorum, yet in Spain money has been squandered in amassing sentimental rubbish, which is lifeless when compared to true living art, and this because no one has been able to read the pulse of the new creative sensibility.[4]

Public Collections

The Museo Nacional Centro de Arte Reina Sofía (also known in Spain as MNCARS) has the largest collection of works by Juan Gris of any public institution in Spain, although until 1995 it held only three pieces by the artist. The Reina Sofía is the successor entity of a former museum conceived in 1894 as a center to house the works of contemporary Spanish artists. Thus, it is not possible to discuss the collections of the current institution without a brief look back at the main events that marked the development of the initial museum in the late nineteenth century.

On August 4, 1894, the Museo de Arte Contemporáneo was established, thereby bringing to fruition the desire of nineteenth-century Spanish artists

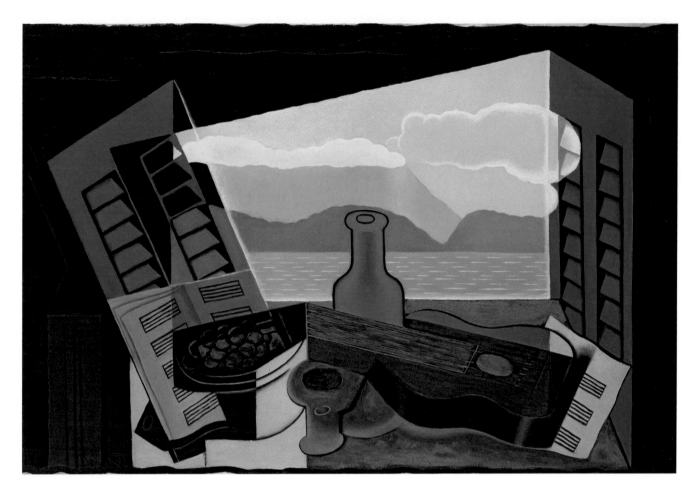

FIG. 36 *The Open Window*, 1921. Oil on canvas. Museo Nacional Centro de Arte Reina Sofía, Madrid.

to have a museum where their work could be exhibited. In 1895, the institution adopted the name Museo de Arte Moderno. After an initial period of organization, it opened its doors to the public on August 1, 1898, in the newly inaugurated Palace of Libraries and Museums on Madrid's Paseo de Recoletos. During the Civil War, the museum was dismantled; yet it was reestablished in the postwar period. By 1968 it was relaunched as the Museo Español de Arte Contemporáneo (MEAC). Beginning in 1975, the museum was relocated to a new building in the neighborhood of Ciudad Universitaria, which represents the immediate antecedent to the current institution. Years later, in 1990, in the restored and remodeled building of the former General Hospital of Madrid, the Reina Sofía Museum was inaugurated, thereby replacing the MEAC and incorporating the latter's collections. Its founding mission included the acquisition of new works that would further enrich and expand its already existing collections.

As previously noted, prior to 1995 the Reina Sofía only held three works by Gris (*Jar and Glass*, 1916; *Bottle of Wine*, 1918; and *Guitar in Front of the Sea*, 1925). However, between 1994 and 2000, when José Guirao—who would become the Spanish Minister of Culture from 2018 to 2019—served as the museum's director, the number of paintings and drawings by Gris increased significantly, not only in quantity but especially in quality, from the three initial pieces to a total of twelve works, in addition to the incorporation into its collections of three artworks via the Douglas Cooper bequest from the Prado Museum.[5] In subsequent years, seven additional works would be acquired, which, together with five graphic works that entered at different times,

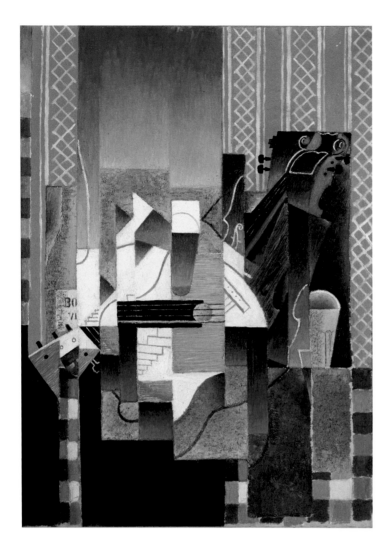

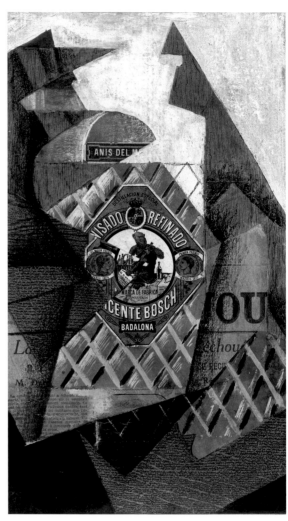

complete the present tally of nearly thirty works overall from between 1913 and 1926 (including figs. 36–38) that comprise the Juan Gris collections at the Reina Sofía.

The current Museo Nacional Thyssen-Bornemisza came into being from what was initially a private collection, which expanded its holdings over time to reach approximately 1,400 works. Established by August Thyssen (1842–1926), founder of a financial empire rooted in the iron and steel industry, it was later handed over to his son Heinrich, who was advised on his purchases by the prestigious art historians Wilhelm von Bode and Max J. Friedländer. The collection ultimately passed to Baron Hans Heinrich Thyssen-Bornemisza, who installed it in the Swiss city of Lugano, after significantly expanding it with a series of works from the twentieth century.[6] In 1993, a purchase agreement for the Thyssen-Bornemisza Collection was signed by the Spanish government. The corresponding collection was then composed of 775 works representing the most important periods in Western art, extending from the thirteenth and fourteenth centuries to the late twentieth century. The Museo Nacional Thyssen-Bornemisza is now based in Madrid, in the Villahermosa Palace, a nineteenth-century structure restored and repurposed by the architect Rafael Moneo.

The Museo Nacional Thyssen-Bornemisza has three works by Juan Gris—two canvases (*The Smoker (Frank Haviland)*, fig. 39; and *Bottle and Fruit*

FIG. 37 *Violin and Guitar,* 1913. Oil on canvas. Museo Nacional Centro de Arte Reina Sofía, Madrid.

FIG. 38 *Bottle of Anis del Mono,* 1914. Oil, collage, and pencil on canvas. Museo Nacional Centro de Arte Reina Sofía, Madrid.

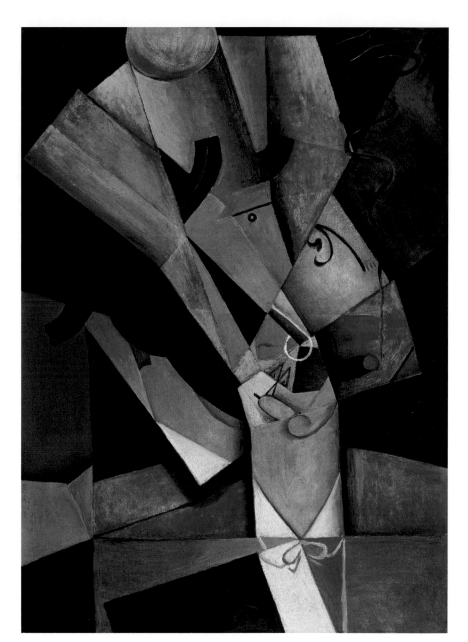

FIG. 39 *The Smoker (Frank Haviland),* 1913. Oil on canvas. Museo Nacional Thyssen-Bornemisza, Madrid.

Dish, cat. 31) and a drawing created in 1913—in addition to another oil painting titled *Seated Woman* (fig. 50, p. 87) from the Colección Carmen Thyssen-Bornemisza, which will be discussed later. Of the first three pieces mentioned, *The Smoker* is a highly original work with an intense palette depicting Frank Burty Haviland, an American amateur painter based in France who actively participated in the early twentieth-century artistic circles of Paris.

Established in 1752 as a pedagogical institution aimed at providing a structured curriculum on art-related subjects and granting prizes and scholarships to the most outstanding artists, the Real Academia de Bellas Artes de San Fernando is one of the oldest art institutions in Spain. It is the custodian of extensive holdings that consist of more than 1,500 paintings, 1,500 sculptures, 15,300 drawings, 35,000 prints, and 2,000 photographs, in addition to numerous objects of silver and gold, porcelain, ceramics, furniture, and other examples of the decorative arts. Some of these collections are permanently exhibited in the Museo de la Real Academia—considered the second most

CUBISM IN COLOR 77

important art exhibition space in the country after the Prado. Including Spanish, Italian, and Flemish masters, from Diego Velázquez, Francisco Goya, Francisco de Zurbarán, José de Ribera, and Peter Paul Rubens, the collection extends across five centuries from the Renaissance to the latest trends of the twenty-first century. Among its works from the twentieth century, and alongside creations by renowned Spanish artists such as Picasso, Julio González, and Joaquín Sorolla, the museum also has a canvas by Juan Gris: *Fruit Bowl and Newspaper* (cat. 33), a balanced and sober composition in brown, gray, and bluish tones, dated February 1920, before Gris's precarious health forced him to relocate to the coastal town of Bandol-sur-Mer.

In 1986, the directors of the Instituto de Crédito Oficial (ICO), a State bank and financial entity operating under the auspices of the Ministry of Economy, launched an institutional patronage initiative by creating a collection of twentieth-century Spanish art (the Colección Instituto de Crédito Oficial, currently the Museo ICO). Following consultations with Aurelio Torrente, the former director of the MEAC, three ongoing projects were launched: the Contemporary Spanish Painting Collection, focusing on the acquisition of pieces by the most outstanding artists of recent years; the Modern Spanish Sculpture and Drawing Collection, comprising small-format sculptures from the twentieth century, accompanied by related drawings; and Picasso's *Vollard Suite,* a series of 100 etchings of which there were few copies in Spain at that time.[7] In the second of these collections, the ICO has a pair of Gris's harlequins—a 1924 drawing and a 1923 sculpture (fig. 40).[8] This small sculpture, which belongs to the group of works that Gris described as "toys" to give to his friends, is a sheet of cut zinc, glued together and painted in oil, which recalls the sculptures that Picasso fashioned from similar materials, despite their conceptual dissimilarities.

In addition to its primary function as a representational branch of government, the Senado de España (Spanish Senate) has traditionally played a role in promoting art and culture.[9] This role has resulted in the creation of an extensive library that also contains numerous sculptures, engravings, and historically themed paintings from the nineteenth century, mostly from exhibitions sponsored by the government that highlight the works of artists such as José Casado del Alisal, Sorolla, and the Madrazo family. After the restoration of democracy in Spain in 1975, the Senate's governing bodies agreed to expand this cultural initiative by acquiring a collection of works by artists from Spain's various autonomous communities.[10] These acquisitions included

FIG. 41 *A Street in Montmartre,* 1911. Ink, water-color, and charcoal on paper. Museu Nacional d'Arte de Catalunya, Barcelona, purchased 1963.

prominent Spanish artists of the twentieth century, such as Joan Miró, Antoni Tàpies, as well as Gris, of whom the Senate has a still life of 1920 titled *Violin, Bottle and Glass* (cat. 34). In a decidedly landscape format, the dimensions of this canvas, as Guillermo Solana, artistic director of the Thyssen-Bornemisza Museum, indicates, "correspond to the proportion of 3/5, a very frequent ratio in Gris's paint-ing at this time. The complex composition is based on a truncated triangle, into which the various figurative ele-ments are embedded, leaving no blank spaces, and form-ing a perfect puzzle."[11]

Located in the National Palace of Montjuïc, the Museu Nacional d'Art de Catalunya (MNAC) is linked, in many ways, to the 1929 Barcelona International Exposition, since the palace that houses its collections was designed for this event by the esteemed modernist architect Josep Puig i Cadafalch. A part of the museum's collections, however, date back to 1880, at which time some of its works were displayed in the Chapel of Santa Ágata under the name of the Museo Provincial de Antigüedades. The calamities of the Spanish Civil War caused much suffering and had a lingering effect. A law was eventually passed in 1990 which merged several Catalan museums (Museu d'Art de Catalunya, Museu d'Art Modern, Gabinet Numismàtic de Catalunya, the Gabinet de Dibuixos i Gravats, and the Biblioteca d'Història de l'Art), thus creating the current Museu Nacional d'Art de Catalunya. Once the National Palace was remodeled as a museum by the Italian architect Gae Aulenti, the museum began exhibiting its current collections, which span centuries of artistic creation, from Romanesque frescos to modern art. The museum is also home to a small but interesting set of six drawings by Juan Gris. Dating from between 1911 and 1913, and acquired principally in 1963 from the Agell Collection, five of these works reflect the artist's patterns of creation prior to his entering the ranks of the Cubists, while one of them, titled *A Street in Montmartre* (fig. 41), clearly anticipates the compositions created by the Madrid painter within the context of the advances spearheaded by Picasso and Braque.[12]

The history of the Juan Gris painting belonging to the Museo de Arte Contemporáneo de Alicante (known as MACA), as well as the existence of the museum itself, is directly linked to the great Alicante artist Eusebio Sempere, who was active from the early 1950s until his death in 1985 and was perhaps the most important exponent of Spanish Kinetic art. In an act of tre-mendous generosity, Sempere donated his entire art collection to his native city of Alicante. These works were meticulously selected over the course of Sempere's lifetime. Due to this donation, the Museo de la Asegurada came into being, opening its doors in 1977 as a direct predecessor to the current MACA.[13]

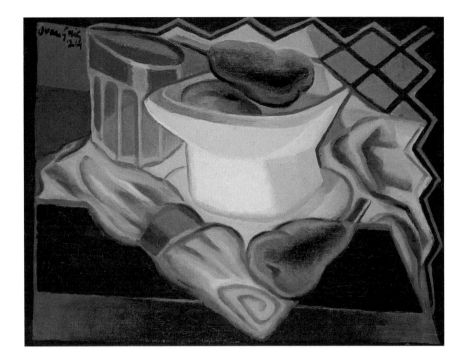

FIG. 42 *Still Life with Napkin,* 1924. Oil on canvas. Museo de Arte Contemporáneo de Alicante (MACA), Alicante.

With the Sempere collection as a foundational pillar, the museum now has representative works from all the main movements of the twentieth century, including such prominent figures as Picasso, Braque, González, Pablo Gargallo, Robert Delaunay, Jean Arp, Jean Cocteau, Marc Chagall, Alberto Giacometti, Joan Miró, Salvador Dalí, Max Ernst, Alexander Calder, Francis Bacon, Roberto Matta, Jean Fautrier, Tàpies, Eduardo Chillida, Manolo Millares, Antonio Saura, Victor Vasarely, Yaacov Agam, Jesús Rafael Soto, James Rosenquist, Claes Oldenburg, and Robert Rauschenberg. To these names we would have to add Gris, with a painting dated 1924, *Still Life with Napkin* (fig. 42), which first belonged to Daniel-Henry Kahnweiler. The acquisition of this work so astonished Eusebio Sempere that he wrote the following to the mayor of Alicante in a letter dated October 8, 1977: "I already have the Juan Gris at home, $75,000! I'm terrified [. . .] I beg you to put proper locks on the doors of the collection [at the Museo de la Asegurada]."[14]

The origin of the Centro de Arte y Naturaleza (CDAN) in Huesca has many similarities with that of the Museo de Arte Contemporáneo de Alicante, since it also owes its existence to the generosity of an artist who decided to donate his collection to the city where he spent the last years of his life. The painter José Beulas began collecting art in the 1950s, ultimately amassing some 200 pieces, which he later bequeathed to the city of Huesca so that it might create a museum of contemporary art. The museum, which would take shape in a majestic building designed by the architect Rafael Moneo, was inaugurated in 2006. The collection—generally comprising Spanish artists who worked in the styles of Expressionism, Informalism, abstraction, and New Figuration—reflects Beulas's main interests, and centers most notably on the works of colleagues with whom he shared both friendship and artistic affinities. In this regard, Gris is an exception to the rule, since the CDAN acquired a gouache on paper dating from 1909, which is in fact the oldest piece in the museum. Exemplifying the usual style of Gris's press drawings, this work, *Pierre Garnete de Sanchair*, was originally published in the satirical magazine *Papitu* in 1909, the same year of its creation.[15]

Private Collecting

Institutional and Corporate Collections

Colección Telefónica, owned by the eponymous foundation, was established in 1983, when the Spanish telecommunications corporation decided to invest part of its profits in the acquisition of works by internationally renowned Spanish artists. These works, selected by the gallery owner Nieves Fernández, focused on four artists: Picasso, Gris, Tàpies, and Chillida. This block of works, referred to as *Inicios* (Beginnings), was acquired between 1983 and 1988, and subsequently came to be considered closed to further expansion. The collection was initially located at Telefónica's corporate headquarters, in a landmark building constructed in 1929 on Madrid's Gran Vía. Over time, the collection was enlarged to accommodate other pieces, which were classified into several groups: paintings corresponding to New Figuration, contemporary photography, paper works under the designation of *Telos*, and a Cubist collection, which was undoubtedly the most important of all the art-related collections created by Telefónica. Consisting of works by artists such as Manuel Ángeles Ortiz, Rafael Barradas, María Blanchard, Albert Gleizes, Auguste Herbin, André Lhote, Louis Marcoussis, Jean Metzinger, and Joaquín Torres-García, among others, the Cubist collection revolves around the figure of Gris, represented here by eleven paintings, from 1913 to 1926 (including fig. 43). These paintings are complemented by a small drawing, *Madonna with Child* (fig. 44), which exemplifies the interpretations executed by Gris from the works of various Italian artists, in this case one of Raphael's Madonnas.[16]

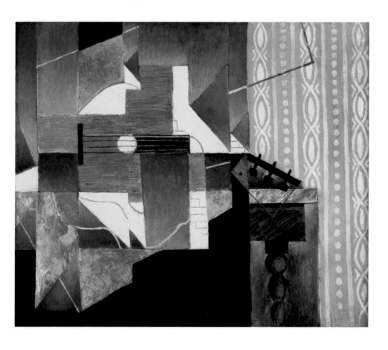

FIG. 43 *The Guitar on the Table,* 1913. Oil on canvas. Telefónica Collection, Madrid.

Of the Telefónica works, three are particularly noteworthy, since they are also associated with pivotal moments in Gris's career: *Glasses, Newspaper, and Bottle of Wine* (1913), *Harlequin* (fig. 45), and *Open Window with Hills* (cat. 37). In the first, a delicate collage of glasses, a newspaper, and a bottle of wine, Gris inserts an ironic element to "confuse" the viewer by intentionally playing with the truth and "obscuring" the identity of the liquid contained in the bottle, hiding the full label and its designation of origin—BORDEAUX—and revealing only its final syllable, EAUX (water). In contrast, the lively structure and palette of the *Harlequin* canvas respond to the dictates of the deductive method, which contribute to an impression of solemn monumentality. Finally, in the last work, the focus is on the prominent role of the window's ornamental grillwork, which acts as an axis around which the rest of the painting's structural components are arranged.

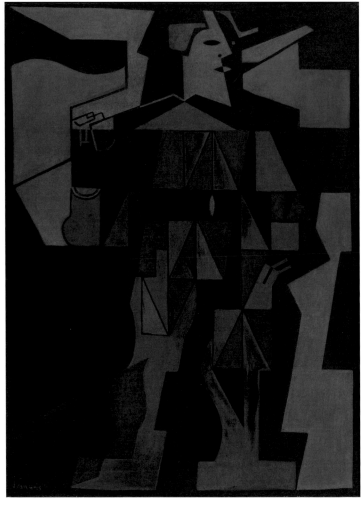

The Museu Fundación Juan March in Palma de Mallorca, founded in 1990, and managed by the foundation of the same name, is an institution created in 1955 by the financier Juan March Ordinas with the mission of promoting culture in Spain. In addition to collecting works of art, organizing exhibitions, concert series, and conferences, the foundation fosters scientific research, and maintains a library of contemporary Spanish music and theater at its headquarters in Madrid. Aside from the Palma de Mallorca museum, it owns and operates another art institution, the Museo de Arte Abstracto Español, which is located in the city of Cuenca. The holdings of these museums include more than 1,600 works by Spanish artists, of which 527 are paintings and sculptures and the rest drawings and graphic works. Known as the Colección de arte español contemporáneo, this vast compendium of works originated through the collecting initiatives carried out by Juan March beginning in the early 1970s. The Museu Fundación Juan March is housed in a seventeenth-century building which, after being renovated and retrofitted by architect Guillem Reynés i Font, has hosted a good part of the collection since 1990, most notably some of the great Spanish exponents of twentieth-century avant-garde art, including Picasso, Miró, Dalí, and Gris. The museum also features a representative selection of the various movements of the mid-twentieth century, as well as numerous works from subsequent generations.

FIG. 44 *Madonna with Child*, 1916. Pencil on paper. Telefónica Collection, Madrid.

FIG. 45 *Harlequin*, 1918. Oil on canvas. Telefónica Collection, Madrid.

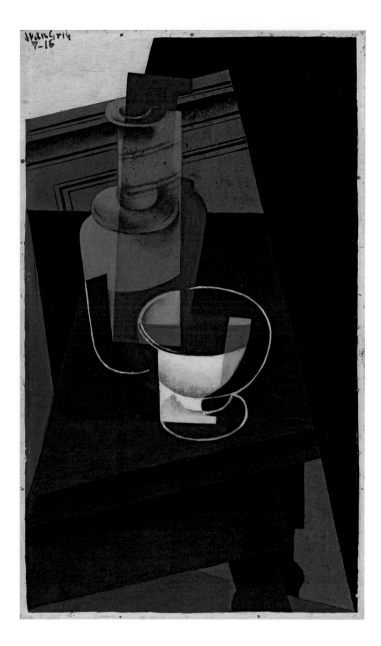

The Gris painting in this collection is an oil-on-panel composition titled *Carafe and Bowl* (*Carafe et Bol*; fig. 46), a painting that was referred to as follows for an exhibition in the French city of Albi:

> The still life *Carafe et Bol* dates from 1916, a productive year in the artist's career. Dating from the same year are such critical works as *Le Violon*, from the Kunstmuseum in Basel, *Fruit Dish, Glass and Lemon,* from the Phillips Collection in Washington, D.C. [*Still Life with Newspaper*; cat. 25], and the *Portrait of Josette Gris*, which Douglas Cooper, author of a catalogue raisonné of Juan Gris's work, donated to the Prado in 1977.[17] In 1916, Juan Gris achieved greater depth in his compositional space. As the title indicates, the work represents a carafe and a bowl reconstructed in Cubist terms. In the hands of Juan Gris, the Cubist way of depicting objects from various points of view is neither a closed system nor a dogmatic belief— it is simply a method. The result is a rigorous painting that is solemn, intimate and modern, yet capable of touching the viewer as would a work by Jean Siméon Chardin or, more appropriately, Francisco de Zurbarán. As Kenneth E. Silver wrote, 'Never before or after did the art of Juan Gris seem so obscurely Spanish as between 1915 and 1917.'[18]

Owned by the eponymous corporation, the Colección Masaveu in Oviedo is currently managed through a collaborative agreement with the Fundación María Cristina Masaveu Peterson, the mission of which includes the dissemination of Spanish historical heritage and the promotion of arts and culture in general. As a result of this agreement, and given the disposition of its directors to continue collecting and to serve as patrons of the arts, some of the most relevant works in this extensive collection have been displayed in temporary exhibitions such as *Picasso, Braque, Gris, Blanchard, Miró y Dalí. Grandes figuras de la vanguardia. Colección Masaveu y Colección Pedro Masaveu.*[19] The corporation's art holdings extend back to the late-nineteenth century, with the first acquisitions being made by its founder, Pedro Masaveu (1886–1968). Subsequently, his son Pedro Masaveu Peterson expanded the collection with works from the medieval period onward, and, most notably, from the nineteenth and twentieth centuries. Comprising approximately 1,500 pieces, this

compendium of paintings, drawings, sculptures, tapestries, and documents encompasses examples of Spanish artistic evolution from the thirteenth century to the present, including such illustrious artists as Juan de Flandes, El Greco, Murillo, Zurbarán, Ribera, Luis Meléndez, Goya, Ramón Casas, Marià Fortuny, Santiago Rusiñol, Joaquín Sorolla, Picasso, Braque, Gris, Dalí, Miró, and Andy Warhol.

The significance of the Gris painting in the Colección Masaveu—*The Violin* (fig. 47)—is that it signalled an experimental turning point in the artist's style. By early 1915, Gris had embarked on a new approach, abandoning the practice of collage in order to resume painting. However, a few months prior to this, he had engaged in another formula, which would also bring positive results for his artistic practice. Echoing Picasso and Braque's decision to integrate the Pointillist technique into some of their 1913–14 compositions, Gris adopted this procedure for the first time in September 1914, specifically in *The Violin*, which displays rigorous geometric planes offset by a chromatic vibration of surfaces, animated by Pointillist dots.

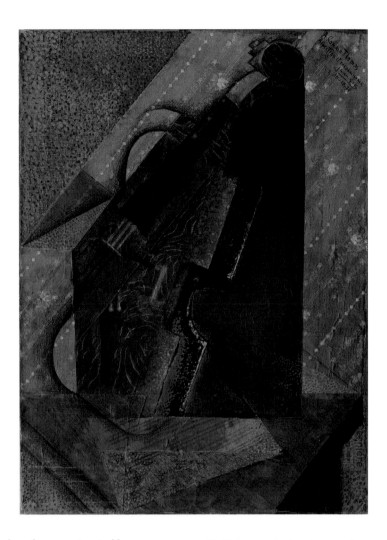

FIG. 47 *The Violin,* 1914. Papier collé, gouache, and charcoal on canvas. Colección Masaveu, Oviedo.

The newspaper *ABC* was founded in Madrid on January 1, 1903, as a weekly publication. On June 1, 1905, it commenced daily distribution, as it continues to do to this day. The decade prior to this (1891) witnessed the founding of *Blanco y Negro*, an illustrated magazine that was the first Spanish periodical to use color and coated paper, and to which Gris sometimes contributed. *Blanco y Negro* was initially distributed as an independent publication; however, in 1986 it merged with *ABC* as the newspaper's Sunday supplement. The Museo ABC de Dibujo e Ilustración, located on Calle Amaniel in Madrid, preserves the artistic legacy of the many, mostly original pieces intended for publication in the magazine *Blanco y Negro*. The museum's holdings encompass over a century of graphic art, with approximately 1,500 works by artists who cultivated a range of styles, techniques, and trends in drawing and illustration.

From the Museo ABC collection, we have chosen two works by Gris from the period during which, after leaving the Escuela de Artes y Manufacturas in Madrid, he decided to emigrate to Paris in 1906. While in the French capital—where he came into contact with Picasso, Guillaume Apollinaire, André Salmon, and Max Jacob—Gris published more than 650 drawings and cartoons in twenty-two different newspapers, of which thirteen were French (*Le Rire, Le Charivari, Le Témoin,* to name three of the more important ones), and nine were Spanish. Among the latter, Gris followed up on his earlier

relationship with *Blanco y Negro*, to which he sent two original drawings, *The Conquest of Bread I*, and *The Conquest of Bread II* (fig. 48). Both works are from 1906 and offer a subtly satirical treatment of the social realities that emerged with the birth of the new century.

In 1976, Mapfre, a Spanish multinational corporation operating in the insurance sector, established the Fundación Mapfre, a private non-profit corporation based in Madrid. The foundation's objectives encompass a range of goals intended to improve quality of life and further social progress, and include various cultural initiatives, mainly in Spanish-speaking countries. In this context the foundation's cultural focus includes collecting art, a venture that was first developed in the latter part of the twentieth century and which continues to the present. In addition to a vast array of images by renowned photographers, and the complete series of etchings from Picasso's *Vollard Suite*, the Fundación Mapfre has assembled a large collection of drawings from the twentieth century, including works by some of the foremost twentieth-century European artists and illustrators (e.g., Henri Matisse, Egon Schiele, Edgar Degas, Auguste Rodin, Francis Picabia, Gustav Klimt), as well as leading Spanish figures such as Picasso, Miró, Gutiérrez Solana, Darío de Regoyos, Chillida, and Gris.

The three drawings by Gris acquired by the Fundación Mapfre were created in the 1920s—the first in 1920, and the remaining two in the years closer to the painter's death, in 1925 and 1925–26, respectively. *Guitar, Book, and Newspaper* (fig. 49), dated January 1920, represents a successful synthesis of the formal Cubist repertoire and the more sober tradition of Spanish seventeenth-century still life, as Juan Antonio Gaya Nuño and Mark Rosenthal have observed in their studies of the artist's still lifes. The second of these drawings, *Portrait of Paul Dermée*, is a depiction of the Belgian poet who was close to Tristan Tzara and the circle of the Dadaists, in a style that embodies assumptions of a "return to order," which Gris imposed in the later years of his life, without ever completely abandoning his unique Cubist praxis. Resolved in a more naturalistic key, the subject of the last of these drawings is seen holding a guitar, a musical instrument often present in the work of the Madrid painter.

The Fundación Francisco Godia was established in 1999 by the daughter of collector Francisco Godia Sales, a very popular figure in Barcelona in the second half of the twentieth century both for his love of art and for his status as an entrepreneur and prominent sports figure.[20] Publicly owned initially,

and privately thereafter, the Fundación Godia
currently occupies a large building in Barcelona,
the former Garriga Nogués residence, where
the approximately 1,500 pieces of this collec-
tion are housed. The paintings, sculptures, glass,
and ceramic pieces make up one of the most sig-
nificant private collections in Spain and cover
Spanish, Catalan, and international art from the
twelfth to the twenty-first centuries, including
such renowned artists as Jaume Huguet, Pedro
Berruguete, Zurbarán, Sorolla, Casas, Rusiñol, Mir,
Nonell, González, Picasso, Gris, Miró, Magritte,
Léger, Karel Appel, Tàpies, and Chillida. A small
oil painting by Gris that belongs to the Godia col-
lection, *Glass and Carafe* (1918), is a clear exam-
ple of the style developed by the painter between
1917–18, at the apogee of his "pictorial rhyme"
or "rhymed correspondence" visual formulas,
which were inspired by the poetic circle of Pierre
Reverdy and the literary magazine *Nord-Sud*.

Other Private Collections

Initially launched with the participation of
Baron Hans Heinrich Thyssen-Bornemisza, the Colección Carmen Thyssen-
Bornemisza centers primarily on nineteenth- and twentieth-century move-
ments and artists, focusing specifically on three main nuclei: Spanish painting,
American painting, and European painting, with an outstanding representa-
tion of Impressionism, Post-Impressionism, and Expressionism. Composed of
approximately 3,000 works, of which around 450 are housed in the Thyssen-
Bornemisza Museum, it has a small, but highly characteristic work by Juan
Gris, *Seated Woman* (fig. 50), one of the three female portraits that the painter
executed during this period, partly inspired by his wife Josette and by some of
Corot's portrait subjects. In this painting, Josette appears elegantly dressed
and proudly displaying a hooped earring, thus evoking the painter's Spanish
ancestry.

The Koplowitz sisters, who gained an appreciation of art beginning in their
childhood, also own two art collections that include works by Juan Gris. The
Colección Esther Koplowitz, sadly notorious for the media coverage it received
over a theft, focuses on artists such as Goya, Pieter Brueghel the Elder, Camille
Pissarro, and Sorolla. It contains a fascinating composition by Gris: *Guitar on
a Chair* (fig. 51), which incorporates significantly novel materials for Cubism,
including sand and, most interestingly, a collage imitating the woven straw
seat of a chair. Picasso had included this material in his first collage, *Nature*

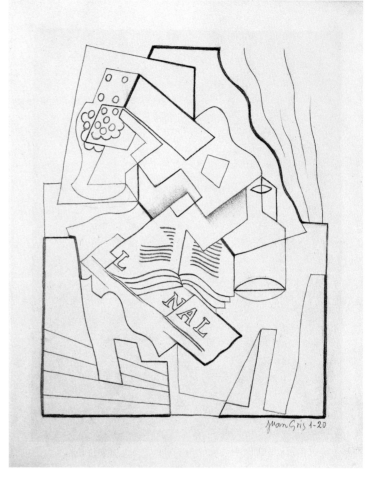

FIG. 49 *Guitar, Book, and Newspaper,* 1920.
Ink and pencil on paper. Colecciones Fundación
MAPFRE, Madrid.

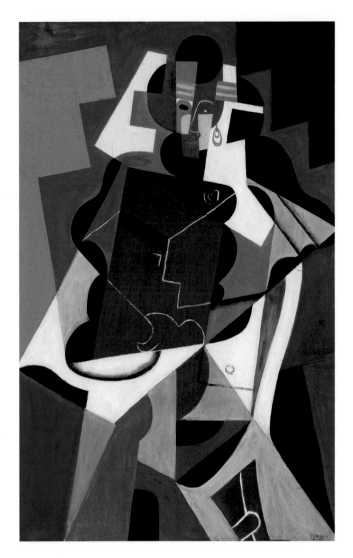

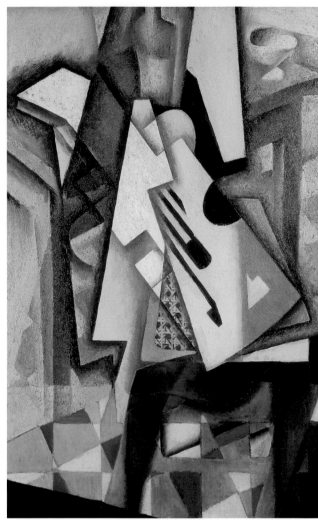

FIG. 50 *Seated Woman*, 1917. Oil on panel. Carmen Thyssen-Bornemisza Collection on loan at the Museo Nacional Thyssen-Bornemisza, Madrid.

FIG. 51 *Guitar on a Chair,* 1913. Oil, papier collé, and sand on canvas. Private collection.

morte à la chaise canée (1912, Musée national Picasso–Paris) from the previous year, but Gris perfects it here, transforming this ersatz chair caning into a fully integrated element within his compositional puzzle. The Colección Alicia Koplowitz-Grupo Omega Capital, exhibited at the Musée Jacquemart-André in Paris in 2017, features paintings by Zurbarán, Goya, Canaletto, Vincent van Gogh, Paul Gauguin, Henri de Toulouse-Lautrec, and Amedeo Modigliani, among others, as well as a rather large canvas by Gris titled *Violin and Newspaper* (1917), where, once again, the painter gave compositional prominence to a musical instrument.

The Colección Abelló, renowned both in Spain and internationally, is the result of the extensive and meticulous patronage carried out over the course of more than thirty years by spouses Anna Gamazo and Juan Abelló. Comprising a vast range of paintings by such artists as Juan de Flandes, Lucas Cranach, José de Ribera, Zurbarán, Bartolomé Murillo, Canaletto, Goya, Sorolla, Modigliani, Picasso, and Francis Bacon, it also includes a large selection of drawings by Van Gogh, Gustav Klimt, Schiele, Modigliani, and Picasso. A more recent addition to the collection is the Alcubierre Album, which contains drawings by Spanish and Italian artists from the sixteenth to eighteenth centuries. The Colección Abelló also has two oil paintings by Gris. The first of these canvases, *Seated Woman* or *The Scottish Woman* (fig. 52), once belonged

to Léonce Rosenberg, one of the leading dealers of Cubist painting, and owner of the Galerie de L'Effort Moderne in Paris. This highly structured composition based on diagonal lines contrasts with the alternatingly warm and cold hues and planes in the second Gris painting, titled *The Saucepan* (1919), a still life in which compositional balance predominates.[21] In addition, the collection features two drawings that represent different eras and styles, *Flattery* (1908), a typical scene from Gris's period as an illustrator, and *Study for Violin* (1913), a perfect example of the Cubist formulas developed by the artist.

The history of the Colección Leandro Navarro is, in certain respects, similar to that of the Colección Abelló, insofar as it was established through the joint collecting efforts of a husband-and-wife team, in this case, the Madrid gallery owner Leandro Navarro and Conchita Valero, who began devoting their efforts to acquiring artworks in 1956. Focusing primarily on the work of José Gutiérrez Solana,[22] this collection also includes other examples of Spanish twentieth-century art,

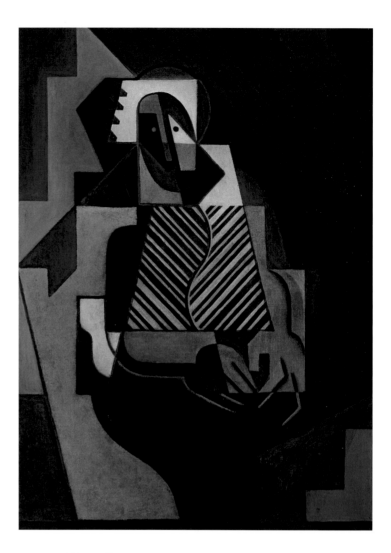

FIG. 52 *Seated Woman* or *The Scottish Woman*, 1918. Oil on canvas. Private collection, Madrid.

especially by the members of the major avant-garde movements. The collection includes a remarkable range of drawings from exponents of Symbolism, Dada, Constructivism, and Cubism, including a pencil drawing on paper by Juan Gris, *Coffee Mill and Bottle*, dated 1917.

The Colección Coca-Moroder began many years ago as a result of the astute acquisitions of the financier Ignacio Coca and his wife Silvia Moroder de León y Castillo. Their collecting interests, aimed largely toward historical avant-gardes, have been carried on by their children. Undoubtedly one of the most outstanding pieces in this collection is a Gris canvas titled *Table Overlooking the Sea* (1925), which is part of a group of still lifes executed by the painter during his time in Toulon, just ten miles away from Bandol-sur-Mer. It was in that same coastal town, mainly around 1921, that Gris created most of his "open-window" canvases. He would eventually return to this theme in later years, perhaps motivated by Matisse's window compositions, and as a result of the close friendship maintained by the two artists. Executed in a horizontal format—the famous "M" canvases intended primarily for the depiction of marine settings—these serene vistas of the Mediterranean coastline exude sensuality and call into question any allegations of Gris's coldness in painting or personality.

Juan Entrecanales de Azcárate, owner of the Colección H.E.F., inherited a love for collecting from his father, José Entrecanales, along with a series of

Spanish paintings dating from 1880–1920. The collection currently includes approximately 500 pieces ranging from the late nineteenth century to the present, and features such artists as Picasso, Chagall, Gris, González, Millares, and Saura. A small canvas by Gris in this collection, *Still Life with Newspaper* (1926–27), poignantly evokes the artist's lifelong passion for painting, despite his struggles in his last days with rapidly declining health, which prevented him from tackling large-format works.

No account of Spanish private collectors of the works of Juan Gris would be complete without considering Emilio Ferré, despite the fact that Ferré's established residence is in Paris. The Colección Emilio Ferré, the result of many years of painstaking work, has managed to compile and authenticate some of Gris's least-known works. Comprising a noteworthy selection of satirical drawings, this extensive collection spotlights the originals that were created for subsequent publication in the press. Thus, primarily between 1904 and 1914, the street life of Paris at the beginning of the century, as well as technological advances and political events were disseminated to a broader public due to their publication in numerous illustrated journals and newspapers, such as *Le Rire, Le Canard Sauvage, Blanco y Negro, L'Indiscret, Le Frou-Frou, Le Cri de Paris*, and *L'Assiette au Beurre*. Some of the collection highlights of these original creations include *The Letter* (c. 1906–07), *May 1 in the Kursall* (1907), and *The Airplanes* (1908).

The collecting of Gris's work in Spain has occurred in a very compressed time frame, with most works acquired in the last 40 years. It is a testament to the dedication of Spanish museums, foundations, and private collectors that today Spain has some of the greatest holdings of the Cubist master's work, from all periods of his career. His example continues to inspire modern collectors and museum visitors alike.

Notes

1. María Dolores Jiménez Blanco, *El coleccionismo de arte en España: Una aproximación desde su historia y su contexto*, Cuadernos Arte y Mecenazgo 2 (Barcelona: Fundación Arte y Mecenazgo, 2013), 22, 25–28.

2. Edmund Peel, "El coleccionismo y la creación de un patrimonio artístico," in *Tesoros de las colecciones particulares madrileñas: pintura y escultura contemporáneas* ed. Paloma Esteban Leal (Madrid: Consejería de Cultura, Dirección General del Patrimonio Cultural, Comunidad de Madrid, 1989), 24–25.

3. Currently the Museo Nacional Centro de Arte Reina Sofía.

4. Paloma Esteban Leal, "Benjamín Palencia, partícipe del Arte Nuevo," in *Benjamín Palencia y el Arte Nuevo: obras 1919–1936* ed. Paloma Esteban Leal (Valencia: Bancaixa, 1994), 15–16.

5. Douglas Cooper was a historian, critic, and collector of British and European art, especially Cubist works.

6. Ángeles Villalba and Javier Portús, *Mercado del arte y coleccionismo en España (1980–1995)*, Cuadernos ICO 6 (Madrid: Instituto de Crédito Oficial, 1995), 126–27.

7. Villalba and Portús, 95–96.

8. As of March 14, 2021 (the date of publication for this catalogue), the painting is on loan to the Museo Nacional Centro de Arte Reina Sofía.

9. The Senado de España is half of the bicameral system that, along with the Congress of Deputies, forms the Cortes Generales, the constitutional body elected by the people of Spain.

10. In Spain an autonomous community is defined as a territorial entity that, within the constitutional order of the state, is endowed with legislative power and executive powers, as well as the faculty of governing itself through its own representatives.

11. Pilar de Miguel, Trinidad de Antonio, Carlos Reyero, Jesús Gutiérrez Burón, and Guillermo Solana, *El arte en el Senado* (Madrid: Dirección de Estudios y Documentación, Departamento de Publicaciones, Secretaría General del Senado, 1999), 366.

12. The Agell Collection, acquired by the Museu Nacional d'Art de Catalunya in 1963, is made up of 16,598 illustrated drawings by a wide variety of artists, largely from Barcelona's Antonio López publishing house, which, among other periodicals, published between the end of the nineteenth century and the first decades of the twentieth century humorous magazines such as *La campana de Gràcia* and *L'Esquella de la Torratxa*.

13. The museum was named after the building that housed it, the oldest civil construction preserved to this day in Alicante, a sober example of seventeenth-century Valencian Baroque architecture.

14. Quote excerpt from the MACA website www.maca-alicante.es (originally in Spanish).

15. *Papitu* 2, no. 14 (February 24, 1909): 227. The vignette was followed by a caption in Catalan: *Es casa amb el vell / Y ja passa por tots els amors d'ella? / Sí, pero por lo que no passa es per qu'estimi a ningú més qu'an ell* (She's marrying the old man / And now she's thinking back on all her past loves? / Yes, but in his own mind there's never been anyone else but him.)

16. Specifically, a version of the *Madonna Tempi* (1507–08), from the Alte Pinakothek in Munich.

17. As noted previously, this portrait of the artist's wife is now part of the collection at the Museo Nacional Centro de Arte Reina Sofía.

18. Danièle Devynck, Javier Maderuelo, and Juan Manuel Bonet, *De Picasso a Barceló: collection de la fondation Juan March* (Albi: Musée Toulouse-Lautrec, 1996), 16.

19. Exhibition held by the Museo de Bellas Artes de Asturias, Oviedo, from July 25, 2018 to January 6, 2019. The English title is *Picasso, Braque, Gris, Blanchard, Miró, and Dalí. Major Figures of the Avant-Garde. Masaveu and Pedro Masaveu Collections.*

20. Francisco (Paco) Godia Sales was a Formula One racing driver who participated in races at Montjuïc, Le Mans, and the Formula One World Championship.

21. Almudena Ros De Barbero, *Colección Abelló* (Madrid: CentroCentro Cibeles de Cultura y Ciudadanía, 2014), 207–208.

22. Conchita's father, Juan Valero, was the foremost collector of artworks by José Gutiérrez Solana during the 1930s.

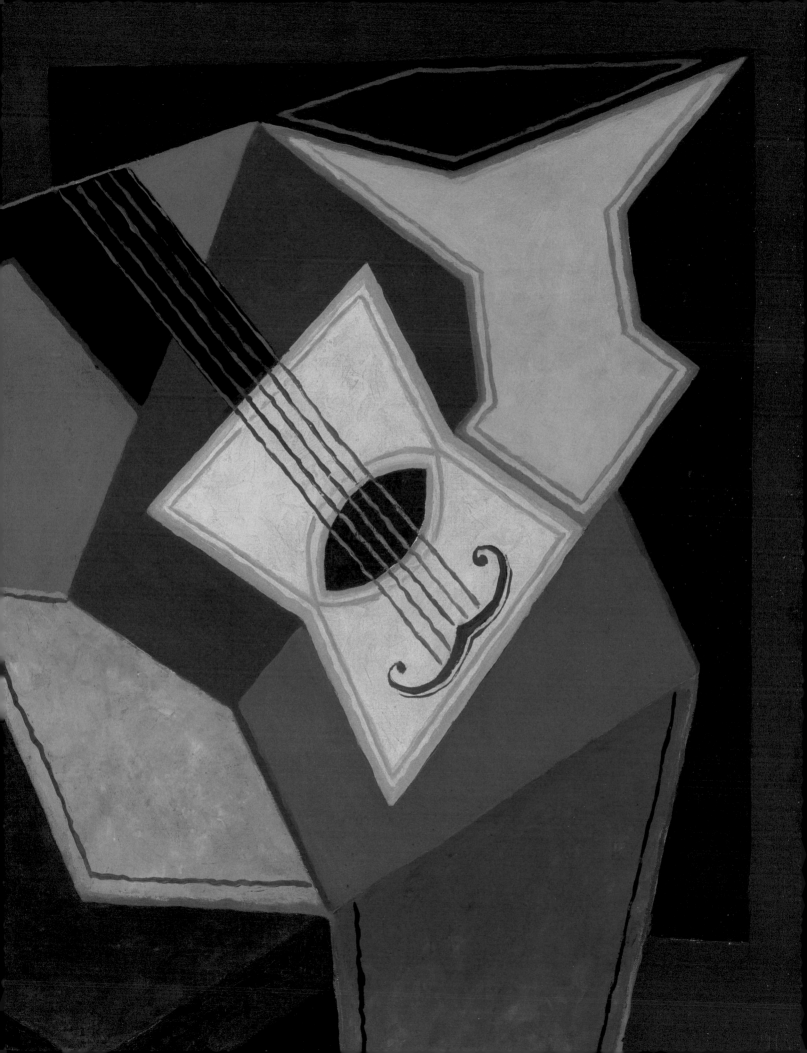

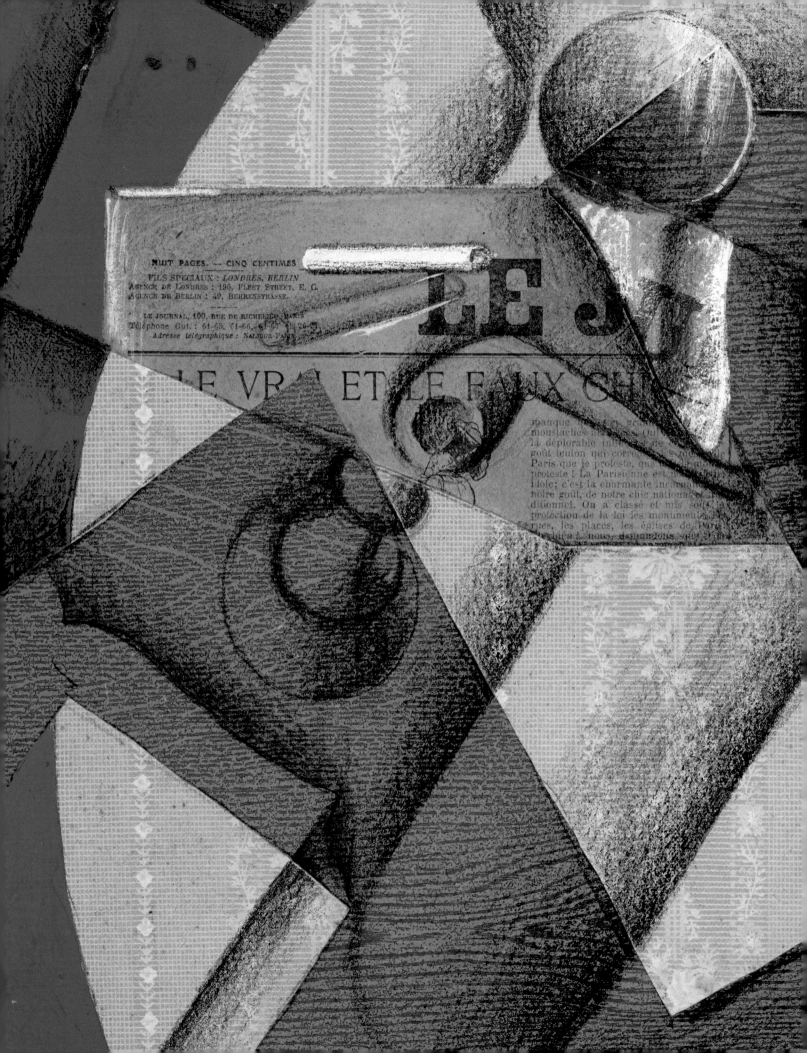

NUIT PAGES. — CINQ CENTIMES

FILS SPÉCIAUX : LONDRES, BERLIN
AGENCE DE LONDRES : 130, FLEET STREET, E. C.
AGENCE DE BERLIN : 49, BEHRENSTRASSE.

LE JOURNAL, 100, RUE DE RICHELIEU, PARIS
Téléphone Gut. : 61-65, 61-66, 61-67 et 26-27
Adresse télégraphique : NALJOUR-PARIS

LE J

LE VRAI ET LE FAUX CHI

banque ... gra...
moustaches ... Qui
la déplorable i... ...ce
goût teuton qui corro... ... n...
Paris que je proteste, que ... n...
proteste ! La Parisienne est ...
idole ; c'est la charmante incarnati...
notre goût, de notre chic national ... l...
ditionnel. On a classé et mis so...
protection de la loi des monumen...
rues, les places, les églises de Par...
... bien... nous demandons qu...

From Geometry to Reality

South American Abstraction and the Legacy of Juan Gris

ANNA KATHERINE BRODBECK

Juan Gris is the perfect geometer. This is why he is the purest of the Cubists. He does not depart, like the others, from nature to move to the abstract, but rather moves from the abstraction of geometry and color plane to reality. . . . A better concept of a constructed painting cannot be had, and, in this sense, he was a true master. The more realistic Picasso, the more lyric Braque, are very far from Juan Gris in terms of pure creation within a perfect arrangement. And in the case of Juan Gris there is more capacity and also more culture. This allowed him to reach greater generalization, a wider and purer concept of art; a true architecture of shapes and colors. Allow me, even if the criterion is not shared, to put him as the first painter of our time.

—JOAQUÍN TORRES-GARCÍA, 1944[1]

Joaquín Torres-García was arguably the greatest proponent of abstract art in the Americas. After a long and diverse career in Europe from 1891 through 1934 (interrupted by a stint in New York from 1920 to 1922), he moved back to his native Uruguay to establish the School of the South, which would go on to influence some of the most important artists to emerge from Latin America. The commentary by Torres-García quoted above has significant repercussions for a contemporary evaluation of Juan Gris, the Cubist artist who, through a variety of circumstances, has garnered the least amount of critical attention among his peers. This essay will explore Torres-García's evaluation of Gris, and by extension, establish how Gris's influence resonates in the work of artists who followed in the Uruguayan master's footprints, notably the groundbreaking Argentine concretists and the Brazilian Neoconcretists.[2] Through Torres-García's influential pedagogy, Gris's forms would find new life in important aesthetic developments in South America. This essay traces that lineage, showing how artists from these

countries continued to engage with the formal and conceptual problems posed in Gris's work.

Gris was the last of the three great Cubist masters to adopt the style, and, as he died in 1927 at the young age of 40, he was the first to cease in its development. In spite of the short length of his career, he was known for several defining characteristics, including: his distinctive use of color; his introduction of the open window motif; and several witty formal inventions of his own, like the incorporation of mirror fragments into one of his compositions, *The Washstand* (fig. 2, p. 15).[3]

These qualities and more are observed by Anne d'Harnoncourt in her essay on the surprising influence of Gris on Joseph Cornell. D'Harnoncourt makes important observations about the unique properties of Gris's work that made him especially attractive to younger artists: "Gris was rigorous in his desire to dissect and reconstitute visual reality with an almost mathematical precision, but he never relinquished the love of the object he was depicting."[4] To illustrate, she notes the formal discrepancy between two still lifes: Pablo Picasso, *Bowl with Fruit, Violin, and Wineglass*, c. 1913 (fig. 53) and Juan Gris, *Still Life: The Table*, 1914 (cat. 11). While Picasso transformed the subject matter into pure sign, Gris maintained an integral connection to the objects depicted therein: they may be distorted, but their singular attributes are highlighted. In fact, that highlighting becomes quite pronounced at times. As Daniel-Henry Kahnweiler described: "One method which was imitated later by other painters was peculiar to Gris: the objects, whose form, colour, and even substance he tried to express, were frequently completed by a sort of projection in the form of a black silhouette."[5]

This black silhouette would have surprising range in its influence. Scholars note that Gris preferred paintings to *papier collé*, such that even his collages were often placed on a canvas or cardboard support, making them more painting-like. However, in her analysis of the outstanding example of Gris's *papier collé* in the Philadelphia Museum of Art cited above, Lisa Forman argues that his collages were the most influential for the development of abstraction in the Americas. Indeed, the most vocal theorist of North American modernism, Clement Greenberg, lauded Gris for the same effects noted in Kahnweiler's assessment, citing a series of 1915 paintings. There, Gris's use of "sonorous blacks" suggests shapes, rather than the shadows employed by Picasso and Braque in their *papiers collés*, pointing to a quality Greenberg asserts as of "the highest importance to Cubism and to the collage's effect upon it: namely, the liquidation of sculptural shading."[6] This liquidation

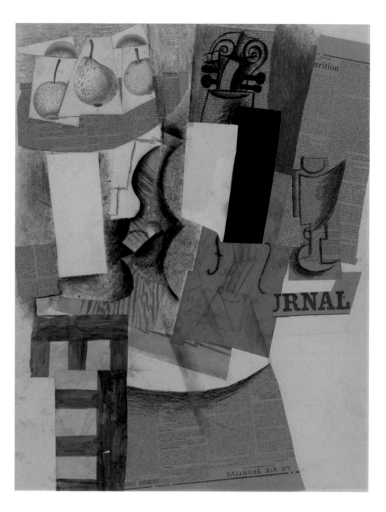

FIG. 53 Pablo Picasso, *Bowl with Fruit, Violin, and Wineglass*, c. 1913. Charcoal, black chalk, watercolor, oil paint, coarse black wash, and collage of printed and colored papers on board. Philadelphia Museum of Art: A. E. Gallatin Collection, 1952-61-106.

FIG. 54 Joaquín Torres-García, *Five Colors Composition*, 1929. Oil on canvas. Private collection.

of sculptural shading provided a necessary precedent for Greenberg's argument that flatness was the unique quality of painting as a two-dimensional medium, and that the American modernists who maintained this medium-specificity reigned supreme. As we will see, the development of abstract art in South America was spurred on by very different theoretical precepts, yet was still dependent on the sharp geometric silhouettes that Gris had foregrounded.

While Gris's treatment of objects served as an important precedent for Greenberg's theories, the perceived effect of the Greenbergian flat picture plane was a literalness that diverged sharply from the intent of the Spanish artist. As Gris had written, "I have also managed to rid my painting of a too brutal and descriptive reality. It has, so to speak, become more poetic. I hope that ultimately I shall be able to express very precisely, and by means of pure intellectual elements, an imaginary reality. This really amounts to a sort of painting which is inaccurate but precise, just the opposite of bad painting which is accurate but not precise."[7] Paintings such as *Fruit Bowl and Newspaper* of 1920 (cat. 33), with its precisely balanced interlocking forms and implied outlines, depict the formal solutions that Gris arrived at in the search of this perfected reality. Gris's work thus foreshadows particular debates about abstraction that only intensified amid the South American movements of the years that followed—namely, how best to construct a new pictorial reality, whether through figurative or geometric means. While Cubism is often seen as being the progenitor of abstraction, elements of figuration were never entirely eliminated, and as we will see, the persistence of such figuration and of the figure-ground relationship in later iterations of abstraction became the subject of much anxiety.

At the center of that debate was Torres-García. Gris's description of his work echoes Torres-García's unique interpretation of abstraction that emphasized above all construction (in the words of Gris, "flat, colored architecture"[8]) and metaphysics (Gris's love of the object). The Uruguayan artist had moved to Barcelona as a teenager and had a peripatetic career, which took him to New York, Italy, and France, before returning to his birth country. Torres-García had flirted with several styles before coming to his signature brand of post-Cubist abstraction, which he developed as he was exposed to, and collaborated with, some of the most important artists of the day (fig. 54). In the late 1920s and early 1930s, soon after Gris's death, he would partake in the development of international Constructivism with the diverse group of artists living in Paris.

Notable among them was Theo van Doesburg, who became a crucial conduit between the first and second generations of abstract artists in Europe and

the Americas. At that moment, they were both experimenting with dynamic arrangements of geometric shapes and intersecting lines (figs. 55 and 56). Torres-García ultimately diverged sharply from the Dutch artist over the role of metaphysical content in art, which had similarly caused the rift between Van Doesburg and his most famous collaborator, Piet Mondrian. In his letter to the Catalan painter J.M. Sucre from April 5, 1928, Torres-García re-aligned himself more closely with Mondrian, writing: "It is completely within the abstract. Not an intellectual, cerebral abstract, however, but a spiritual, intuitive, metaphysical abstract, or if you prefer—but still within Construction—the architecture of painting."[9] After splitting with Van Doesburg, Torres-García would go on collaborate with the Belgian poet and artist Michel Seuphor to form the short-lived but influential association of abstract artists Cercle et Carré, a group of which Mondrian was a member. However, Torres-García diverged with all three artists on the role of figuration, which he believed could co-exist with the ideals of abstraction. In this way, he follows closely Gris's love of the depicted object, which, distinguishing itself from Picasso's approach, was not utilized as a mere premise for abstraction. Gris thus pointed the way toward a revolutionary reconfiguring of the depiction of reality within abstraction as developed by the Brazilian artists with which I will conclude this essay.

In April 1934, Torres-García returned to his native Uruguay, where he was able to find fertile new ground to spread his brand of abstraction, away from the contentious polemics he left behind in Europe, and it is here that he cemented his legacy. At that time the Southern Cone was dominated by the academic genres that had been introduced by institutions founded under colonial models, and he went to work to spread the word of the various abstract movements that he had participated in while in Europe. Torres-García delivered 600 lectures and organized twenty-four exhibitions of his work during the last fifteen years of his life. In 1935 he founded the Asociación de Arte Constructivo and from 1936 to 1943 published *Círculo y cuadrado*, which was modeled on the publication produced by Cercle et Carré. It was followed in 1944 by *Removedor*, the official publication of his workshop, the Taller Torres-García, and in the same year he published his magnum opus *Universalismo constructivo*, with a chapter dedicated to Gris that was quoted from at the beginning of this essay. His influence spread quickly throughout South America as he sought to create a pan-American model that celebrated the unique geographical and cultural position of his region.

By the early 1940s, the rapid industrialization of the region made the environment especially ripe for abstraction to flourish. Vanguard movements

responded to industrial modernization by promoting art that was up-to-date in both material and form, with local artists and patrons looking to European movements that they saw as representative of the utopian industrial society they wished to create at home. Torres-García became an important conduit for South American artists to learn about these movements: beginning with Cubism, which set the stage for Mondrian's brand of Neoplasticism, and finally, Swiss Concretism, through the influence of Van Doesburg's disciples Max Bill and Georges Vantongerloo.[10]

Beyond his native Uruguay, Torres-García had strong connections to Argentina. He had a hallmark exhibition at the Galeria Müller in Buenos Aires in 1942 that was influential for the development of abstraction there, and in Europe in the mid-1930s he had met the Uruguayan-born artist Carmelo Arden Quin, whose importance to the Argentine scene will be explored below.[11] The treatises written by the burgeoning Argentine abstract avant-garde show evidence of Torres-García's continual emphasis on construction and invention. Jorge Brito, Alfredo Hlito, Tomás Maldonado, and several other young artists published their manifesto-like single-issue journal *Arturo* in 1944, spearheading the abstract movement within the country. Appropriate for their desired break with the past, the battle cry around which these artists gathered would be "Invención" (invention), the title of the article located on the verso of the journal's cover. For these young artists, "invention was synonymous with pure creation," and its affirmation required a rejection of "expression (primitivism), representation (realism) and symbolism (decadence)," for innovation was valued over representation.[12] In the journal's revolutionary concluding article, "The Frame: A Problem in Contemporary Art," Rhod Rothfuss criticized the use of the traditional square frame in abstract art for conflicting with the compositional purity of the shapes depicted within.[13] The Argentine avant-garde's solution to the square format was called the *marco recortado*, or cutout frame. As we will see, the *marco recortado* would be a groundbreaking discovery, even as it pointed out a formal problem that would continue to frustrate artists in the region in the years that followed: that of a persistent figure-ground duality that approximated the effects of representational figuration.

Soon after the publication of *Arturo*, a schism occurred between the contributors to the journal, who then formed two groups—the Asociación Arte Concreto-Invención and the Movimiento de Arte Concreto-Invención (which would later become the Madí). Rothfuss, the original theoretician of the irregular frame, would join the latter, but both groups initially utilized the device. Notwithstanding the shared use of the *marco recortado*, there were substantial differences between the two groups. While artists of the

Asociación Arte Concreto-Invención were more orthodox abstractionists with a coherent theoretical program and an avowed dedication to Marxism, the Madí artists maintained a playfulness that is apparent in their Dada-like name, which corresponds to no Spanish word.

The hardline nature of the Asociación Arte Concreto-Invención can be seen in their evolving treatment of the *marco recortado* as a continual attempt to address the problematic figure-ground relationship. As Maldonado would argue in "The Abstract and the Concrete in Modern Art" (1946), any mark against a background will create a figure-ground relationship, even if there is harmony between the interior composition and the frame.[14] Therefore, in the same year of Maldonado's treatise, the Asociación artists adopted the "coplanar": an arrangement of discrete shapes on separate canvases held together by wires that could then be hung directly on the wall (fig. 57). However, the

FIG. 57 Juan Melé, *Coplanar No. 13*, 1946. Oil on hardboard, acrylic bars, wooden dowels, and screws. Fundación Malba - Museo de Arte Latinoamerica de Buenos Aires, Donación Eduardo F. Costantini, Buenos Aires, 2003.03.

coplanar should not be confused with the mobile—as these planes were carefully arranged to create subtle and fixed relationships. This was not the case with the Madí, who prized spectator interaction as a defining quality of their work. As the drive towards formal purity characterizes the evolution of the Asociación Arte Concreto-Invención, the coplanar would soon be abandoned, as even this inventive device created a figure-ground relationship—the gallery walls, often painted or wallpapered themselves, served as the new ground to the distinct elements of the coplanar, recreating this hierarchy. The artists of the Asociación Arte Concreto-Invención would thus return to the rectilinear frame, abandoning the search for novel framing devices.

The artists that formed the Madí were even more inventive in their search for a solution to the figure-ground duality. The sense of the limitless possibilities afforded when the traditional frame is abandoned comes through in a speech made by Carmelo Arden Quin at the Art Concrete-Invention exhibition (the inaugural presentation of the group that would later become the Madí) held at the home of Enrique Pinchón-Rivière in 1945. He declared: "By abandoning the four classic orthogonal angles—the square and the rectangle— as a basis for composition, we have increased possibilities for invention of all kinds. We can create an infinite number of planar forms."[15] Arden Quin would become a leading proponent of the Madí and would create a European division of the group in Paris, where he emigrated in 1947. In terms of painting, Arden Quin would be best known for a continuation and refinement of the *marco recortado*, making beautifully nuanced forms that maintained a sense of mechanical dynamism (fig. 58). However, while still in Argentina,

FIG. 58 Carmelo Arden Quin, *Trío no. 2*, 1951. Alkyd and acrylic on plywood. Colección Patricia Phelps de Cisneros.

he made coplanars and mobile sculptures, even writing the "Manifesto of the Mobile" in 1945, wherein he termed immobile right angles "the prison of abstraction" and challenged the privilege given to the square and the rectangle by using a variety of shapes in his compositions.[16]

When Arden Quin relocated to Paris, Rothfuss and Gyula Kosice remained in the Río de la Plata region and continued to promote the local proliferation of the Madí. Rothfuss, the original theoretician of the *marco recortado*, continued to exploit its capabilities of creating an autonomous painting that does not reference the world outside. Rothfuss writes: "A painting with a regular frame suggests a continuity of a theme that disappears only when the frame is rigorously structured according to the painting's composition. This means that the edge of the canvas plays an active role in the work of art. A role that it must always play. A painting should begin and end with itself."[17] Criticizing Neoplasticism, he associated even the pared-down use of vertical and horizontal elements with the illusionism of the Renaissance painting tradition, and sought to eliminate all such reference from painting—as seen in his own Madí compositions and superstructures (fig. 59). Through this isolation of form, all reference is excluded and the geometric shapes exist in purity—what Torres-García valued most in his assessment of Gris.

The figure-ground dilemma, and the various formal solutions proposed by the Argentines to solve it, ultimately relate back to those Gris introduced as, in Torres-García's words, the "first painter of our time." As illustrated by Yale University Art Gallery's *Newspaper and Fruit Dish* from 1916 (cat. 21), where his shadows frame each interior element, Gris's highlighting of depicted objects within a composition becomes equivalent to the isolation of the individual elements within the composition in the Argentine coplanars and *marcos recortados*.

In this way, Gris's work prefigured the major formal innovation by these Argentine artists; in another, perhaps more enduring, manner, his legacy can be felt in the work of Brazilian Neoconcretist artists. As we've seen, Torres-García lauded Gris's creation of a new world made of geometric abstract forms, never losing his love of the object in his quest for mathematically precise geometry. The Brazilian artists with whom I will conclude this essay exemplify this complex duality, highlighting how Torres-García's unique translation of Gris spoke to the organic and environmentally contingent innovations for which their work is known.

The origins of abstract art in Brazil have many similarities to that of Argentina, including an interest in Swiss Concretism and the work of Max

Bill; however, more than in Argentina, artistic production in Brazil was complemented by industrial patronage, which sponsored the creation of cultural institutions such as the Museu de Arte de São Paulo (MASP) and the Bienal de São Paulo that showed contemporary art from Europe and North America alongside pieces by Brazilian artists.[18] While this work would evolve beyond the imported models, the institutional support for Constructivist art showcased the optimism of both Brazilians and the European Constructivists that Brazil would carry the mantle of abstraction, which had steadily declined in popularity on the European continent.[19]

The display of European concrete artists such as Max Bill at MASP and the Bienal de São Paulo was especially formative for the first wave of Brazilian concretists, including Waldemar Cordeiro and Geraldo de Barros, who would form the Grupo Ruptura in 1952. This São Paulo-based group, like the Asociación Arte Concreto-Invención before it, was primarily interested in rigid geometries and mathematically based compositions. However, another group emerged in Rio de Janeiro that took very different lessons from the same European source material.

Grupo Frente was formed in 1954 by students of Ivan Serpa, artist and teacher at the Museu de Arte Moderna do Rio de Janeiro (MAM-RJ). Like Torres-García, Serpa was a great pedagogue, teaching both adults and children with a similar method, first and foremost emphasizing the power of creative freedom.[20] His most-famed students include Hélio Oiticica, Lygia Pape, and Lygia Clark. These *Carioca* artists (of Rio de Janeiro) let experience dictate form as opposed to preordained mathematical functions like those used by the *Paulista* artists (of São Paulo), which has led Ana Maria Belluzzo to characterize their work as "intuitive and empirical over theoretical."[21]

When the two groups exhibited together at the First National Exhibition of Concrete Art in São Paulo in 1956, it would become apparent just how far Grupo Frente had deviated from the orthodox abstraction of São Paulo's Grupo Ruptura, who thought that their *Carioca* colleagues had misunderstood Constructivist theories entirely. It was this event that sparked a codification of Grupo Frente's ideas in the newly formed Neoconcretist group, encouraged by the written articulation of their distinct innovations by critics such as Mário Pedrosa, who spearheaded the schism.

FIG. 59 Rhod Rothfuss, *Madí Composition*, 1946. Enamel on wood. The Museum of Fine Arts, Houston, Museum purchase funded by the Caroline Wiess Law Accessions Endowment Fund, 2004.1658.

The advances of these artists were soon to be lauded by another critic, the poet Ferreira Gullar, who would write the manifesto for the group in 1959. This manifesto analyzes the European precedents from which the concrete tradition in Brazil arose, suggesting that the Neoconcretists must surpass their predecessors' merely formal application of theory to create a holistic experience of art. Here Gullar focused on Neoplasticism, taking the same point of departure as Rothfuss in his manifesto on the irregular frame; however, in contrast to Rothfuss, who critiqued Neoplasticism for maintaining continuity with the world outside the painting, it was just this continuity that was valued in the work of the Neoconcretists. Gullar writes:

> Either the vertical and the horizontal planes really are the fundamental rhythms of the universe and the work of Mondrian is the application of that universal principle, or the principle is flawed and his oeuvre is founded on an illusion. . . . Nevertheless, the work of Mondrian exists, alive and fertile, in spite of such theoretical contradictions. . . . The same can be said of Vantongerloo and Pevsner. It does not matter what mathematical equations are at the root of a piece of sculpture or of a painting by Vantongerloo. It is only when someone sees this as a work of art that its rhythms and colors have meaning.[22]

In this passage, Gullar disputes the validity of the Neoplasticists' position that their formal simplifications could ever fully eliminate reference to the outside world, for the viewer always brings their own perceptual apparatuses and experience to bear. This reading became the basis of the "non-object," the influential notion which Gullar developed in 1960.[23] Rather than signaling the negation of the object, Gullar sought to promote a total sensory experience of the art object over its mere physical appearance. Interestingly, it is in this theory that Gullar addresses the very contradictions that had paralyzed the Argentine artists in their quest to surpass the figure-ground duality of abstract art through their use of inventive framing forms. When asked whether the non-object solves the figure-background disjunction, Gullar responded:

> On the plane of perception, that contradiction is insoluble since the background is in itself the same thing as perceiving; everything we perceive is on a background. This explains the dead-end at which abstract art found itself after limiting its expression to the field of pure perception: it ran into the insurmountable dualism that duplicates, on another plane, the subject-object paradox. In the non-object, since the problem of representation is avoided, the problem of the figure-background is avoided as well. The background, on which the non-object is perceived, is not a metaphorical background of abstract expression, but is real, actual space—the world.[24]

The theory of the non-object would be influential on Oiticica, Pape, and Clark, who would use it as the means to open up their works to the surrounding world. They would break open the static form in order to introduce new

variants subject to co-creation by the spectator. This aspect of spectator participation, which would become the most lauded aspect of the Brazilian legacy, also found an important precedent in Torres-García. Torres-García had begun by creating wooden toys in Barcelona before departing for New York in 1920, a move made in part to promote his business venture Aladdin Toys (fig. 60). While continuing to make such toys, which in addition to being sold commercially were exhibited in art contexts, Torres-García began to make wooden figures that were more abstract, many of which he titled "Plastic Exercises." His earliest such pieces were made in 1924 when he was in Italy. He continued to create wooden sculptures prior to his joining of Cercle et Carré, and they were exhibited in that group's first exhibition (fig. 61). The figures had a handmade, organic quality, which diverged from the sleek industrial aesthetic promoted by Van Doesburg; moreover, the toys were interactive, which would be a formative influence for Argentine sculptors such as Gyula Kosice (fig. 62) and a harbinger of some of the most advanced work coming out of Brazil in the late 1950s.

For example, in the *Book of Creation* (fig. 63), Pape created a series of individual sculptures on the scale of book-size sheets, much in the vein of origami. Each sculpture corresponded to a description of the origins of the cosmos, such as the creation of light or water. Here the variations of the plane are created by individual spectators, and while the title corresponds to the Genesis story, it can also refer to the co-authorship of the work by the spectator. Clark created her *Bichos* out of metal geometric forms hinged together with no default position; viewers were encouraged to interact with the work to alter its appearance. Oiticica's concurrent *Bólides,* or containers for pure pigment and organic materials meant to be explored by the participant, were also

FIG. 60 Joaquín Torres-García, *Perro,* c. 1924–25. Oil on wood, nine parts. Private collection.

FIG. 61 Joaquín Torres-García, *Structure in Primary Colors,* 1929. Oil and nails on wood, five pieces glued. The Museum of Fine Arts, Houston. Gift of Cecilia de Torres in honor of Dr. Mari Carmen Ramírez, Wortham Curator of Latin American Art at the Museum of Fine Arts, Houston, 2002.59.

FIG. 62 Gyula Kosice, *Röyi no. 3*, 1944. Wood joined with bolts and wing nuts. The Museum of Fine Arts, Houston. Museum purchase funded by the Caroline Wiess Law Accessions Endowment Fund, 2004.1654. © Museo Kosice, Buenos Aires.

FIG. 63 Lygia Pape, *Book of Creation*, 1959–60. Artist's book with sixteen unbound pages, some with gouache on board, paper, and string. The Museum of Modern Art, New York. Gift of Patricia Phelps de Cisneros. 1349.2001.a-r.

manipulable. His earlier *Spatial Reliefs,* or inventive arrangements of geometric forms hung from the ceiling, suggest endless variations depending on the position of the spectator (figs. 64–65).

Clark's *Bichos* and Oiticica's *Bólides* are both built of geometric planes, but their references are to living organisms. *Bicho* means critter; *Bólides,* fireballs. Oiticica created these works while working with his father, an accomplished entomologist, to catalog butterflies and moths at the Museu Nacional in Rio. According to Irene Small, his encounter there with Goethe's theories of morphology was the impetus for great formal change in his work, culminating in the *Parangolés*: wearable geometric forms that are considered by many to be his most influential works.[25]

To return to the quote with which I started this essay, Torres-García lauded Gris as the "purest of Cubists" for starting, unlike the others, "from the abstract of geometry and the color plane" to represent "reality." Clark, Oiticica, and Pape described the world around them through geometric means; their work was pure construction in the manner desired by Torres-García. But this construction never lost connection to humanism or metaphysics. Instead, geometry was seen as the very vehicle to engage our fellow human in the act of co-creation on the worldly stage of environmental contingency. While Gris was not the direct inspiration for their work, his contributions to Cubism formed a strong precursor for the spirit of their work. Moreover, it should not be forgotten that it was Cubism that first provided viewers with the unprecedented ability to see works from multiple angles, ever sensitive to their own vantage point as moving subjects in space, much like Oiticica's *Spatial Reliefs* achieved decades later.

As a movement, Cubism had been criticized for not going far enough to create the world anew, but the readings made by Torres-García and Greenberg of Gris's unique formal treatments would suggest that it was exactly his version of Cubism that opened up the possibility of true creation within the idiom of geometric abstraction. Tracing his legacy through the works of his successors in Brazil and Argentina offers a salient reminder that these South American artists have only recently come into mainstream critical acclaim for their own contributions to our new understanding of the transformative power of geometry.

FIGS. 64–65 Hélio Oiticica, *Untitled* (two views), c. 1960. Oil on wood. Promised gift of Deedie and Rusty Rose to the Dallas Museum of Art.

Notes

1. "Juan Gris es el geómetra perfecto. Por esto el más puro de los cubistas. No parte, como los otros, de la naturaleza para ir a lo abstracto, sino de lo abstracto de la geometría y el plano de color, para ir a la realidad. . . . Mejor concepto de una pintura construida no puede tenerse, y, en este sentido, fue un verdadero maestro. Más realista Picasso, más lírico Braque, quedan muy lejos de Juan Gris cuanto a pura creación dentro de un perfecto ordenamiento. Y es que en Juan Gris hay más capacidad y también más cultura. Esto le permitió llegar a mayor generalización, a más amplio y puro concepto de arte; a una verdadera arquitectura de formas y colores. Permítaseme, aunque no se comparta el criterio, que lo ponga como el primer pintor de nuestra época." Joaquín Torres-García, "Lección 74. Juan Gris y el Cubismo," in *Universalismo constructivo: contribución a la unificación del arte y la cultura de América*, (Buenos Aires: Editorial Poseidón, 1944), 513–14.

2. For the purposes of this essay, the Argentine and Brazilian artists (with the exception of the Neoconcretists) are described as concretists because of their adherence to the major principles of the Concrete movement in Europe. Because they did not formally describe themselves as such with consistency, I have referred to the movement and adjective in the lower-case.

3. Anne d'Harnoncourt, "The Cubist Cockatoo: A Preliminary Exploration of Joseph Cornell's Homages to Juan Gris." *Philadelphia Museum of Art Bulletin* 74, no. 321 (June 1978): 2–17.

4. Ibid., 9.

5. Gris to Kahnweiler, August 25, 1919, letter in *Juan Gris* (New York: Buchholz Gallery, 1950), cited in d'Harnoncourt, "The Cubist Cockatoo," 12.

6. Clement Greenberg, "Collage" in *Art and Culture* (Boston: Beacon Press, 1961), 81–82, quoted in Lisa Florman, "Re-fusing Collage: Juan Gris's 'Still Life'," *Bulletin of the Detroit Institute of Arts* 75, no. 2 (2001): 6–7.

7. Gris to Kahnweiler, August 25, 1919, letter cited in d'Harnoncourt, "The Cubist Cockatoo," 9.

8. Juan Gris, "On the Possibilities of Painting," in Daniel-Henry Kahnweiler, *Juan Gris: His Life and Work*, trans. Douglas Cooper (New York: Harry N. Abrams, 1968), 196.

9. Reproduced in Pilar Garcia-Sedas, *Joaquin Torres-García Epistolari català: 1909–1936* (Barcelona: Edicions catalanes, 1997), 114. Cited in Tomàs Llorens, "Torres-García: onstructivist Painting in Paris," in *Joaquín Torres-García : un mundo construido*, ed. Emmanuel Guigon (Madrid: Fundación ICO, 2002), 314.

10. Tomás Maldonado, one of the foremost promoters of abstract art in Argentina, had gone to Europe in 1948, where he met Max Bill and Georges Vantongerloo and saw the work of the leading abstractionists of the concretist vein. In 1949, Jorge Romero Brest, the critic and later director of the Museo de Bellas Artes, also began publishing the work of Bill in his groundbreaking publication *Ver y estimar*, and with these contacts in place, Bill's work would be reproduced in *Arte Concreto-Invención, Ciclo, Ver y estimar, Arte Madí, Perceptismo,* and *Contemporánea*. The relationship between Bill and the Argentine avant-garde, as well as his more institutional introduction on the Brazilian scene discussed below is traced in Maria Amalia García, "Max Bill on the Map of Argentina-Brazilian Concrete Art," in Héctor Olea and Mari Carmen Ramírez, *Building on a Construct: The Adolpho Leirner Collection of Brazilian Constructive Art at the Museum of Fine Arts, Houston* (Houston: Museum of Fine Arts, Houston, 2009): 52–68.

11. Ibid.

12. Carmelo Arden Quin, "Invención," *Arturo* (Buenos Aires) 1, no. 1 (1944); reproduced in *Inverted Utopias: Avant-Garde Art in Latin America*, ed. Mari Carmen Ramírez and Héctor Olea (New Haven: Yale University Press, in association with the Museum of Fine Arts, Houston, 2004), 491–92.

13. Rhod Rothfuss, "EL MARCO: Un problemo de la plástica actual," *Arturo* (Buenos Aires) 1, no. 1 (1944); reproduced in Ramírez and Olea, *Inverted Utopias*, 490–91.

14. Tomás Maldonado, "Lo abstracto y lo con-reto en el arte moderno," *Arturo* (Buenos Aires) 1, no. 1 (1944); discussed in *Manifesto de cuatro jovénes* (Buenos Aires, 1941), reproduced in Mario Gradowczyk and Nelly Perazzo, *Abstract Art from Rio de la Plata: Buenos Aires and Montevideo, 1933–1953* (New York: Americas Society, 2001), 57.

15. "The Mobile," speech read at the home of psychoanalyst Enrique Pinchón-Rivière in 1945, cited in Mari Carmen Ramírez, "Vital Structures: The Constructive Nexus in South America," in Ramírez and Olea, *Inverted Utopias*, 194.

16. Claudia Laudanno, "Carmelo Arden Quin: Aestheticism and Asceticism of a Madí," *Art Nexus* no. 47 (Jan/March 2003): 60–65.

17. Rothfuss, "EL MARCO; reproduced in Ramírez and Olea, *Inverted Utopias*, 400–401.

18. For a discussion of industrial patronage and its role in promoting abstract art in Brazil, see Ana Maria Reyes, "The São Paulo Bienal of 1951: Building Abstraction in Brazil," *Chicago Art Journal* 8 (Spring 1998): 31–42.

19. "With all avenues closed in the heart of Europe, the periphery now declared itself open to the project involving Constructive art," García, "Max Bill on the Map of Argentina-Brazilian Concrete Art," 59.

20. Mari Carmen Ramírez, *Hélio Oiticica: The Body of Color* (Houston: Museum of Fine Arts, Houston 2007), 35.

21. Ana Maria Belluzzo, "The Rupture Group and Concrete Art," in Ramírez and Olea, *Inverted Utopias*, 203.

22. Ferreira Gullar, "Manifesto neoconcreto," *Jornal do Brasil* (Rio de Janeiro), March 22, 1959, Sunday supplement: 4–5; republished in English in *Inverted Utopias*, 496–97.

23. Ferreira Gullar, "Teoria do não-objeto," *Jornal do Brasil* (Rio de Janeiro), November 21, 1960, Sunday supplement; republished in English in Ramírez and Olea, *Inverted Utopias*, 521–22.

24. Ibid.

25. Irene Small, "Morphology in the Studio: Hélio Oiticica at the Museu Nacional," *Getty Research Journal* 1 (February 2009): 107–26.

1911–12
Proto-Cubist Beginnings

Juan Gris was born in 1887 in Madrid as José Victoriano Carmelo Carlos González Pérez. He received an education in engineering in his hometown at the Escuela de Artes e Industrias, which he left after only two years to take private lessons with local painters José Moreno Carbonero and Cecilio Plá. Around this time, he started to earn his living as an illustrator for various magazines and continued to do so after his move to Paris in 1906. Upon his arrival in the French capital, he permanently changed his name to Juan Gris (John Gray) to create a new artistic identity—paradoxically choosing a name that was anything but remarkable. Gris moved into the infamous residence for artists known as the Bateau-Lavoir in Montmartre, and became the neighbor and friend of Pablo Picasso and the writer Maurice Raynal, both of whom would be influential for his career. In 1909, Georges González-Gris, his only child, was born, but Gris would soon thereafter separate from his first wife Lucie Belin, and the boy was sent to Madrid to live with Gris's sister.

In 1910, at the age of twenty-three, Gris started to paint and produced a series of naturalistic watercolors. Under the influence of Paul Cézanne and having admired the work of Cubist artists—many of whom were his close friends—since the movement's initial phase in 1907, he began to change his style in 1911. Cézanne had often treated the objects in his still lifes as geometric shapes, building them from cones, cylinders, or spheres. Gris approached his first proto-Cubist works in a similar vein, using a rigorous, geometric, grid-like structure as the framework for his paintings. The application of diamond-shaped faceting to objects in these still lifes is especially striking and makes them appear as if seen through a prism. Unlike Cézanne's relatively naturalistic tones, *Jar, Bottle, and Glass* (cat. 1) and *Table at a Café* (cat. 2) both have a monochromatic color scheme, which was most likely inspired by Picasso and Georges Braque's Analytic Cubism. Yet compared to his fellow artists' paintings, Gris's metallic palette gives these works a cooler appearance overall, with the distinction between the background and the foreground remaining intact and the objects somewhat recognizable, as if emerging from

a metallic fog. With these early works, he introduced important reoccurring motifs such as the glass, the bottle, and the jar, to which he added fruit dishes, books, coffee pots, lamps, stringed instruments, and later, newspapers and playing cards. In *Still Life with Flowers* (cat. 3) Gris expanded his palette to include red and yellow. Unlike its predecessors, this painting does not appear as an inventory of objects. Here Gris placed the elements on the middle of a clearly visible table, adding a spatial impression and thus creating a centralized composition.

In 1912, Gris had his first exhibition with fifteen works at the art dealer Clovis Sagot's Paris gallery, and three of his paintings were included at the Salon des Indépendants in the same section as the other Cubists. In October, he exhibited at the first Salon de la Section d'Or with the Puteaux group, a circle of artists who organized their works according to mathematical principles and with whom Gris exchanged artistic ideas. These accomplishments led to his first exclusive contract with the Paris-based German gallerist Daniel-Henry Kahnweiler, a champion of Cubism and Picasso and Braque's dealer.

Notes

Unless otherwise indicated, the sources for these short texts are:

Daniel-Henry Kahnweiler, *Juan Gris: His Life and Work*, trans. Douglas Cooper (New York: Harry N. Abrams, 1968).

Christopher Green, "Synthesis and the 'Synthetic Process' in the Painting of Juan Gris 1915–19." *Art History 5*, no. 1 (March 1982): 87–105.

Christopher Green, Christian Derouet, and Karin von Maur, *Juan Gris* (London: Whitechapel Art Gallery, 1992).

Paloma Esteban Leal, "A Contained Passion," in *Juan Gris: Paintings and Drawings 1910–1927* (Madrid: Museo Nacional Centro de Arte Reina Sofía, 2005).

James T. Soby, *Juan Gris* (New York: Arno Press, 1958).

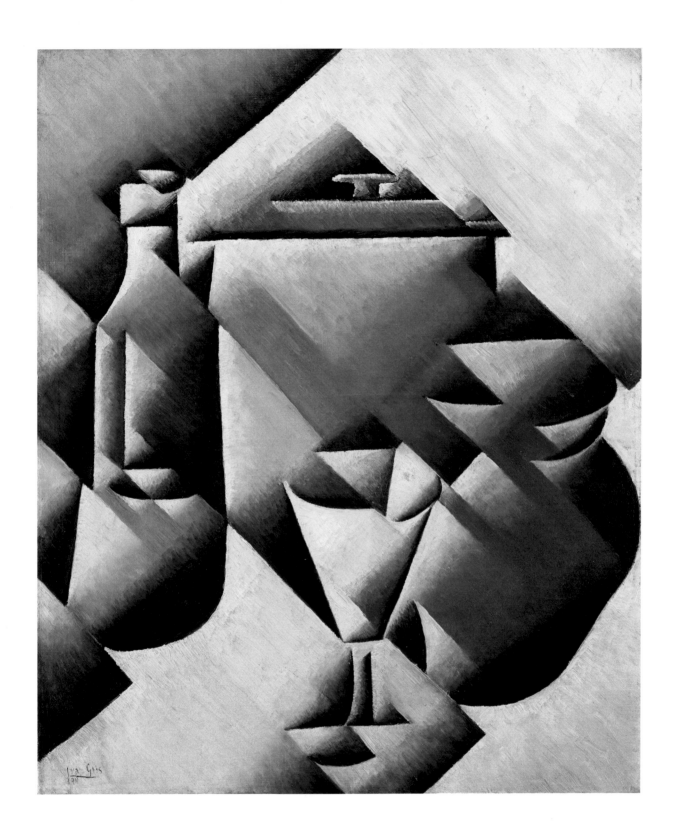

1 | **Jar, Bottle, and Glass**, 1911
Oil on canvas
23½ × 19¾ in. (59.7 × 50.2 cm)
The Museum of Modern Art, New York. Acquired
through the Lillie P. Bliss Bequest (by exchange), 1941

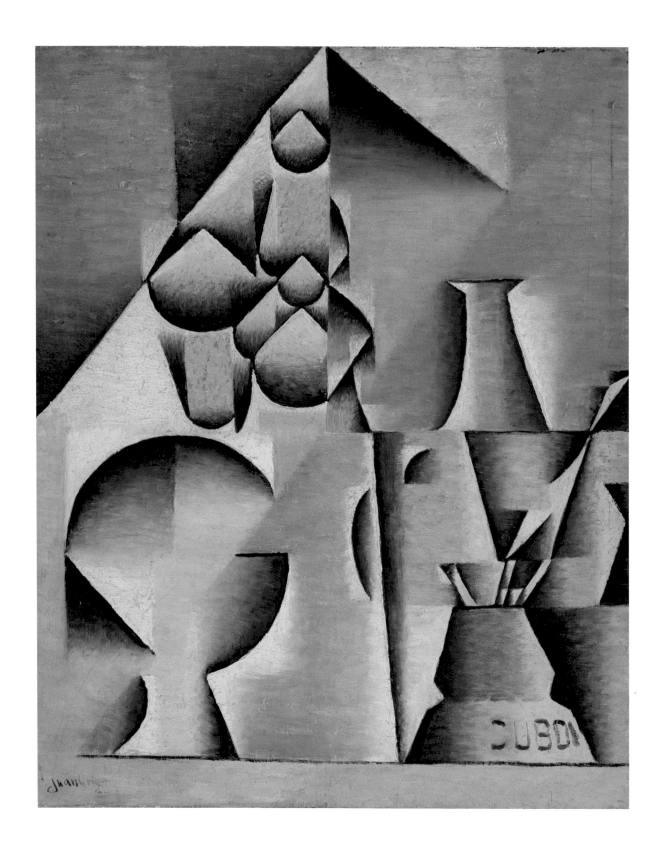

2 | **Table at a Café**, 1912
Oil on canvas
18 × 14⅞ in. (45.7 × 37.8 cm)
The Art Institute of Chicago,
Bequest of Kate L. Brewster, 1950.122

3 | **Still Life with Flowers**, 1912
Oil on canvas
44⅛ × 27⅝ in. (112.1 × 70.2 cm)
The Museum of Modern Art, New York. Bequest of Anna Erickson Levene
in memory of her husband, Dr. Phoebus Aaron Theodor Levene, 1947

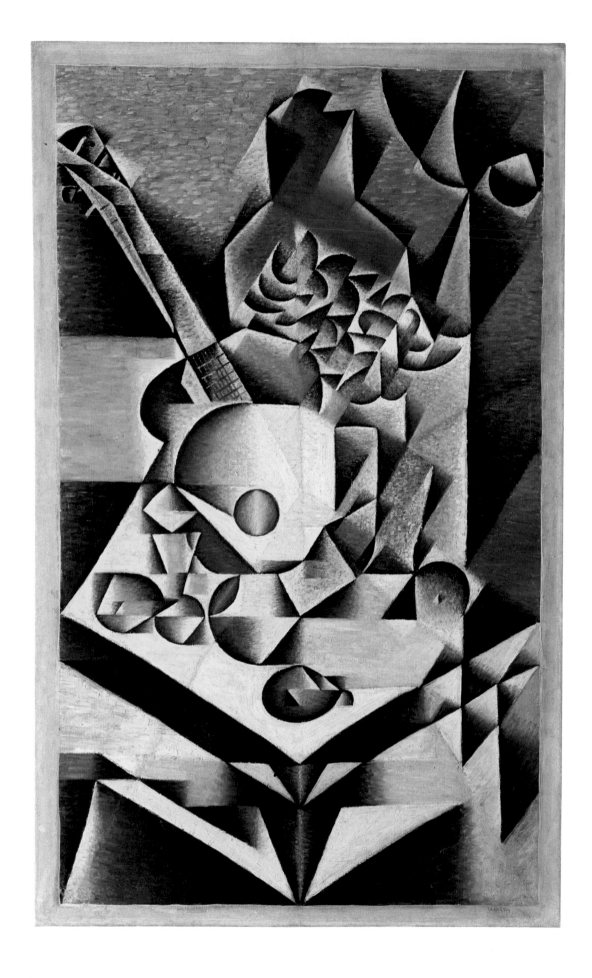

1913–14
Fragmentation

During the second half of 1912, Gris started to experiment with new styles. Braque and Picasso had by this time introduced a collage technique to Cubism that was known as *papier collé*, incorporating pieces of cut-out newspaper, pages from books, or wallpaper into their drawings. Gris included unconventional material for the first time in the 1912 work *The Washstand* (fig. 2, p. 15), where he glued actual shards of mirror to denote the mirror over the sink, but he did not fully experiment with the technique until 1913. Additionally, he began to introduce vibrant color into his works, which would quickly distinguish him as a master colorist among his fellow Cubists.

The works from 1913, a transitional year for Gris, are characterized by his use of bands or strips that fragment the objects. At first, he composed these bands in purely vertical arrangements, and over time progressively fanned them out. As a result, these paintings look as if Gris has cut the works into strips and then put them back together while shifting them up and down against each other. Paying close attention to details of color, material, and substance, he combined fragmentation with elements of collage and trompe-l'oeil techniques. In *Guitar and Pipe* (cat. 5a–5b), Gris alternated bands of tonal gradations and subdued colors like black or darker blues with naturalistically rendered still-life objects, thus contrasting illusionistic passages with flat patches of color. In these works, Gris applied the compositional strategies of Analytic Cubism, depicting objects simultaneously from various perspectives; at the same time he introduced elements of Synthetic Cubism, eliminating traces of three-dimensional representation. *The Siphon* (cat. 7) exemplifies this mixture of styles, while also showing how the artist continued to resist fully adopting the Synthetic approach. The canvas shows a marbleized bistro table and the slim bent back of a chair in front of faux-bois wallpaper. Placed on the table are a variety of objects, difficult to identify and represented through repeating white lines on the blue background. The tap of the siphon is modeled through the reflection of light on its metallic surface, with Gris still including some elements of three-dimensionality in the work. By playing with notions of realism

and illusion, Gris tricks the viewer in such compositions. He relies on the imitation of materials like wood paneling or marble through trompe-l'oeil techniques, while at the same time subtly incorporating real-life objects in other works—for example pages from the 1834 novel *Le Bourreau du Roi* by Roland Bauchery in *The Book* (cat. 4), or the wallpaper and playing card in *Playing Cards and Glass of Beer* (cat. 6).

For the first time since his arrival, Gris left Paris in the summer of 1913 and spent a few months in the South, in Collioure, near Céret, in the French Pyrenees. He was accompanied by his new partner, Josette Herbin, who had moved into his studio the previous winter. The works he produced there show a new luminosity in color, inspired by the region's Mediterranean light, as well as a transition from vertical strips to angular planes. The return to Paris was marked by an abundance of color, as well as the comeback of the grid in the form of the checkerboard and an increasing fragmentation of objects. The checkerboard in *Grapes* (cat. 9), for example, is a complex structure of overlapping modules that denies the viewer a simple grasp of the interrelationships of the painting's individual elements.

In 1914 Gris continued to develop his strategies of fragmentation, and his experiments with collage culminated in a series of *papiers collés* created between late spring and fall. His compositions from this time are complex, as the glued-on components are not merely foreign elements meant to disrupt the viewing experience, but rather are integral parts of the image. Unlike what we see in *papiers collés* by Picasso, for Gris the added elements represent just what they are—such as wallpaper—rather than signifying other subjects. Furthermore, he drew and painted over the pasted papers and let the pictorial elements overlap. *Still Life: The Table* (cat. 11) incorporates no less than four collage items: floral-printed and faux-bois wallpapers, pages from a book, and newspaper. Gris made use of the oval as the central element of this work, as did other fellow Cubists. As a result, the empty margins of the table appear to be in the dark, while the center is illuminated and the various objects are clearly visible. The flatness of the image is broken by the trompe-l'oeil element of the cigarette on the newspaper whose modeling indicates its three-dimensionality. The headline of the newspaper, *Le Journal,* reads "Le Vrai et le Faux" (The True and the False), providing the motto for the collage as well as his practice in general.

In June, Gris left Paris again for Collioure; when the First World War broke out in August, he and Josette became stranded. While Gris, as a Spaniard, did not have to serve in the military, many of his friends, including Braque, Maurice Raynal, and Guillaume Apollinaire, were mobilized and sent to the front. As a German citizen, Kahnweiler, who was traveling in Italy at that time, was forced into exile and finally settled in Switzerland. Over the following months, Gris's financial situation steadily worsened, as his exclusive contract with Kahnweiler prohibited him from selling his works directly. He and Josette had to rely on the generosity of others to survive. Henri Matisse, who also spent his summer in the South of France, became an important friend and contact during that time.

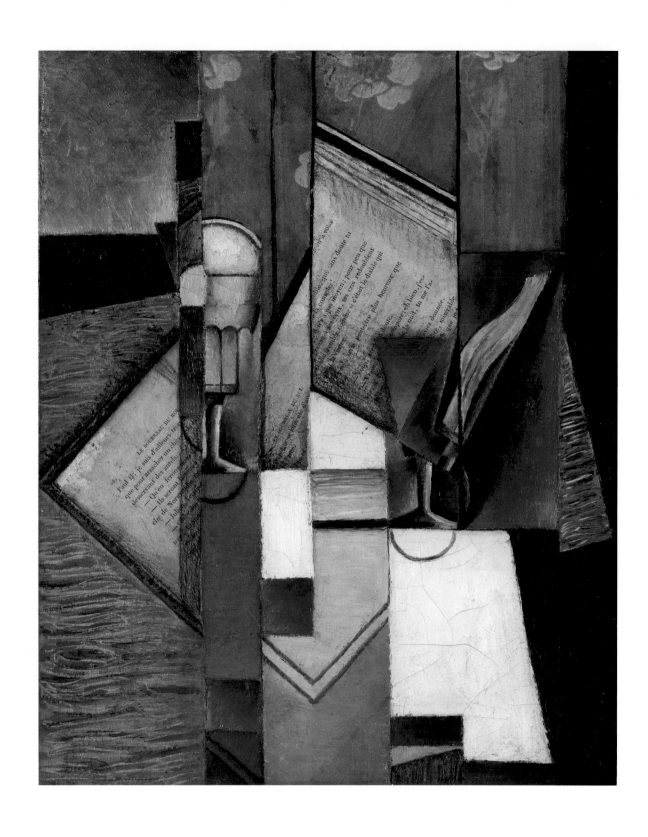

4 | **The Book**, 1913
Oil and collage on canvas
16⅛ × 13⅜ in. (41 × 34 cm)
Musée d'Art Moderne de Paris, Gift of Henry-Thomas in 1976

5a | **Guitar and Pipe** (recto), 1913
Oil and charcoal on canvas
25⅝ × 19¾ in. (65.1 × 50.2 cm)
Dallas Museum of Art, The Eugene and Margaret
McDermott Art Fund, Inc., 1998.219.A–B.McD

5b | **Guitar** (verso), 1913
Oil, charcoal, and wallpaper on canvas
25⅝ × 19¾ in. (65.1 × 50.2 cm)
Dallas Museum of Art, The Eugene and Margaret
McDermott Art Fund, Inc., 1998.219.A–B.McD

6 | **Playing Cards and Glass of Beer**, 1913
Oil and collage on canvas
21⅝ × 14⅞ in. (54.9 × 37.8 cm)
Columbus Museum of Art, Ohio: Gift of Ferdinand Howald,
1931.061

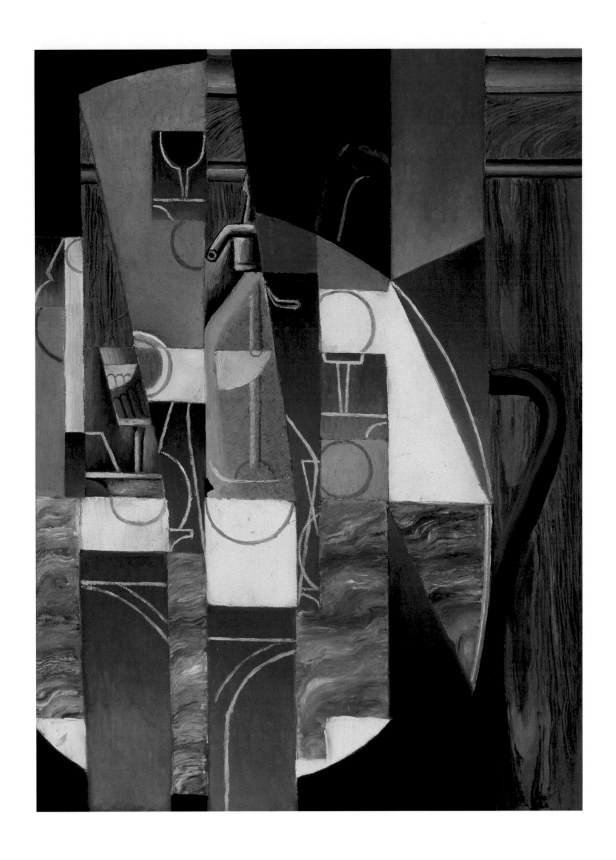

7 | **The Siphon**, 1913
Oil on canvas
32 × 23⅝ in. (81.3 × 60 cm)
Rose Art Museum, Brandeis University, Waltham,
Massachusetts, Gift of Edgar Kaufmann, Jr.

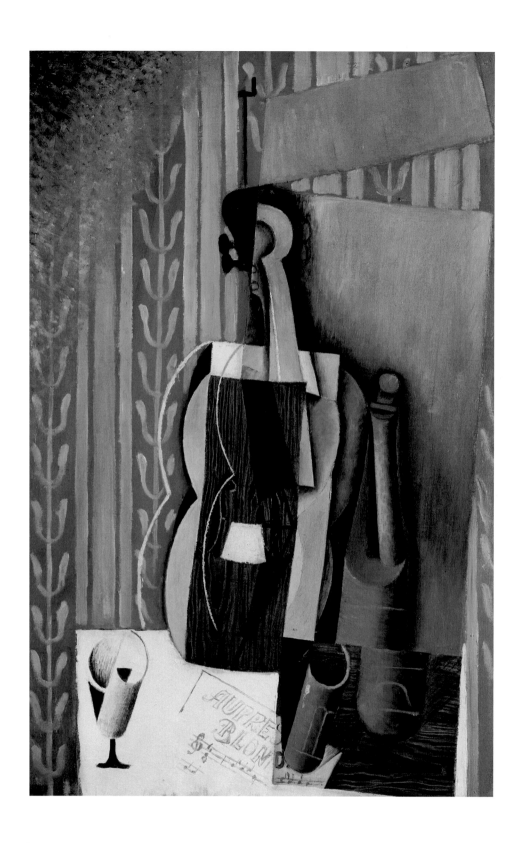

8 | **Violin**, 1913
Oil on canvas
36¼ × 23⅝ in. (92.1 × 60 cm)
Philadelphia Museum of Art: A. E. Gallatin Collection, 1952-61-34

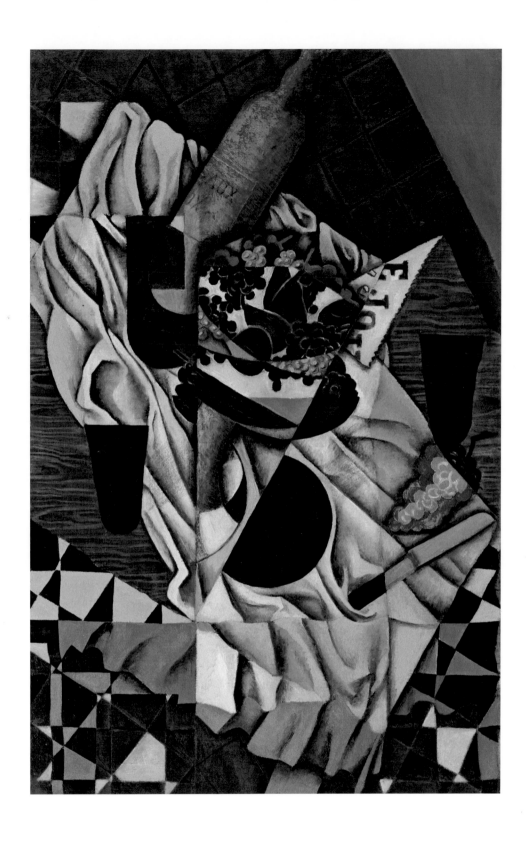

9 | **Grapes**, 1913
Oil on canvas
36¼ × 23⅝ in. (92.1 × 60 cm)
The Museum of Modern Art, New York. Bequest of
Anna Erickson Levene in memory of her husband,
Dr. Phoebus Aaron Theodor Levene, 1947

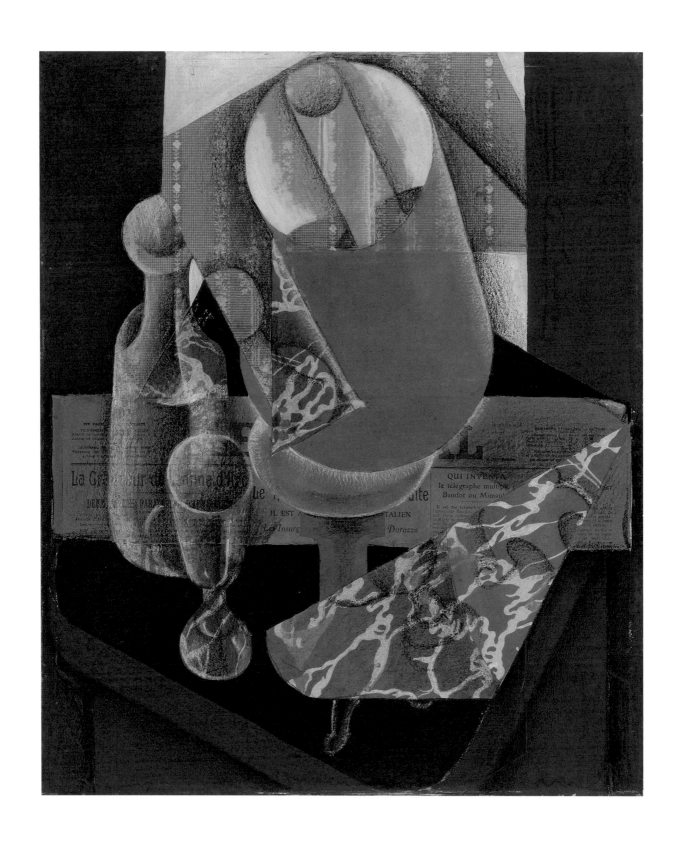

10 | **The Lamp**, 1914
Pasted papers, gouache, and conté
crayon on canvas
21¾ × 18¼ in. (55.2 × 46.3 cm)
Private collection

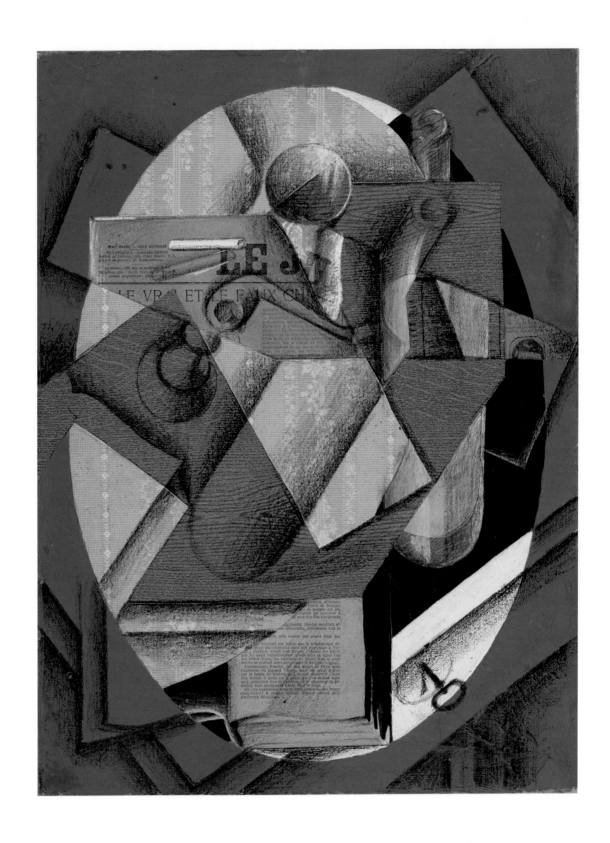

11 | **Still Life: The Table**, 1914
Collage of plain and printed papers with opaque watercolor and
crayon, on paper mounted on canvas
23½ × 17½ in. (59.7 × 44.5 cm)
Philadelphia Museum of Art: A.E. Gallatin Collection, 1952-61-43

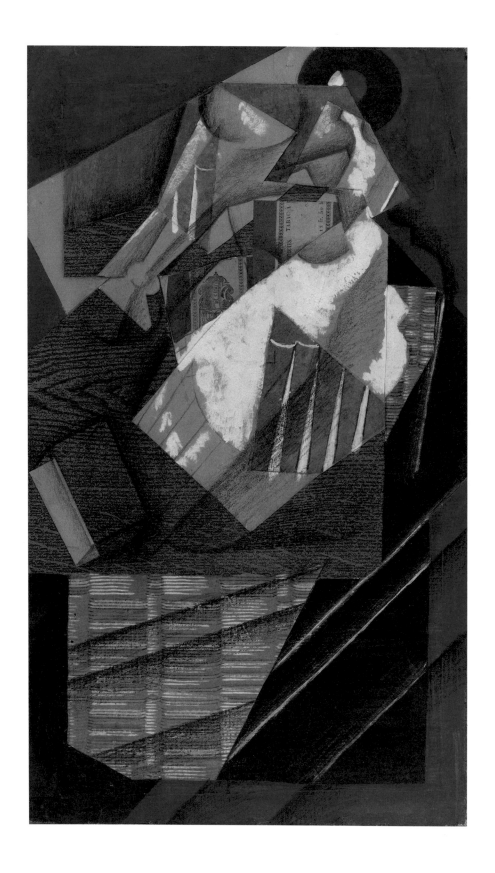

12 | Carafe, Glass, and Packet of Tobacco, 1914
Pasted paper, gouache, and charcoal on canvas
18¼ × 10¾ in. (46.4 × 27.3 cm)
Virginia Museum of Fine Arts, Richmond, T. Catesby Jones Collection

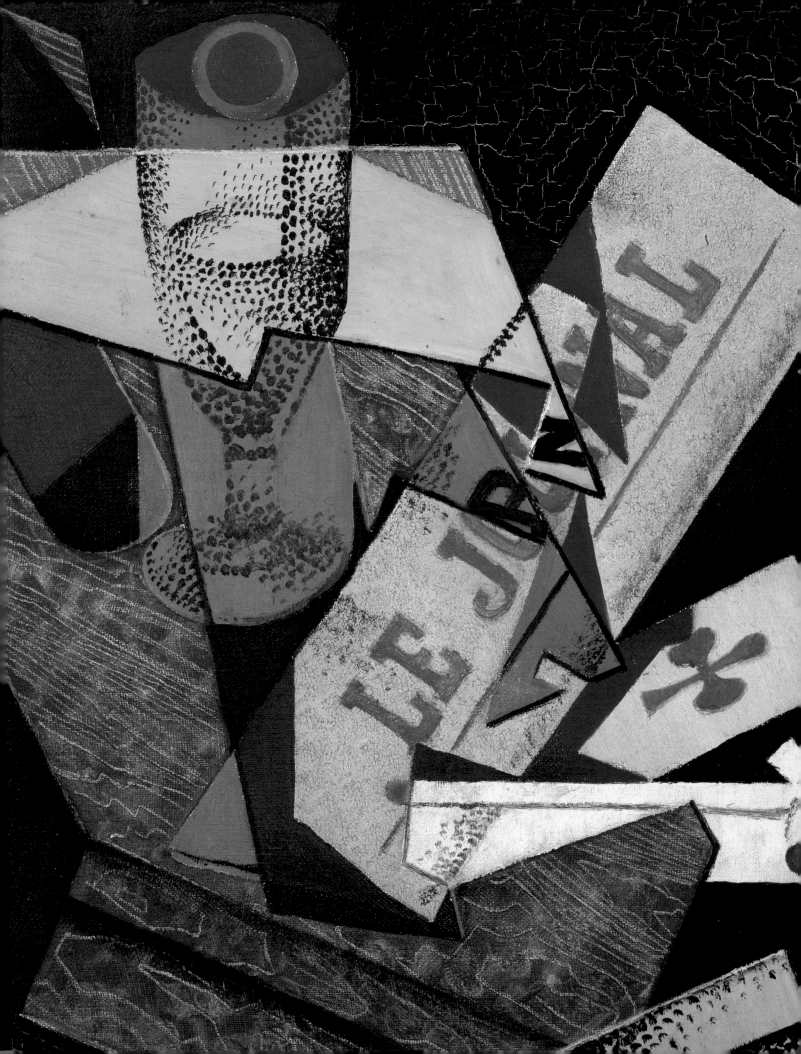

1915–16
Color and Luminosity

In November 1914, Gris was finally able to return to Paris. Following an abrupt halt in communication with the exiled Kahnweiler, he entered into a new contract with the dealer Léonce Rosenberg, another important champion of Cubism. After his extensive experiments with *papier collé* and collage, Gris stopped using this technique in late 1914. This led in 1915 to a shift towards a more Synthetic style in which he gradually stepped away from the multiple viewpoints of Analytic Cubism, and tried to emphasize the readability of the elements. Applying the lessons learned from *papier collé*, he started working with multilayered structures, covering each overlapping plane with objects, as seen in *Still Life with Checked Tablecloth* (fig. 11, p. 33). Volume and the illusion of depth were achieved through shading, and he deemphasized multi-perspective depiction. In June of 1915, he painted the view from his Bateau-Lavoir studio in *Still Life before an Open Window, Place Ravignan* (cat. 13), one of his most iconic works, not least because he was the first Cubist to depict a still life set before an open window. Within one composition, Gris combines an indoor and an outdoor scene, with an elaborate still life on a table in the foreground and a simple street scene in the background. The transition from one space into the next is not achieved through perspective, but rather by the chromatic contrast between the night scene rendered in a cold blue and the warmer colors of the interior, as well as the interconnected planes that fuse background and foreground. This leads to the illusion that the two spaces co-exist as a harmonious whole.

Gris continued to work with multiple overlapping planes and introduced cutout shapes and silhouettes, as well as heavily textured passages of paint, in a series of smaller paintings that includes *Ace of Clubs and Four of Diamonds* (cat. 14) and *Abstraction* (cat. 15). The use of stippling in these paintings to denote glass, which can be read as a pictorial translation of either transparency or light, would return more prominently in the works of the following year.

The colorful painting *Fantômas* from August 1915 (cat. 17) shows a continuation of the use of faux bois and the checkerboard, which could represent a

variety of things, including floor tiles, a chessboard, or a tablecloth. Gris also returned to the white contour he had employed in earlier works, but here it becomes a dominant feature, representing the glass, the fruit dish filled with pears, and the newspaper. The various planes seem to play hide and seek with the objects, while the shadows and black fields provide a sense of depth. The title offers a reference to popular culture, a source he sporadically included in his works up until this point, but would abandon thereafter. The well-liked series of novels featuring the fictional criminal genius Fantômas delighted many during the pre-war period, including Gris and other Parisian avant-garde artists like Picasso.

In a letter to Kahnweiler from December 14, 1915, Gris voiced his concern that his works were missing a "sensuous and sensitive side."[1] In order to bring these qualities into his paintings, Gris started to experiment and produced the most colorful and luminous works of his career. In the paintings of the first three months of 1916, Gris made extensive use of a Pointillist technique, producing a small group of works that are among his most abstract. At this moment, when he was becoming increasingly interested in the depiction of light in various forms—a predominant concern from this point forward— stippling helped Gris to depict the incidence of light or the transparency of objects. In *Glass on Table* (cat. 18) and *Glass and Newspaper* (cat. 16), the play of light and shadow on objects such as glasses or bottles are painted with small, irregular dots. The stippling remains confined to the objects or smaller areas, and the works remain highly legible. As the series progresses, the dots are increasingly used on larger surfaces to show light or as a means to convey atmosphere, which makes the two paintings both titled *Newspaper and Fruit Dish* (cat. 20–21) some of Gris's least figurative works. In the most extreme instances of this technique, objects no longer have contours, but are composed entirely of stippling—as seen in the wine bottle in *Fruit Dish and Bottle* (cat. 19).

Notes

1. Gris to Kahnweiler, December 14, 1915, in Douglas Cooper, trans. and ed., *Letters of Juan Gris [1913–1927]. Collected by Daniel-Henry Kahnweiler* (London, 1956), 33.

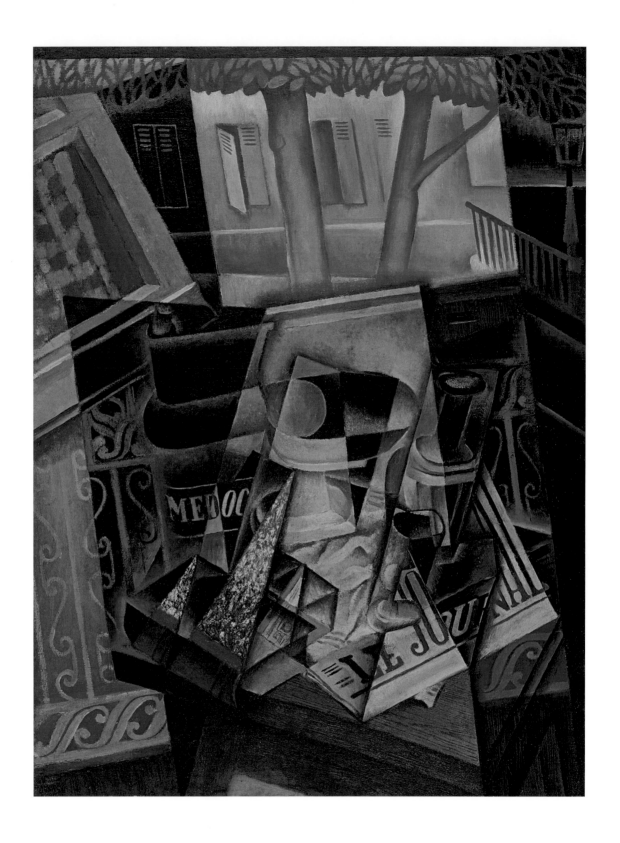

13 | **Still Life before an Open Window,
Place Ravignan**, 1915
Oil on canvas
45⅝ × 35 in. (115.9 × 88.9 cm)
Philadelphia Museum of Art: The Louise and Walter
Arensberg Collection, 1950-134-95

14 | **Ace of Clubs and Four of Diamonds**, 1915
Oil and fine wood particles on laminated paperboard
12 × 6½ in. (30.5 × 16.5 cm)
National Gallery of Art, Washington, D.C.,
Gift of Robert and Mercedes Eichholz, 2014.17.12

15 | **Abstraction**, 1915
Oil and oil with sand on cardboard
11⅜ × 7¾ in. (28.9 × 19.7 cm)
The Phillips Collection, Washington, D.C.,
Acquired 1930

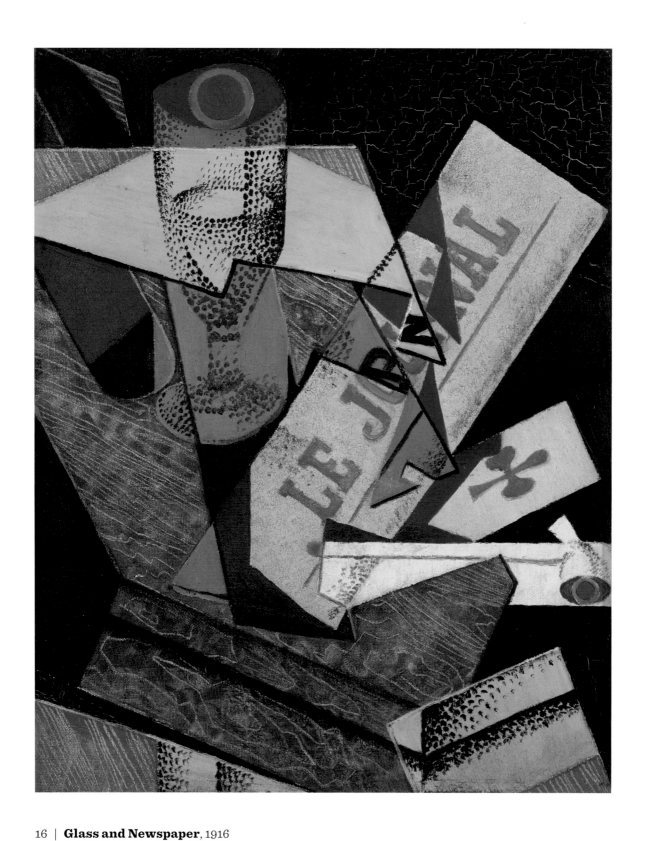

16 | **Glass and Newspaper**, 1916
Oil on canvas
16⅛ × 13 in. (59.8 × 73.3 cm)
Centre Pompidou, Paris, Musée national d'art moderne/Centre de
création industrielle. Gift of Louise and Michel Leiris, 1984
Not exhibited

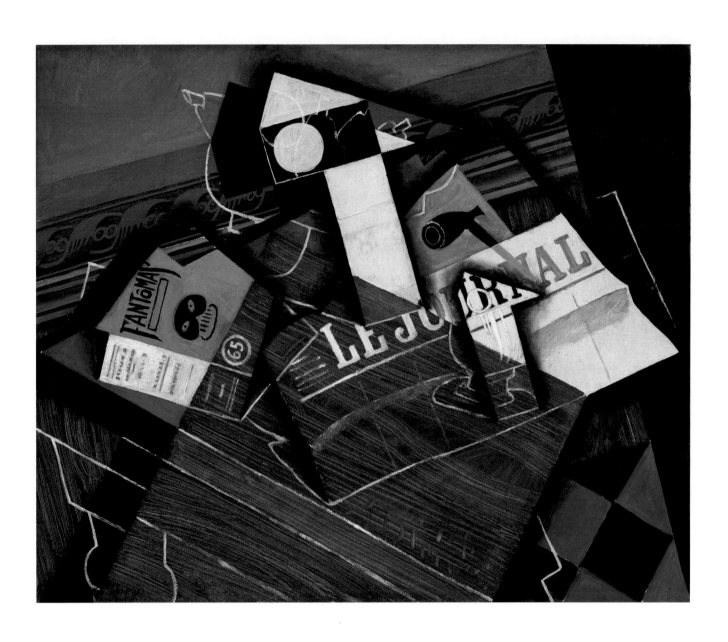

17 | **Fantômas**, 1915
Oil on canvas
23¾ × 28⅞ in. (59.8 × 73.3 cm)
National Gallery of Art, Washington, D.C., Chester Dale Fund, 1976.59.1

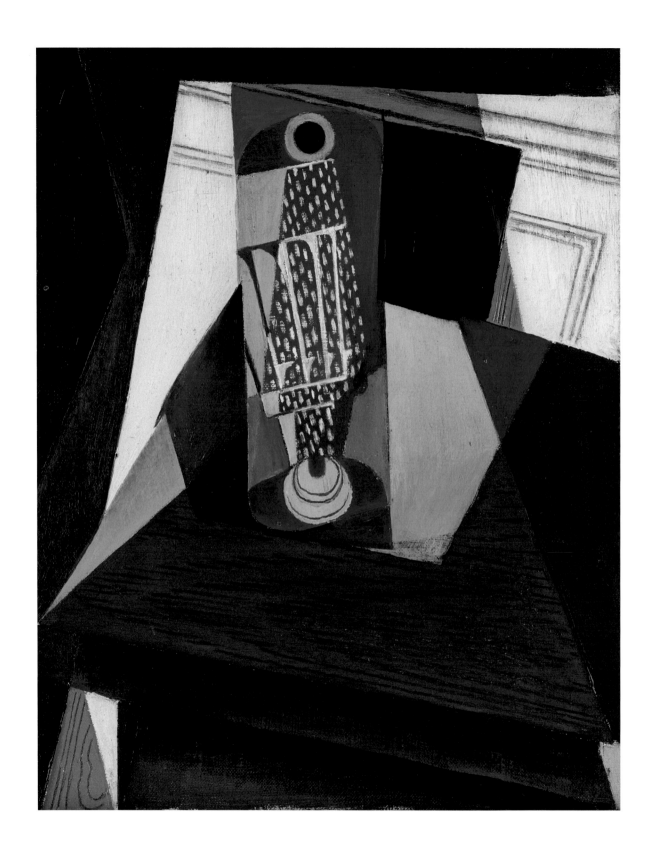

18 | **Glass on Table**, 1916
Oil on canvas
16 × 12⅝ in. (40.6 × 32.1 cm)
Denver Art Museum Collection: Charles Francis
Hendrie Memorial Collection, 1966.169

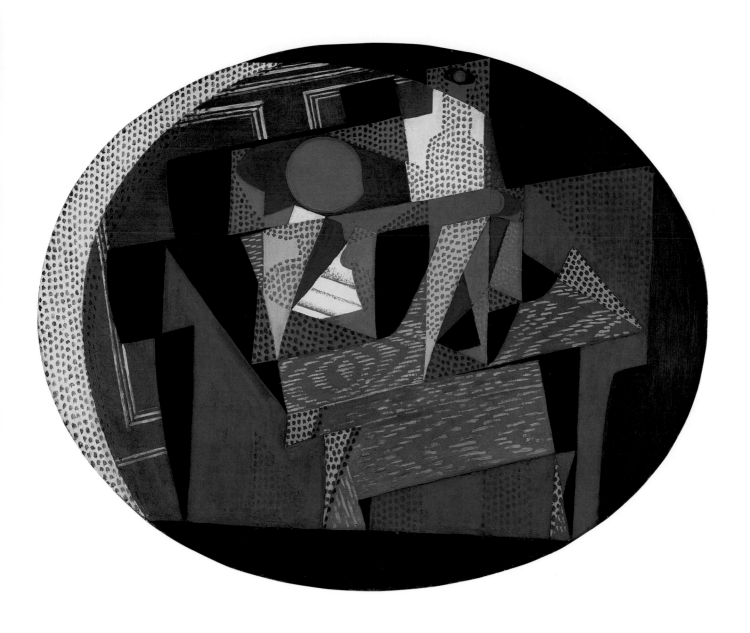

19 | **Fruit Dish and Bottle**, 1916
Oil on canvas
Oval: 25⅝ × 31⅞ in. (65.1 × 81 cm)
Gift of Joseph Brummer, Smith College Museum of Art,
Northampton, Massachusetts, SC 1921.8.4

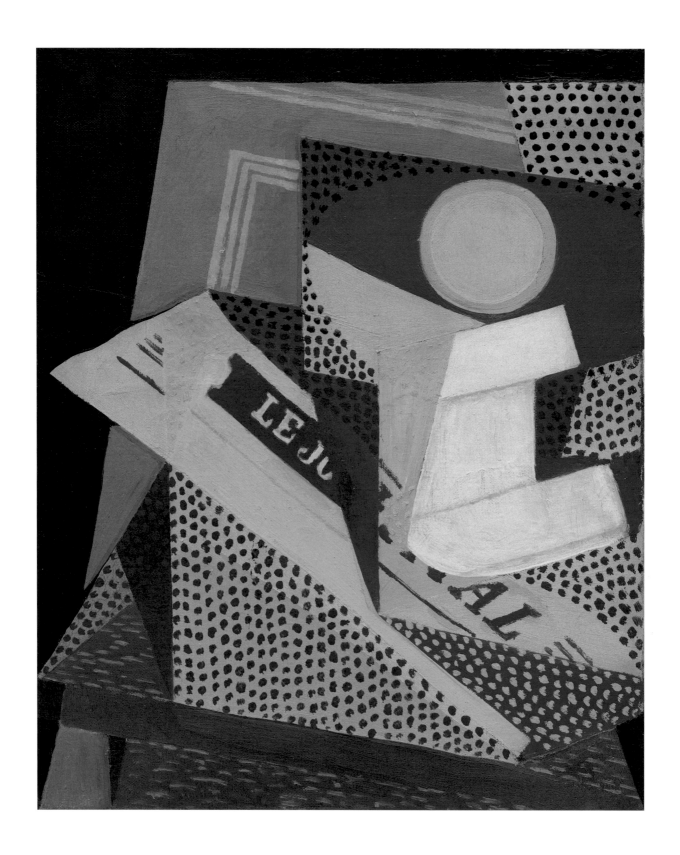

20 | **Newspaper and Fruit Dish**, 1916
Oil on canvas
18³⁄₈ × 15 in. (46.7 × 38.1 cm)
Solomon R. Guggenheim Museum, New York,
Gift, Estate of Katherine S. Dreier, 1953, 53.1341

21 | **Newspaper and Fruit Dish**, 1916
Oil on canvas
37 × 24 in. (94 × 61 cm)
Yale University Art Gallery,
Gift of Collection Société Anonyme

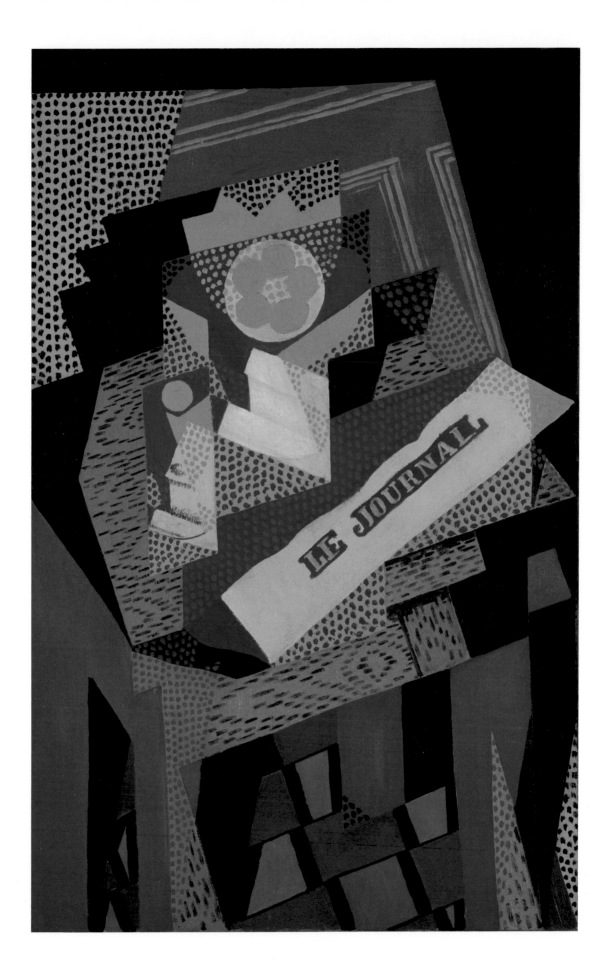

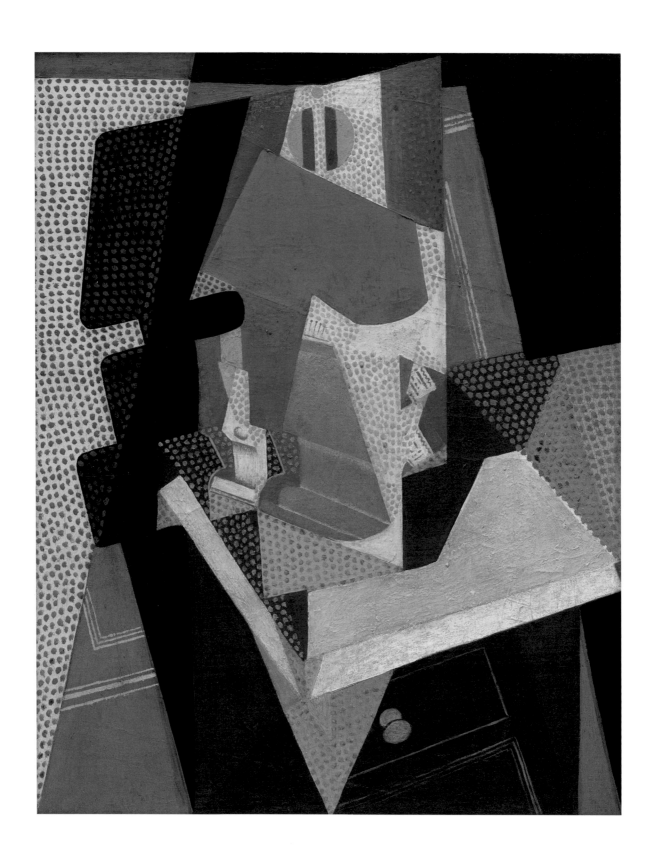

22 | **Lamp**, 1916
Oil on canvas
31⅞ × 25½ in. (81 × 64.8 cm)
Philadelphia Museum of Art: The Louise and
Walter Arensberg Collection, 1950-134-96

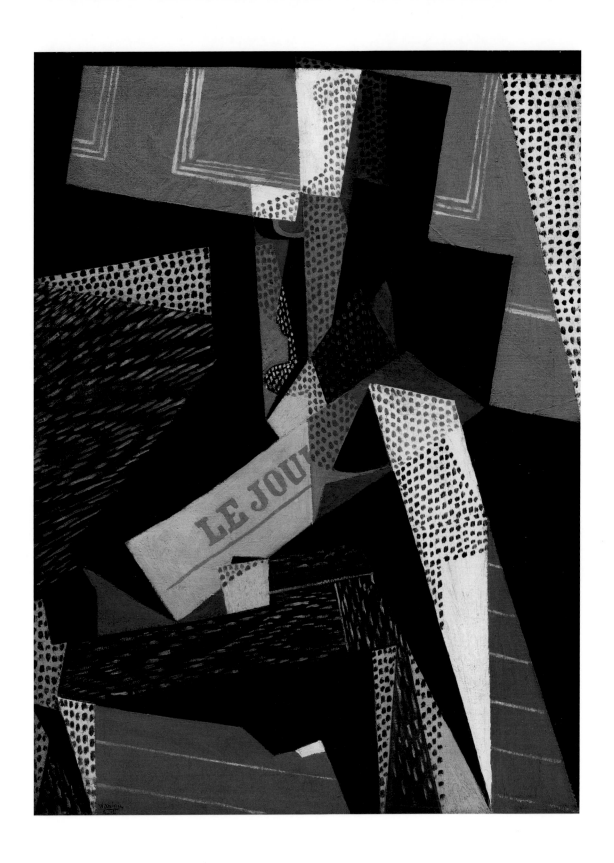

23 | **Still Life**, 1916
Oil on canvas
31¾ × 23½ in. (80.6 × 59.7 cm)
Detroit Institute of Arts, Founders Society Purchase with
funds from the Dexter M. Ferry, Jr. Trustee Corporation

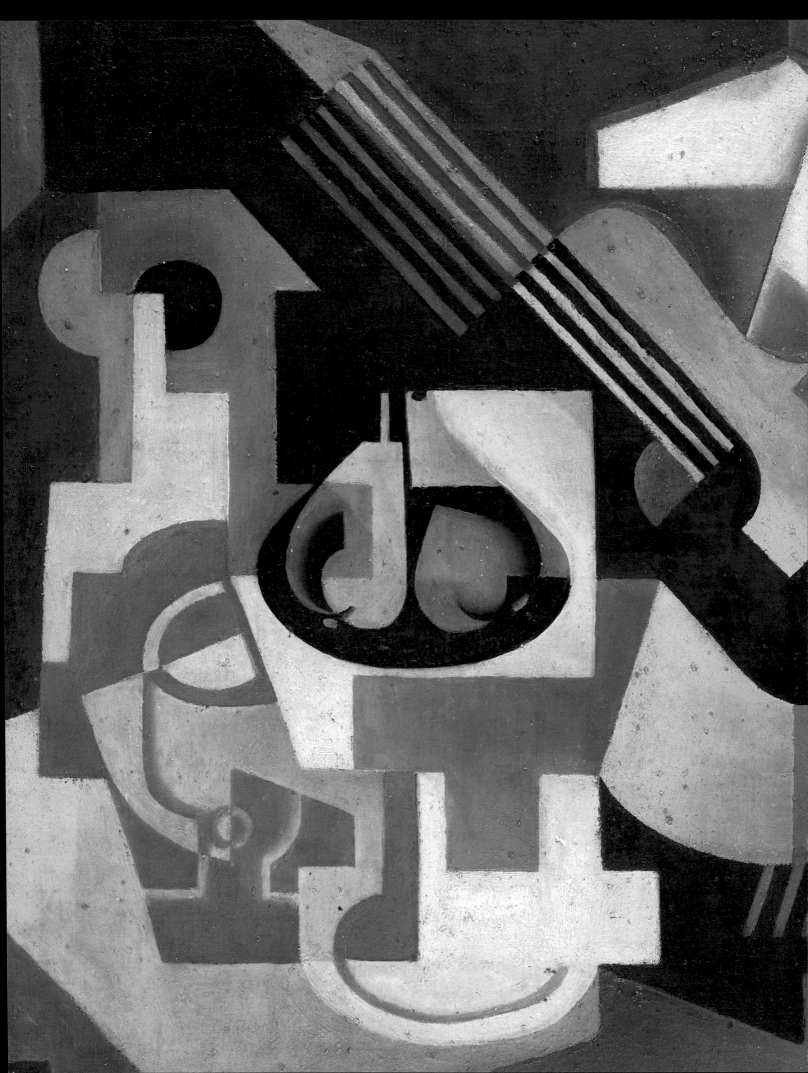

1916–19
Classical Cubism

After only a few months, Gris abruptly stopped using the Pointillist technique in the spring of 1916 and started working in a new direction. He moved away from linear drawing and the use of planes, and turned toward depicting still-life objects with more monochromatic areas of color and basic geometric shapes embellished by volumetric modeling. Applying the chiaroscuro technique that he had first employed in 1912 with his diamond faceting, Gris used black both as a prominent compositional element and also to convey volume, all of which can be seen in *The Coffee Mill* (cat. 24). Gris also introduced pictorial forms that represent objects such as glasses, cups, or bottles by simply implying them, so that these emblems come to stand for the real objects. Additionally, he looked back at revered artists like Jean-Baptiste-Camille Corot and Paul Cézanne, both copying and reinterpreting their works.

Perhaps in emulation of the austere still lifes that he admired by Francisco de Zurbarán, Gris focused on the arrangement of only a few objects and explored the effects of the absence of light in this period. *Still Life with Newspaper* (cat. 25) appears almost flat, as the light is focused on the center of the canvas and only a few objects are illuminated. The space outside the direct reach of the light source is mostly modeled in somewhat abstract black and grey color fields. In a possible further nod to seventeenth-century still lifes, Gris included a lemon in the composition, introducing a traditional motif and an unexpected splash of color.

Gris continued experimenting with overlapping planes in the first months of 1917, a culmination of his interest in the interplay between objects and different representational systems. *The Sideboard* (cat. 27) has light emanating from the left side and the resulting play between shadow and brightness creates an almost naturalistic illusion that is heightened by details such as the keyhole in the dresser. The faux-marble surface as well as the dresser and the wood paneling are painted in a realistic manner. The cluster of still-life objects, however, belongs to the realm of the synthetic, emblems that represent

Gris's own personal pictorial vocabulary. *Chessboard, Glass, and Dish* (cat. 28) operates in a similar manner.

Gris was vacationing in Beaulieu, Josette's hometown near Loches, where they first stayed the year before, when the war ended in 1918. After the Armistice, French artists responded in various ways to the end of the turmoil that the war had inflicted on Europe. The so-called "return to order" was part of the broader backlash against abstraction and resulted in the reappearance of traditional French cultural values, with artists embracing physical clarity and simplification in their work, as well as a reduced palette. This second phase of Cubism, alternatively called Classical Cubism or Crystal Cubism, and of which Gris was celebrated as the leader, is characterized by its emphasis on the purity and stability of form and composition. Gris's own work saw a gradual return to solidity during that time, inspired by his study of Corot, Cézanne, and Jean-Auguste-Dominique Ingres. The objects in *Bottle and Glass* (cat. 29) fuse together with the background, suggesting flatness rather than depth. Furthermore, shapes start to interlock, creating the impression of pieces in a jigsaw puzzle, as with *Guitar and Fruit Dish on a Table* (cat. 30). This is especially prominent in the guitar, where the illuminated top and darker bottom mesh into an F-shape. The shadow, which extends beyond the instrument, brings added ambiguity as it transitions into the background. Additionally, Gris moves towards a rhyming of forms, which can be seen in this work through the roundness of the sound hole of the instrument being repeated in the opening of the bottle as well as in the glass.

In 1919, Gris had his first retrospective exhibition at Rosenberg's Galerie de L'Effort Moderne, where he showed around fifty paintings from the years between 1916 and 1918. The works from 1919, such as *Still Life with a Bottle of Bordeaux* (cat. 32), display an increasing rhyming of forms that unifies the composition through the repetition of pictorial elements. In this painting, the oval of the opening of the wine bottle seemingly dances over the painting, offering guidance to the eye to move from the fruit on the top to the glasses and pipe on the bottom.

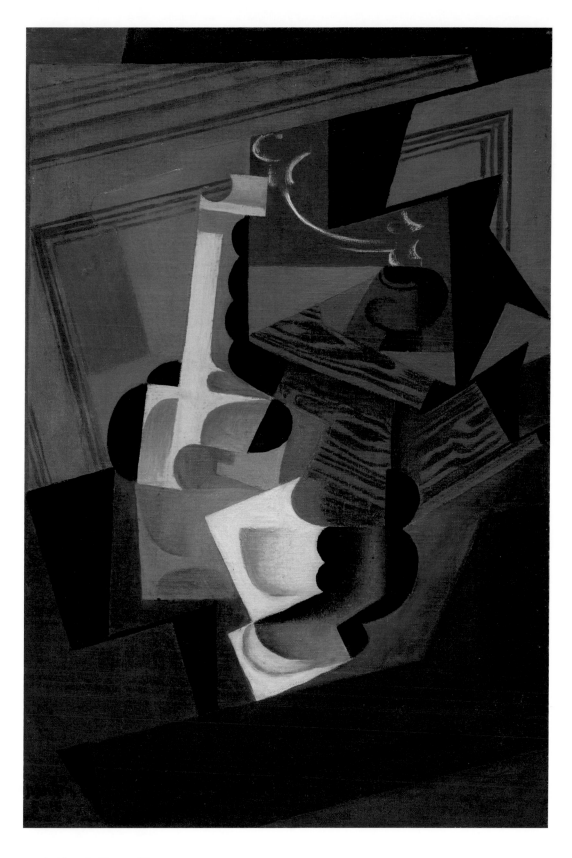

24 | **The Coffee Mill**, 1916
Oil on canvas
21⅝ × 15 in. (55 × 38.1 cm)
The Cleveland Museum of Art, Purchase from the J. H. Wade Fund, 1980.8

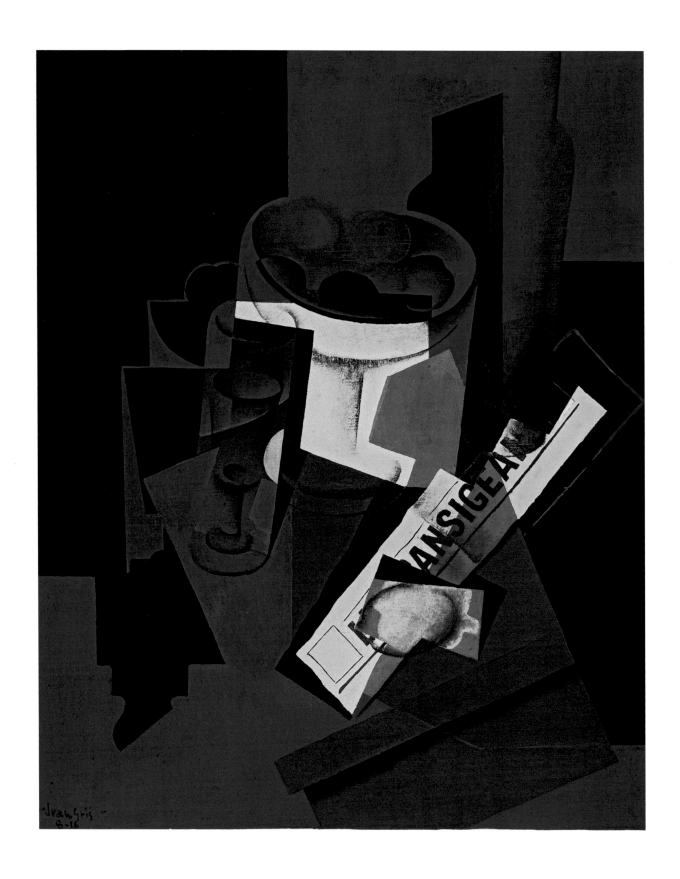

25 | **Still Life with Newspaper**, 1916
Oil on canvas
29 × 23¾ in. (73.7 × 60.3 cm)
The Phillips Collection, Washington, D.C., Acquired 1950

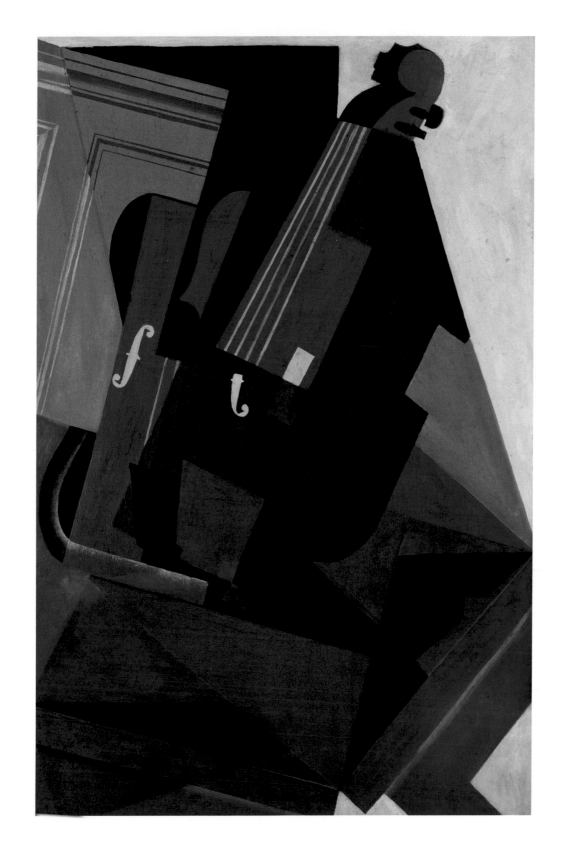

26 | **The Violin**, 1916
Oil on plywood
31½ × 21⅛ in. (80 × 53.7 cm)
Museo Nacional Centro de Arte Reina Sofía,
Madrid

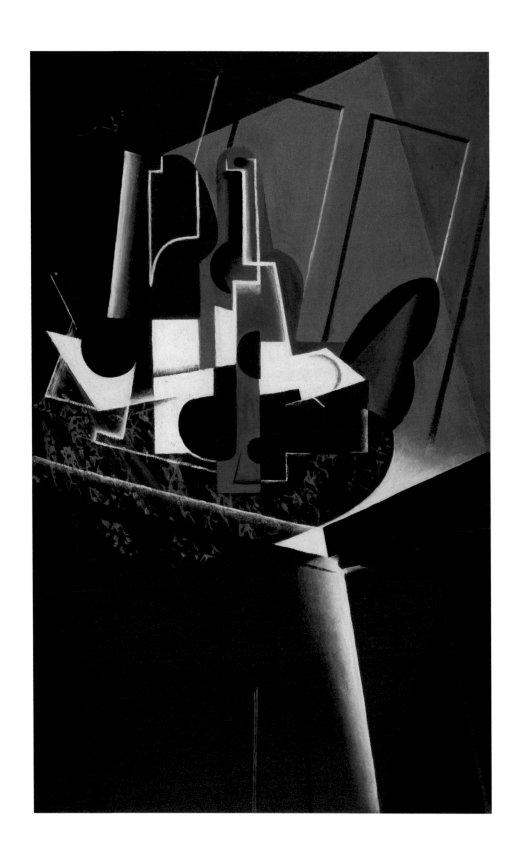

27 | **The Sideboard**, 1917
Oil on plywood
45⅞ × 28¾ in. (116.2 × 73.1 cm)
The Museum of Modern Art, New York.
Nelson A. Rockefeller Bequest, 1979

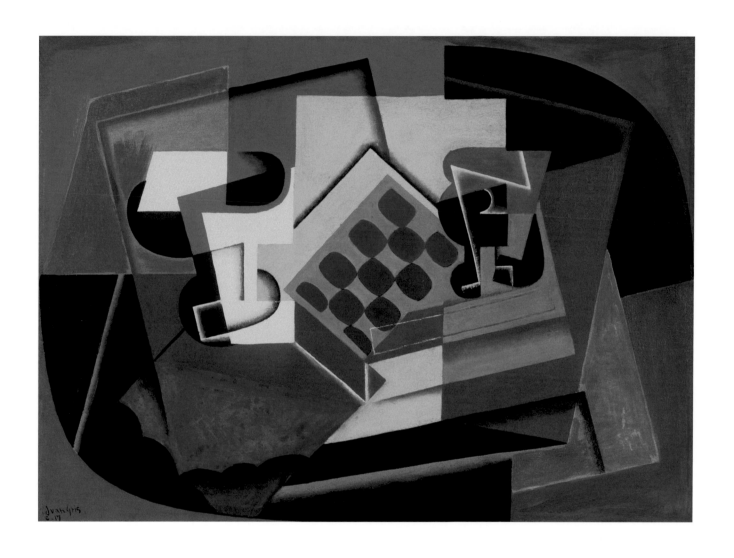

28 | **Chessboard, Glass, and Dish**, 1917
Oil on wood panel
28⅞ × 40⅝ in. (73.3 × 103.2 cm)
Philadelphia Museum of Art: The Louise and
Walter Arensberg Collection, 1950-134-98

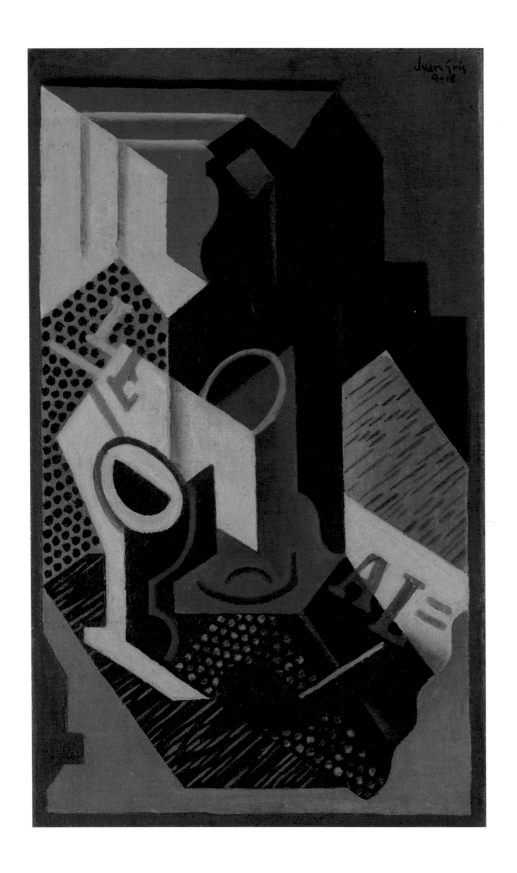

29 | **Bottle and Glass**, 1918
Oil on canvas
21½ × 13 in. (54.6 × 33 cm)
The Baltimore Museum of Art: Bequest of Saidie A. May, BMA 1951.305

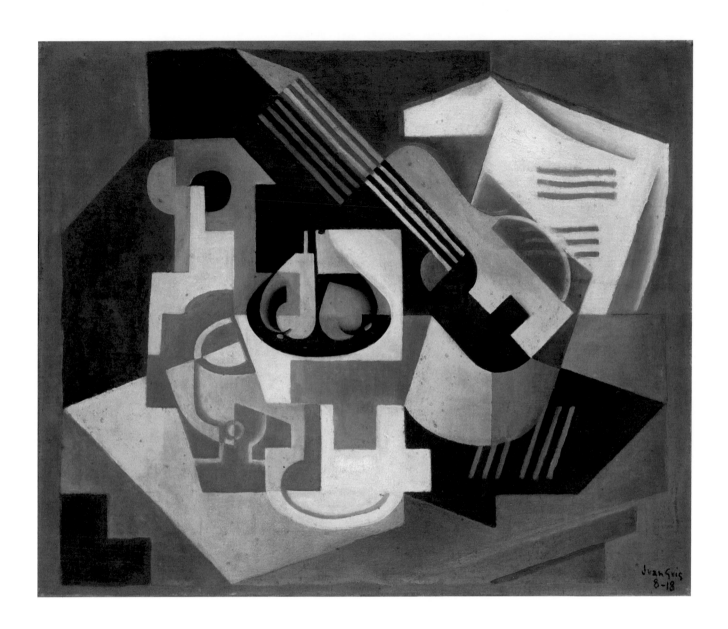

30 | **Guitar and Fruit Dish on a Table
(Guitar and Fruit Dish)**, 1918
Oil on canvas
23⅝ × 28¾ in. (60 × 73 cm)
Kunstmuseum Basel, Donation Dr. h.c. Raoul La Roche 1952

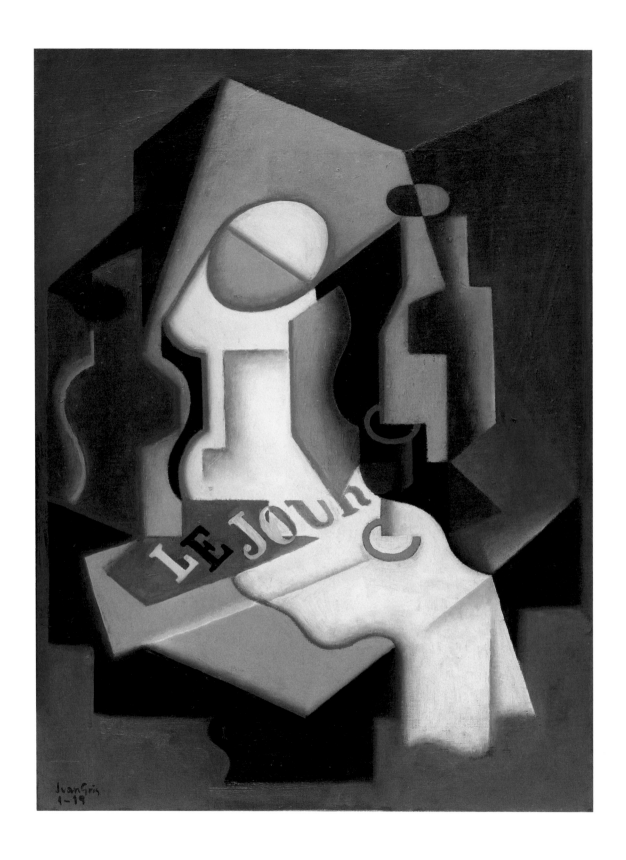

31 | **Bottle and Fruit Dish**, 1919
Oil on canvas
29⅛ × 21¼ in. (74 × 54 cm)
Museo Nacional Thyssen-Bornemisza, Madrid

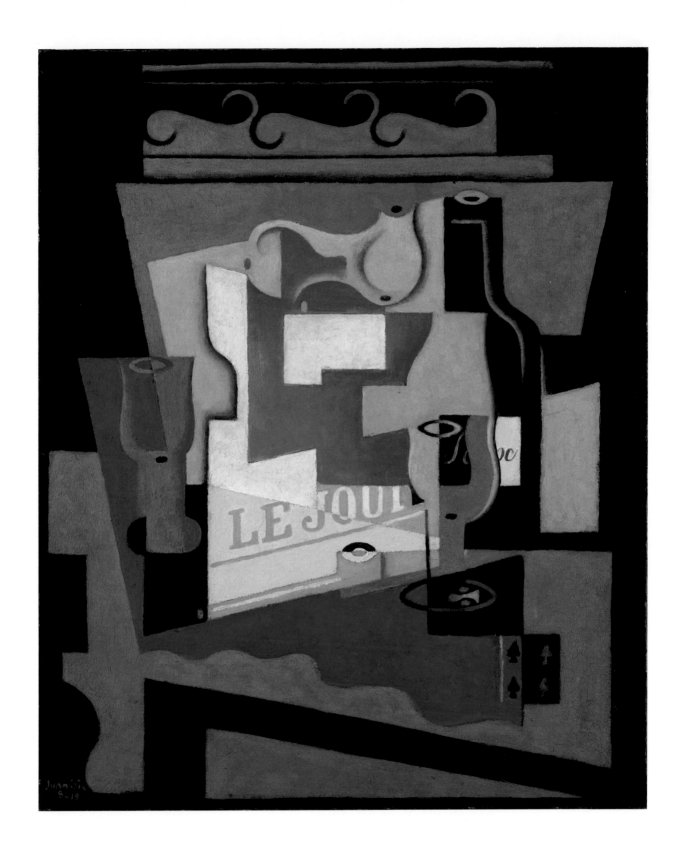

32 | **Still Life with a Bottle of Bordeaux**, 1919
Oil on canvas
32 × 25½ in. (81.3 × 64.7 cm)
Denver Art Museum Collection: Gift of Marion G. Hendrie, 1966.176

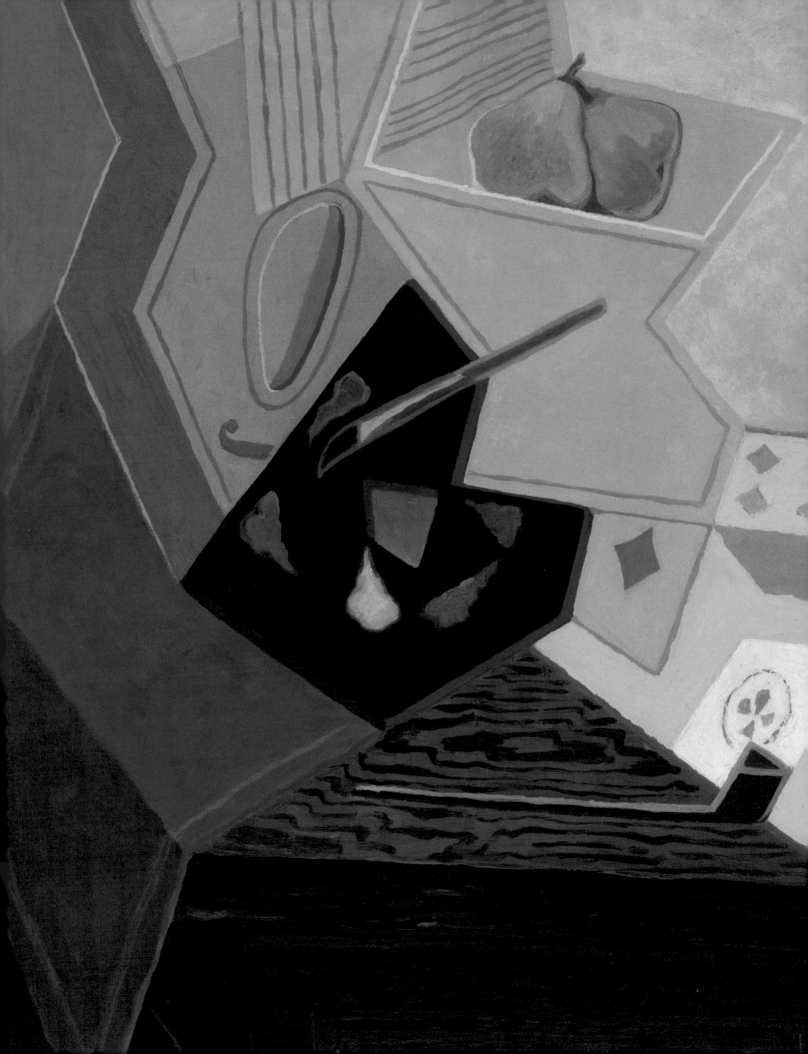

1920–27
The Final Years

In 1920, Gris renewed his contract with Rosenberg while also signing a new one with Kahnweiler, an arrangement predicated on supplying both dealers with different-sized canvases. He also took part in two exhibitions: the new revival of the Salon de la Section d'Or and a group show titled *Les Cubistes* at Galerie Moos in Geneva, organized by Rosenberg. In the summer of 1920, Gris started to show the first symptoms of a chronic illness, ultimately diagnosed as uremia, which would greatly impact his final years. After having spent the summer in the hospital with pleurisy (a symptom of the illness), unable to work, he only resumed painting in September. Gris continued to explore his interest in merging objects with one another as well as with the background to create a unified surface, giving up any illusion of depth, as seen in *Fruit Bowl and Newspaper* (cat. 33). Objects and their shadows or projections interlock with each other while at the same time maintaining their integrity, which leads to complex formal rhyming. Gris painted shared contours between the objects rather than leaving space between the individual elements. In October he produced *Still Life with Guitar* (cat. 35), in which the bottle and the guitar share the curve of their bodies, and the transparency of the glass allows for an interesting play with the solidity of the two objects. Both *Fruit Bowl and Newspaper* and *Still Life with Guitar* are examples of the interplay between angularity and sinuousness that characterize Gris's compositions during this period.

1921 marked the return of the motif of the open window, first introduced in 1915, and now realized in a larger series. Gris and Josette had spent a considerable amount of time in the first half of the year in Bandol, a coastal town in Provence that afforded the artist an opportunity to paint views of the sea. In paintings like *The Open Window* (fig. 36, p. 75), Gris once again grappled with the depiction of light. These works are characterized by the contrast of warm and cold colors that merge the interior with the exterior. In the series, Gris also blends the subjects together, so that clouds penetrate the interior, or tabletop elements become sailboats on the ocean. After a short stay in Paris in the late summer, he returned to the Mediterranean in November 1921, this

time to Céret. *Le Canigou* (cat. 36) depicts the peak of the Pyrenean mountain that gives the work its title, seen through the window. The inside and outside meet where the flank of the mountain pierces through the window on the right side. The table and guitar are rendered in warm browns, while the tablecloth mirrors the cool blue of the sky, its white creases imitating the snow-covered peaks or clouds. The table is tilted in such a way that its back corner aligns with the mountain and can be read simultaneously as both the peak and the corner of the table.

Due to Gris's declining health, he and Josette finally left the studio at the Bateau-Lavoir in the spring of 1922. They moved to Boulogne-sur-Seine, where Kahnweiler found them an apartment so that Gris could live close by. When in town, they spent their Sundays at the Kahnweilers' home, which was an important meeting spot for artists and intellectuals of the period.

From 1922 until 1924, Gris cut back on his painting practice in order to work with Sergei Diaghilev on costume and stage designs for the Ballets Russes. Nevertheless, in March 1923, he had a solo exhibition with fifty-four works at Galerie Simon, Kahnweiler's new gallery in Paris. Because of his health, he increasingly split his time between Boulogne-sur-Seine and various locations in the South of France. Despite phases of convalescence interrupted by bouts of sickness, Gris's output in his final years was prolific. Returning both to vibrant colors and to the geometrically structured compositions that he characterized as "flat, colored architecture,"[1] Gris sought to balance architecture and poetry. He treated his still-life objects as one cohesive mass set off from solid color fields, typically in red, by an encompassing outline or contour. Whereas he changed his style on a regular basis in the first ten years of his artistic career, Gris worked consistently in this new style until his death. He continued to place a table with objects in front of windows, as in *Mandolin and Fruit Dish* (cat. 39), but the playful interaction of inside and outside does not reappear. The window is smaller and the view is obscured by the still-life arrangement. The perspective used for the window and that of the table do not correspond with each other, and the shutter on the right side merges with the still life. The depiction of the objects is reduced to a minimum and Gris again returns to representation through emblems, yet they are more legible in these works than at any other time in his career. It is also the first time that he refers to the act of painting by including a palette, thus inscribing himself into his images. This can be seen in *The Painter's Window* (cat. 40), in which he plays with symmetries and the repetition of forms, creating a poetic, continuous composition. The dark red that surrounds the table serves as a framing device. Along with the palette seen here, Gris included a stringed instrument in a majority of his late paintings—objects that serve as traditional allegories of the arts while at the same time evoking the senses. Gris's depiction of musical instruments and fruit may refer to the seventeenth-century European tradition of *vanitas* still lifes, suggesting the passage of time.

Though Gris was making plans for his son Georges to come live with him and had initiated the process of becoming a French citizen, by late 1926 his health had rapidly deteriorated. His doctors sent him back from Beaulieu to Paris, as the Mediterranean climate seemed to worsen his condition, and he died at his home on May 11, 1927, from chronic renal failure. Kahnweiler, his son Georges, Picasso, Raynal, and other friends and artists attended his funeral. In the following years, important retrospective exhibitions of Gris's works were held in Paris (1928), Berlin (1930), and Zürich (1933).

Notes

1. Juan Gris, "On the Possibilities of Painting," in Daniel-Henry Kahnweiler, *Juan Gris: His Life and Work*, trans. Douglas Cooper (New York: Harry N. Abrams, 1968), 196.

33 | **Fruit Bowl and Newspaper**, 1920
Oil on canvas
23⅝ × 28¾ in. (60 × 73 cm)
Museo de la Real Academia de Bellas Artes de San Fernando, Madrid

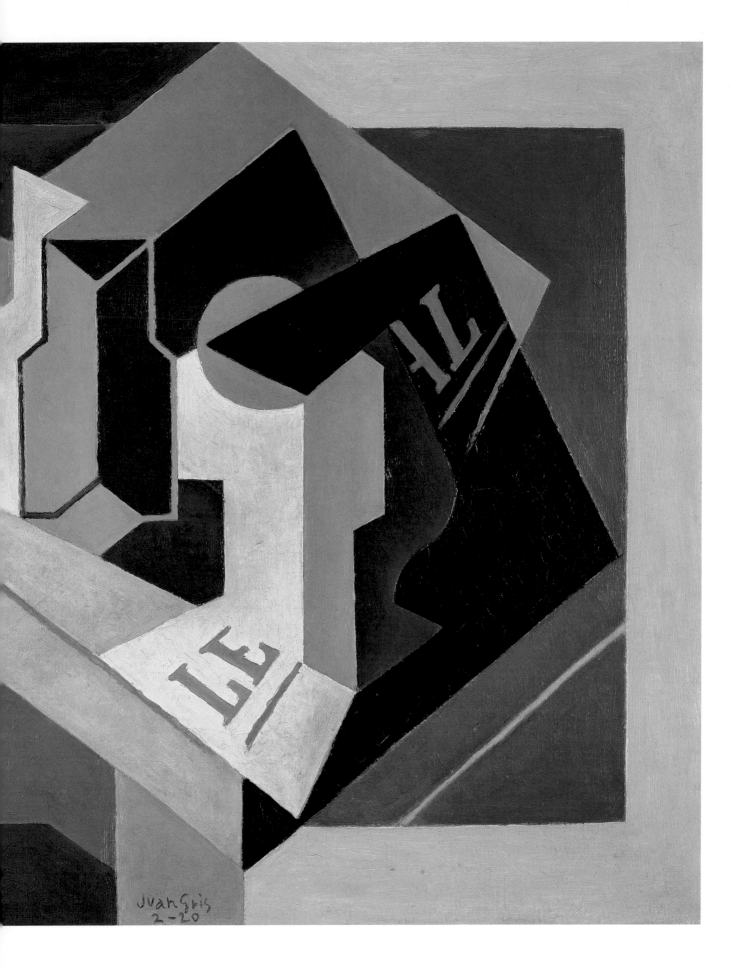

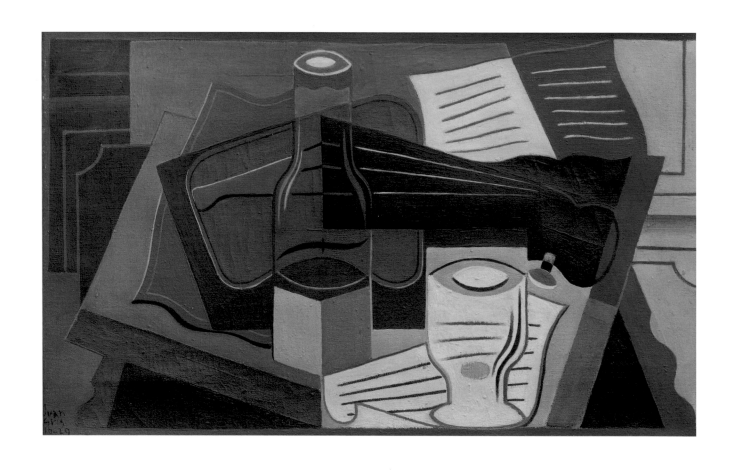

34 | **Violin, Bottle, and Glass**, 1920
Oil on canvas
13 × 21¾ in. (33 × 55 cm)
Senado de España, Madrid

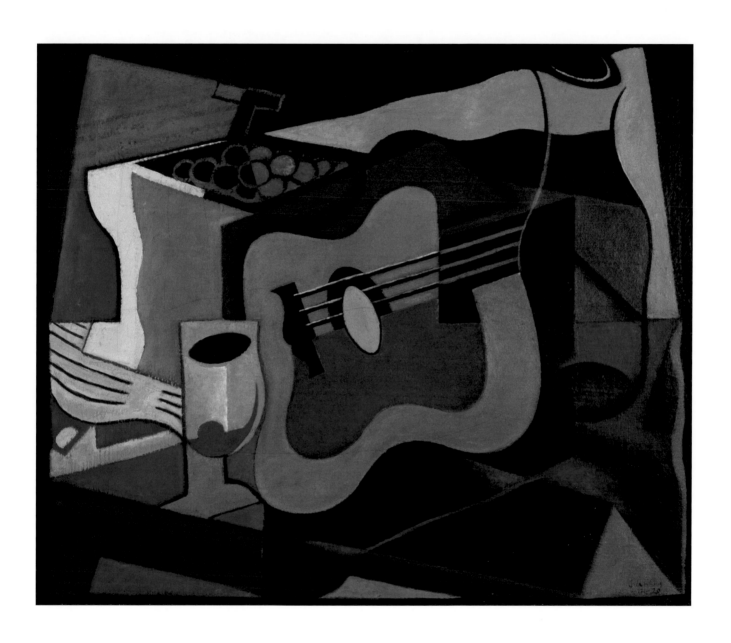

35 | **Still Life with Guitar**, 1920
Oil on canvas
20 × 24 in. (50.8 × 61 cm)
Saint Louis Art Museum. Museum Purchase, 9:1940

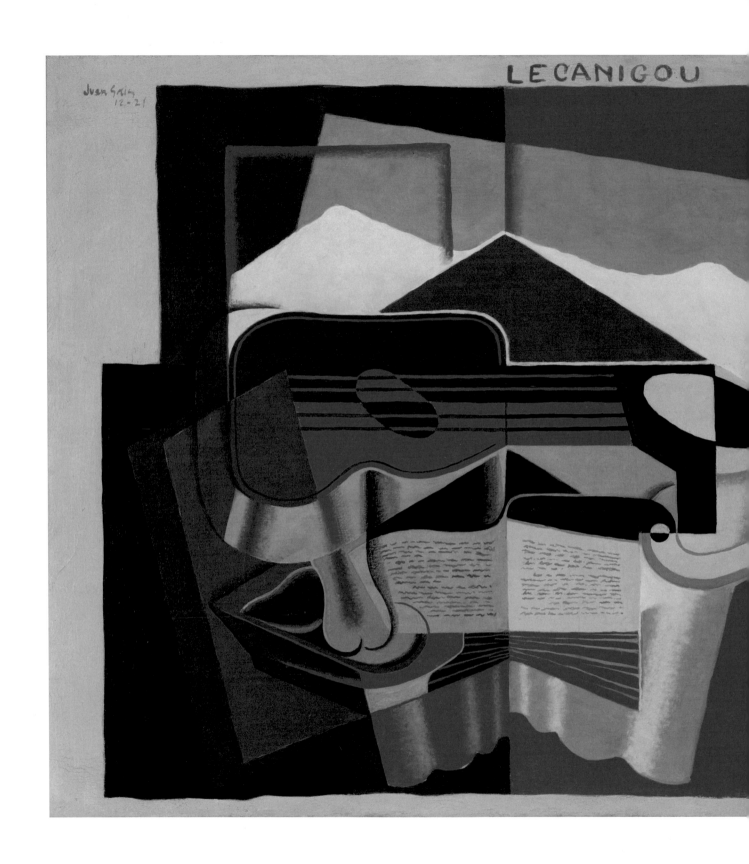

36 | **Le Canigou**, 1921
Oil on canvas
25½ × 39½ in. (64.8 × 100.3 cm)
Collection Albright-Knox Art Gallery, Buffalo, New York,
Room of Contemporary Art Fund, 1947

37 | **Open Window with Hills**, 1923
Oil on canvas
28¾ × 36½ in. (73 × 92.7 cm)
Telefónica Collection, Madrid

38 | **The Electric Lamp**, 1925
Oil on canvas
25⅝ × 32 in. (65 × 81 cm)
Centre Pompidou, Paris, Musée national d'art moderne/Centre de
création industrielle. Gift of Louise and Michel Leiris, 1984

39 | **Mandolin and Fruit Dish**, 1925
Oil on canvas
28¾ × 37¼ in. (73 × 94.6 cm)
Museum of Fine Arts, Boston. Gift of Joseph Pulitzer, Jr., 67.1161

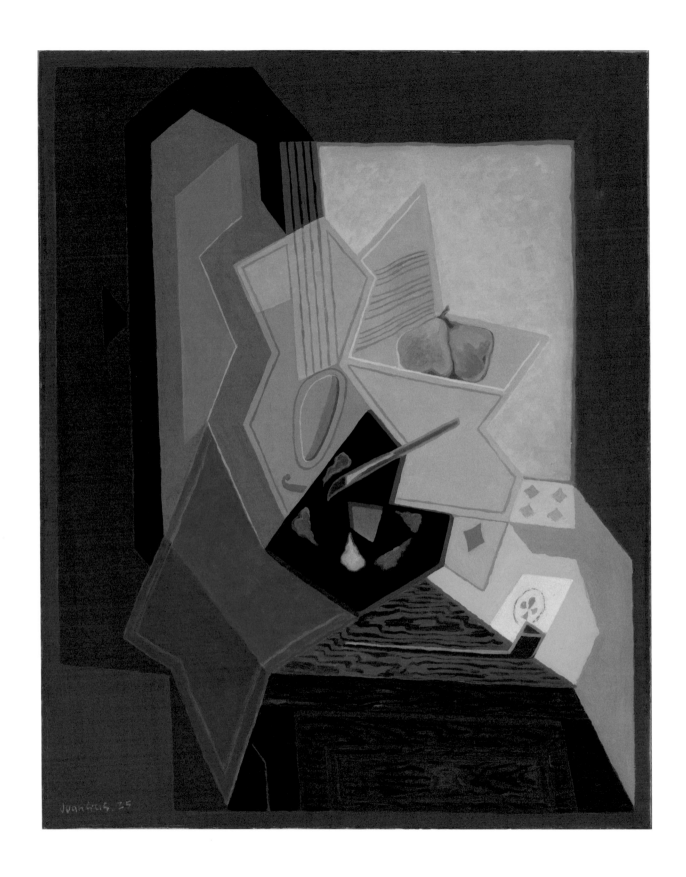

40 | **The Painter's Window**, 1925
Oil on canvas
39¼ × 31¾ in. (99.7 × 80.6 cm)
The Baltimore Museum of Art: Bequest of Saidie A. May, BMA 1951.306

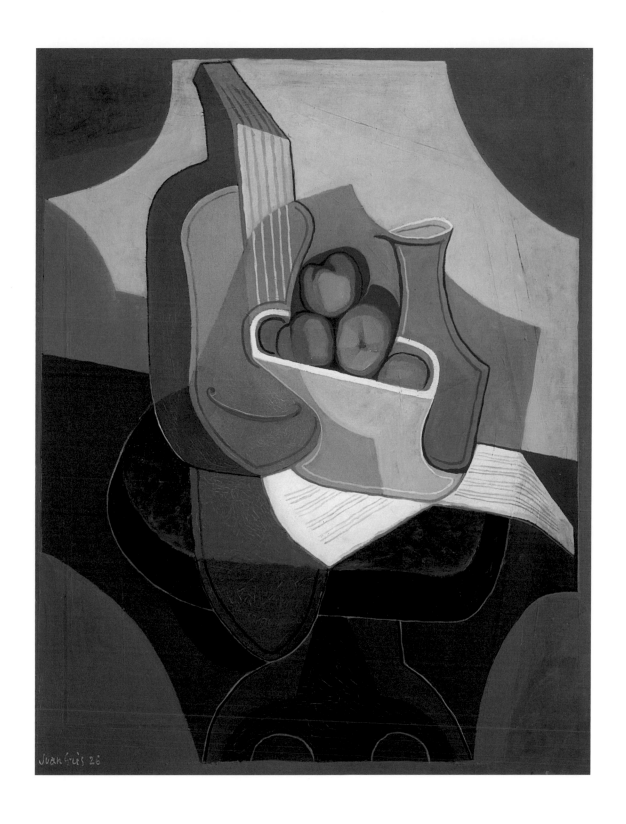

41 | **Still Life: Table with Red Cloth**, 1926
Oil on canvas
36 3/8 × 29 in. (92.4 × 73.7 cm)
Mildred Lane Kemper Art Museum, Washington University in
St. Louis. Gift of Charles H. Yalem, 1963

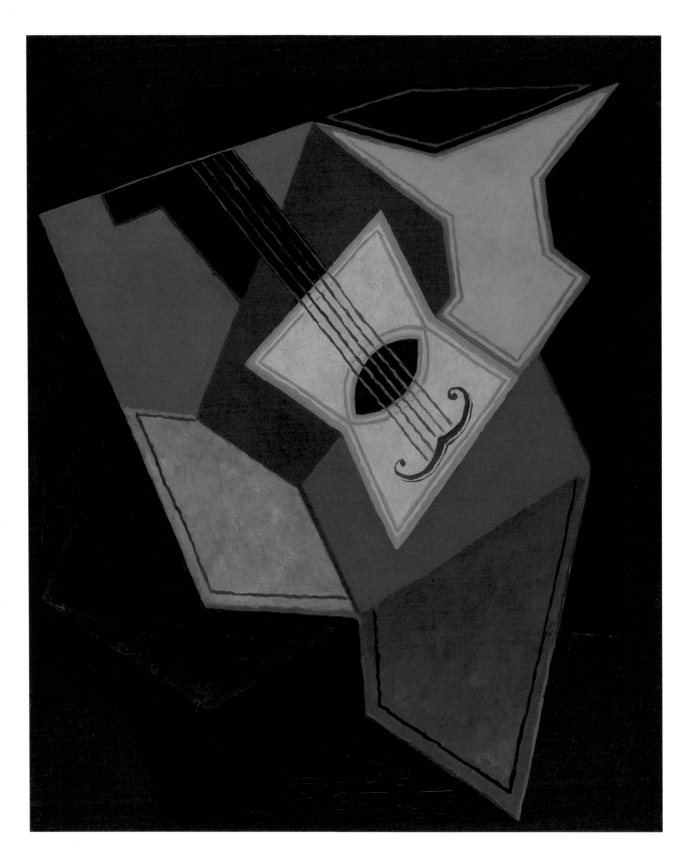

42 | Guitar and Fruit Dish, 1926–27
Oil on canvas
28¾ × 23⅝ in. (73 × 60 cm)
Telefónica Collection, Madrid

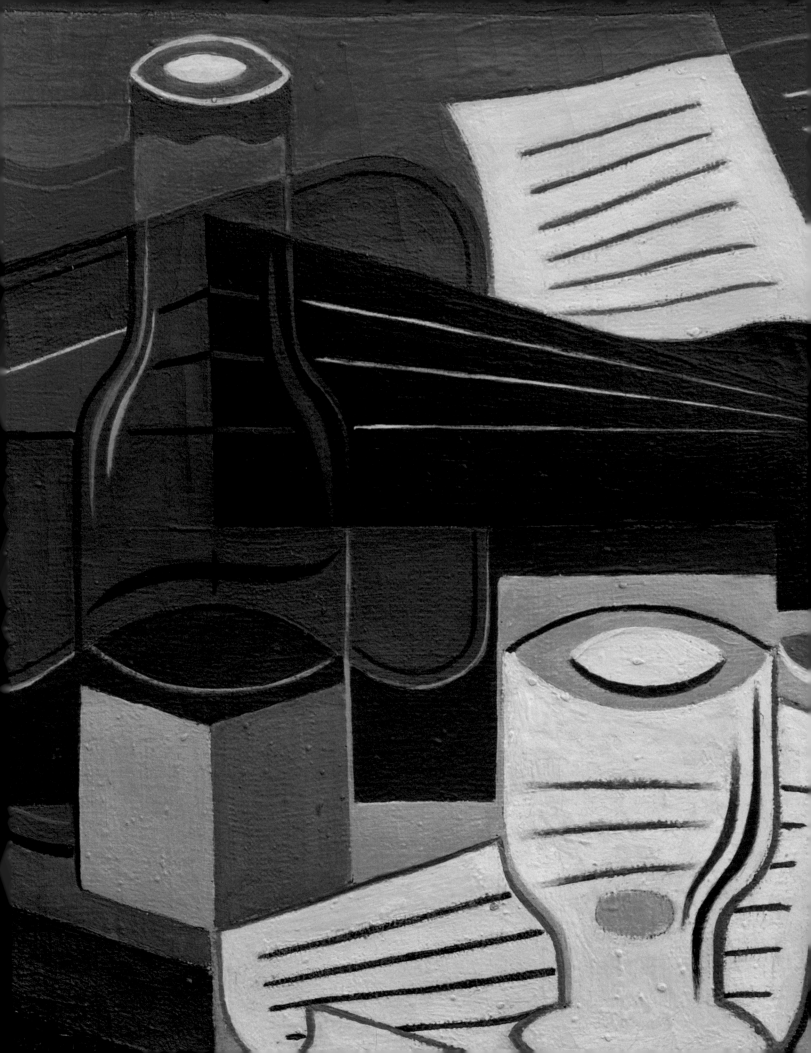

Lenders to
the Exhibition

Albright-Knox Art Gallery, Buffalo, New York
The Art Institute of Chicago
The Baltimore Museum of Art
Centre Pompidou, Paris, Musée national d'art moderne/Centre de création industrielle
The Cleveland Museum of Art
Columbus Museum of Art, Ohio
Dallas Museum of Art
Denver Art Museum
Detroit Institute of Arts
Solomon R. Guggenheim Museum, New York
Mildred Lane Kemper Art Museum, Washington University in St. Louis
Kunstmuseum Basel
Musée d'Art Moderne de Paris
Museo de la Real Academia de Bellas Artes de San Fernando, Madrid
Museo Nacional Centro de Arte Reina Sofía, Madrid
Museo Nacional Thyssen-Bornemisza, Madrid
Museum of Fine Arts, Boston
The Museum of Modern Art, New York
National Gallery of Art, Washington, D.C.
Philadelphia Museum of Art
The Phillips Collection, Washington, D.C.
Rose Art Museum, Brandeis University, Waltham, Massachusetts
Saint Louis Art Museum
Senado de España, Madrid
Smith College Museum of Art, Northampton, Massachusetts
Telefónica Collection, Madrid
Virginia Museum of Fine Arts, Richmond
Yale University Art Gallery, New Haven, Connecticut

And a private collector who prefers to remain anonymous

Checklist of the Exhibition

Note to the reader: Each painting is referenced by a unique Cooper number, an identification established by Douglas Cooper in the catalogue raisonné for Juan Gris. See Douglas Cooper with Margaret Potter, *Juan Gris: Catalogue Raisonné of the Paintings*, 2nd ed., updated by Alan Hyman and Elizabeth Snowden, 2 volumes (San Francisco: Alan Wofsy Fine Arts, 2014).

1

Jar, Bottle, and Glass
1911
Oil on canvas
23½ × 19¾ in. (59.7 × 50.2 cm)
The Museum of Modern Art, New York. Acquired through the Lillie P. Bliss Bequest (by exchange), 1941
Cooper no. 10

2

Table at a Café
1912
Oil on canvas
18 × 14⅞ in. (45.7 × 37.8 cm)
The Art Institute of Chicago, Bequest of Kate L. Brewster, 1950.122
Cooper no. 19

3

Still Life with Flowers
1912
Oil on canvas
44⅛ × 27⅝ in. (112.1 × 70.2 cm)
The Museum of Modern Art, New York. Bequest of Anna Erickson Levene in memory of her husband, Dr. Phoebus Aaron Theodor Levene, 1947
Cooper no. 20

4

The Book
1913
Oil and collage on canvas
16⅛ × 13⅜ in. (41 × 34 cm)
Musée d'Art Moderne de Paris, Gift of Henry-Thomas in 1976, Inv.: AMVP 2419
Cooper no. 32

5a

Guitar and Pipe (recto)
1913
Oil and charcoal on canvas
25⅝ × 19¾ in. (65.1 × 50.2 cm)
Dallas Museum of Art, The Eugene and Margaret McDermott Art Fund, Inc., 1998.219.A–B.McD
Cooper no. 130

5b

Guitar (verso)
1913
Oil, charcoal, and wallpaper on canvas
25⅝ × 19¾ in. (65.1 × 50.2 cm)
Dallas Museum of Art, The Eugene and Margaret McDermott Art Fund, Inc., 1998.219.A–B.McD
Cooper no. 130

6

Playing Cards and Glass of Beer
1913
Oil and collage on canvas
21⅝ × 14⅞ in. (54.9 × 37.8 cm)
Columbus Museum of Art, Ohio: Gift of Ferdinand Howald, 1931.061
Cooper no. 35

7

The Siphon
1913
Oil on canvas
32 × 23⅝ in. (81.3 × 60 cm)
Rose Art Museum, Brandeis University, Waltham, Massachusetts, Gift of Edgar Kaufmann, Jr., 1959.34
Cooper no. 37

8

Violin
1913
Oil on canvas
36¼ × 23⅝ in. (92.1 × 60 cm)
Philadelphia Museum of Art: A. E. Gallatin Collection, 1952-61-34
Cooper no. 44
Baltimore only

9

Grapes
1913
Oil on canvas
36¼ × 23⅝ in. (92.1 × 60 cm)
The Museum of Modern Art, New York. Bequest of Anna Erickson Levene in memory of her husband, Dr. Phoebus Aaron Theodor Levene, 1947
Cooper no. 59

10

The Lamp
1914
Pasted papers, gouache, and conté crayon on canvas
21¾ × 18¼ in. (55.2 × 46.3 cm)
Private collection
Cooper no. 93

11

Still Life: The Table
1914
Collage of plain and printed papers with opaque watercolor and crayon, on paper mounted on canvas
23½ × 17½ in. (59.7 × 44.5 cm)
Philadelphia Museum of Art: A.E. Gallatin Collection, 1952-61-43
Cooper no. 90
Baltimore only

12

Carafe, Glass, and Packet of Tobacco
1914
Pasted paper, gouache, and charcoal on canvas
18¼ × 10¾ in. (46.6 × 27.3 cm)
Virginia Museum of Fine Arts, Richmond, T. Catesby Jones Collection, 47.10.28
Cooper no. 106

13

Still Life before an Open Window, Place Ravignan
1915
Oil on canvas
45⅝ × 35 in. (115.9 × 88.9 cm)
Philadelphia Museum of Art: The Louise and Walter Arensberg Collection, 1950-134-95
Cooper no. 131

14

Ace of Clubs and Four of Diamonds
1915
Oil and fine wood particles on laminated paper-board
12 × 6½ in. (30.5 × 16.5 cm)
National Gallery of Art, Washington, D.C., Gift of Robert and Mercedes Eichholz, 2014.17.12
Cooper no. 132

15

Abstraction
1915
Oil and oil with sand on cardboard
11⅜ × 7¾ in. (28.9 × 19.7 cm)
The Phillips Collection, Washington, D.C., Acquired 1930
Cooper no. 133

16

Glass and Newspaper
1916
Oil on canvas
16⅛ × 13 in. (59.8 × 73.3 cm)
Centre Pompidou, Paris, Musée national d'art moderne/Centre de création industrielle. Gift of Louise and Michel Leiris, 1984. On deposit at Musée d'art moderne de Céret since 1995, AM 1984-524
Cooper no. 156
Not exhibited

17

Fantômas
1915
Oil on canvas
23¾ × 28⅞ in. (59.8 × 73.3 cm)
National Gallery of Art, Washington, D.C., Chester Dale Fund, 1976.59.1
Cooper no. 146

18

Glass on Table
1916
Oil on canvas
16 × 12⅝ in. (40.6 × 32.1 cm)
Denver Art Museum Collection: Charles Francis Hendrie Memorial Collection, 1966.169
Cooper no. 160

19

Fruit Dish and Bottle
1916
Oil on canvas
Oval: 25⅝ × 31⅞ in. (65.1 × 81 cm)
Gift of Joseph Brummer, Smith College Museum of Art, Northampton, Massachusetts, SC 1921.8.4
Cooper no. 165
Baltimore only

20

Newspaper and Fruit Dish
1916
Oil on canvas
18⅜ × 15 in. (46.7 × 38.1 cm)
Solomon R. Guggenheim Museum, New York, Gift, Estate of Katherine S. Dreier, 1953, 53.1341
Cooper no. 161

21

Newspaper and Fruit Dish
1916
Oil on canvas
37 × 24 in. (94 × 61 cm)
Yale University Art Gallery, Gift of Collection Société Anonyme, 1941.489
Cooper no. 162

22

Lamp
1916
Oil on canvas
31⅞ × 25½ in. (81 × 64.8 cm)
Philadelphia Museum of Art: The Louise and Walter Arensberg Collection, 1950-134-96
Cooper no. 166

23

Still Life
1916
Oil on canvas
31¾ × 23½ in. (80.6 × 59.7 cm)
Detroit Institute of Arts, Founders Society Purchase with funds from the Dexter M. Ferry, Jr. Trustee Corporation, 64.84
Cooper no. 164

24

The Coffee Mill
1916
Oil on canvas
21⅝ × 15 in. (55 × 38.1 cm)
The Cleveland Museum of Art, Purchase from the J. H. Wade Fund, 1980.8
Cooper no. 168

25
Still Life with Newspaper
1916
Oil on canvas
29 × 23¾ in. (73.7 × 60.3 cm)
The Phillips Collection, Washington, D.C.,
Acquired 1950
Cooper no. 188

26
The Violin
1916
Oil on plywood
31½ × 21⅛ in. (80 × 53.7 cm)
Museo Nacional Centro de Arte Reina Sofía,
Madrid
Cooper no. 190

27
The Sideboard
1917
Oil on plywood
45⅞ × 28¾ in. (116.2 × 73.1 cm)
The Museum of Modern Art, New York.
Nelson A. Rockefeller Bequest, 1979
Cooper no. 225

28
Chessboard, Glass, and Dish
1917
Oil on wood panel
28⅞ × 40⅝ in. (73.3 × 103.2 cm)
Philadelphia Museum of Art: The Louise and
Walter Arensberg Collection, 1950-134-98
Cooper no. 226

29
Bottle and Glass
1918
Oil on canvas
21½ × 13 in. (54.6 × 33 cm)
The Baltimore Museum of Art: Bequest of Saidie
A. May, BMA 1951.305
Cooper no. 283

30
**Guitar and Fruit Dish on a Table
(Guitar and Fruit Dish)**
1918
Oil on canvas
23⅝ × 28¾ in. (60 × 73 cm)
Kunstmuseum Basel, Donation Dr. h.c. Raoul La
Roche 1952, Inv. 2296
Cooper no. 279

31
Bottle and Fruit Dish
1919
Oil on canvas
29⅛ × 21¼ in. (74 × 54 cm)
Museo Nacional Thyssen-Bornemisza, Madrid,
1976.7 (566)
Cooper no. 292
Dallas only

32
Still Life with a Bottle of Bordeaux
1919
Oil on canvas
32 × 25½ in. (81.3 × 64.7 cm)
Denver Art Museum Collection: Gift of Marion G.
Hendrie, 1966.176
Cooper no. 314

33
Fruit Bowl and Newspaper
1920
Oil on canvas
23⅝ × 28¾ in. (60 × 73 cm)
Museo de la Real Academia de Bellas Artes de
San Fernando, Madrid, 1393
Cooper no. 328

34
Violin, Bottle, and Glass
1920
Oil on canvas
13 × 21¾ in. (33 × 55 cm)
Senado de España, Madrid
Cooper no. 351

35
Still Life with Guitar
1920
Oil on canvas
20 × 24 in. (50.8 × 61 cm)
Saint Louis Art Museum, Museum Purchase,
9:1940
Cooper no. 353

36
Le Canigou
1921
Oil on canvas
25½ × 39½ in. (64.8 × 100.3 cm)
Collection Albright-Knox Art Gallery, Buffalo,
New York, Room of Contemporary Art Fund,
1947, RCA1947:5
Cooper no. 384

37
Open Window with Hills
1923
Oil on canvas
28¾ × 36½ in. (73 × 92.7 cm)
Telefónica Collection, Madrid
Cooper no. 417

38
The Electric Lamp
1925
Oil on canvas
25⅝ × 32 in. (65 × 81 cm)
Centre Pompidou, Paris, Musée national d'art
moderne/Centre de création industrielle. Gift
of Louise and Michel Leiris, 1984. On deposit
at Musée d'art moderne et contemporain de la
Ville de Strasbourg since 1999, AM 1984-537
Cooper no. 526

39
Mandolin and Fruit Dish
1925
Oil on canvas
28¾ × 37¼ in. (73 × 94.6 cm)
Museum of Fine Arts, Boston. Gift of Joseph
Pulitzer, Jr., 67.1161
Cooper no. 531

Index

Juan Gris. New York: Buchholz Gallery, 1950.

Jewell, Edward Alden. "The Abstract Art of Juan Gris." *The New York Times*, February 6, 1932, 23.

Kahnweiler, Daniel-Henry. *Juan Gris: His Life and Work*. Translated by Douglas Cooper. New York: Harry N. Abrams, 1968.

Kahnweiler, Daniel-Henry, Man Ray, and Donald Gallup. *Picasso, Gris, Miró: The Spanish Masters of Twentieth Century Painting*. San Francisco: San Francisco Museum of Art, 1948.

Kline, Katy. "Juan Gris." In *Albright-Knox Art Gallery: Painting and Sculpture from Antiquity to 1942*, edited by Steven A. Nash, Katy Kline, Charlotta Kotik, and Emese Wood. New York: Rizzoli International Publications, 1978.

Mai, James. "Juan Gris's Compositional Symmetry Transformations." *Bridges 2012: Mathematics, Music, Art, Architecture, Culture* (2012): 283–90.

Moss, Sarah. "'Le Vrai et le Faux' in Juan Gris's 'The Table' (1914)." *The Burlington Magazine* 63 (September 2011), 574–78.

Pinturicchio [Louis Vauxcelles]. "Perplexité." *Le Carnet de la semaine* no. 167 (August 18, 1918): 7.

——. "Mort de quelqu'un." *Le Carnet de la semaine* no. 408 (April 1, 1923): 8.

Poggi, Christine. *In Defiance of Painting: Cubism, Futurism, and the Invention of Collage*. New Haven, CT: Yale University Press, 1992.

Radiguet, Raymond. "Allusions." *Sic* 42–43 (March 30–April 15, 1919): 330, [340].

Raynal, Maurice. *Anthologie de la peinture en France de 1906 à nos jours*. Paris: Montaigne, 1927.

A Retrospective Exhibition of the Work of Juan Gris, 1887–1927. Cincinnati: The Cincinnati Modern Art Society, 1948.

Rosenthal, Mark. *Juan Gris*. Berkeley: University Art Museum, University of California, 1983.

Russell, John. "Art View; Juan Gris: The Other Cubist." *The New York Times*, October 23, 1983, Section 2, 29.

Soby, James T. *Juan Gris*. New York: The Museum of Modern Art, 1958.

Stein, Gertrude. "Juan Gris." *Little Review* (Autumn and Winter 1924–1925): 16.

——. "The Life of Juan Gris: The Life and Death of Juan Gris." *Transition* (July 1927): 160–62.

——. *The Autobiography of Alice B. Toklas*. 1933. Reprint, New York: Vintage, 1990.

Stavitsky, Gail. "The Development, Institutionalization, and Impact of the A. E. Gallatin Collection of Modern Art." Ph.D. dissertation, New York University, May 1990.

Torres-García, Joaquín. *Universalismo constructivo: contribución a la unificación del arte y la cultura de América*. Buenos Aires: Editorial Poseidón, 1944.

Vauvrecy [Amédée Ozenfant], *L'Esprit Nouveau*, no. 5 (1921): 533–34.

Willats, John. "Unusual Pictures: An Analysis of Some Abnormal Pictorial Structures in a Painting by Juan Gris." Special issue, "Psychology and the Arts." *Leonardo* 16, no. 3 (Summer 1983): 188–92.

Selected Bibliography

Barr, Alfred H. *Cubism and Abstract Art.* New York: The Museum of Modern Art, 1936.

Bishop, Janet C., ed. *The Steins Collect: Matisse, Picasso, and the Parisian Avant-Garde.* San Francisco: San Francisco Museum of Modern Art, 2011.

Braun, Emily, and Rebecca Rabinow, eds. *Cubism: The Leonard A. Lauder Collection.* New York: The Metropolitan Museum of Art, 2014.

Bréon, Emmanuel. *Juan Gris à Boulogne.* Paris: Herscher, 1992.

Camfield, William A. "Juan Gris and the Golden Section." *The Art Bulletin* 47, no. 1 (March 1965): 128–34.

Cooper, Douglas. *Juan Gris ou Le Goût du solennel.* Geneva: Skira, 1949.

Cooper, Douglas, trans. and ed., *Letters of Juan Gris [1913–1927]. Collected by Daniel-Henry Kahnweiler.* London, 1956.

Cooper, Douglas, with Margaret Potter. *Juan Gris Catalogue Raisonné.* 2nd ed., updated by Alan Hyman and Elizabeth Snowden, 2 vols. San Francisco: Alan Wofsy Fine Arts, 2014.

da Costa, René. "Juan Gris and Poetry: From Illustration to Creation." *The Art Bulletin* 71 (December 1989): 674–92.

d'Harnoncourt, Anne. "The Cubist Cockatoo: A Preliminary Exploration of Joseph Cornell's Homages to Juan Gris." *Philadelphia Museum of Art Bulletin* 74, no. 321 (June 1978): 2–17.

Derouet, Christian. "Le cubisme 'bleu horizon' ou le prix de la guerre. Correspondance de Juan Gris et de Léonce Rosenberg, 1915–1917." *Revue de l'Art* no. 113 (1996): 40–64.

Derouet, Christian, ed. *Juan Gris, Correspondances avec Léonce Rosenberg, 1915–1927.* Les Cahiers du Musée national d'art moderne. Paris: ADAGP, 1999.

Devree, Howard. "Art: Juan Gris Display." *The New York Times,* April 8, 1958, 26.

Esteban Leal, Paloma. *Juan Gris: Painting and Drawings 1910–1927.* 2 vols. Madrid: Museo Nacional Centro de Arte Reina Sofía, 2005.

Florman, Lisa. "Re-fusing Collage: Juan Gris's 'Still Life'." *Bulletin of the Detroit Institute of Arts* 75, no. 2 (2001): 4–13.

Gaya Nuño, Juan Antonio. *Juan Gris.* Barcelona: Ediciones Polígrafa, 1986.

Green, Christopher. "Synthesis and the 'Synthetic Process' in the Painting of Juan Gris 1915–19." *Art History* 5, no. 1 (March 1982): 87–105.

——. *Juan Gris, Peinture et Dessins.* Marseille: Musées de Marseille–Réunion des musées nationaux, 1998.

Green, Christopher, Christian Derouet, and Karin von Maur, *Juan Gris.* London: Whitechapel Art Gallery, 1992.

Golding, John. *Visions of the Modern.* Berkeley: University of California Press, 1994.

Gris, Juan. *Der Querschnitt,* nos. 1 and 2 (Summer 1923): 77–78.

Juan Gris. New York: Buchholz Gallery, 1944.

Juan Gris. New York: Buchholz Gallery, 1947.

40

The Painter's Window

1925
Oil on canvas
39¼ × 31¾ in. (99.7 × 80.6 cm)
The Baltimore Museum of Art: Bequest of Saidie
A. May, BMA 1951.306
Cooper no. 543

41

Still Life: Table with Red Cloth

1926
Oil on canvas
36⅜ × 29 in. (92.4 × 73.7 cm)
Mildred Lane Kemper Art Museum, Washington
University in St. Louis. Gift of Charles H. Yalem,
1963
Cooper no. 586

42

Guitar and Fruit Dish

1926–27
Oil on canvas
28¾ × 23⅝ in. (73 × 60 cm)
Telefónica Collection, Madrid
Cooper no. 607

Illustration and Copyright Credits

Cat. 1, 3, 9, and 27: Digital Image © The Museum of Modern Art / Licensed by SCALA / Art Resource, NY; cat. 4: © Musée d'Art Moderne / Roger-Viollet. Photo: Eric Emo / Parisienne de Photographie; cat. 5a–5b: © Dallas Museum of Art; cat. 10: © 2015 Christie's Images Limited; cat. 12: Photo by Katherine Wetzel © Virginia Museum of Fine Arts; cat. 16 and 38: © CNAC / MNAM / Dist. RMN-Grand Palais / Art Resources, NY; cat. 18 and 32: Photograph courtesy of the Denver Art Museum; cat. 20: The Solomon R. Guggenheim Foundation / Art Resource, NY; cat. 21: Yale University Art Gallery; cat. 24: Courtesy of The Cleveland Museum of Art; cat. 29 and 40: Photo by Mitro Hood; cat. 33: Photo by Carlos Manso © Real Academia de Bellas Artes de San Fernando, Madrid; cat. 36: Albright-Knox Art Gallery / Art Resource, NY; cat. 37 and 42: © Fernando Maquieira; courtesy Fundación Telefónica; cat. 39: Photograph © 2021 Museum of Fine Arts, Boston.

Figs. 5 and 36: © The Metropolitan Museum of Art. Image source: Art Resource, NY; fig. 6: © 2021 Estate of Pablo Picasso / Artists Rights Society (ARS), New York; fig. 7: © Museum Ulm – Loan of the State Baden-Württemberg; photo by Oleg Kuchar, Ulm; fig. 8: © CNAC / MNAM / Dist. RMN-Grand Palais / Art Resource, NY. Photo by Jean-Claude Planchet; fig. 10: Chronicle / Alamy Stock Photos; fig. 11: © The Metropolitan Museum of Art. Image source: Art Resource, NY; fig. 12: Photo by Tom Haartsen, Ouderkerk a/d Amstel; fig. 13: Overlay courtesy of Jaclyn Le; fig. 15: Infrared photography capture, Super 6K-HS, 6000 x 8000 pixels—Native CCD resolution, 137 MB max. file 24-bit RGB (274 MB in 48-bit RGB), 9000 x 12000 pixels—Enhanced Resolution™, 309 MB max. file 24-bit RGB (618 MB in 48-bit RGB). Overlay courtesy of Laura Hartman; figs. 16 and 21: © CNAC / MNAM / Dist. RMN-Grand Palais / Art Resource, NY. Photo by Philippe Migeat; fig. 17: © Tate, London 2021; fig. 18: Infrared image capture, Santa Barbara FocalPlane ImagIR LC InSb. "H" filter, 1.5–1.8 microns, September 2019, infrared reflectogram composite / Adobe Photoshop assembly. Overlay courtesy of Laura Hartman; fig. 19: Photo by Rik Klein Gotink, Harderwijk; fig. 20: Overlay courtesy of Jaclyn Le; fig. 22: Albright-Knox Art Gallery / Art Resource, NY; overlay courtesy of Jaclyn Le; fig. 23: Photograph courtesy of Sotheby's, Inc. © 2006; fig. 24: © CNAC / MNAM / Dist. RMN-Grand Palais / Art Resource, NY; fig. 25: Overlay courtesy of Jaclyn Le; fig. 30: © Peter A. Juley & Son Collection, Smithsonian American Art Museum; figs. 34 and 63: Digital Image © The Museum of Modern Art / Licensed by SCALA / Art Resource, NY; fig. 40: Photographic Archives Museo Nacional Centro de Arte Reina Sofia; fig. 41: © Museu Nacional d'Art de Catalunya, Barcelona (2021); fig. 42: Album / Art Resource, NY; figs. 43–45: © Fernando Maquieira; courtesy Fundación Telefónica; fig. 46: Courtesy Fundación Juan March, Madrid. Photo © Joan-Ramon Bonet/

Published in conjunction with the exhibition entitled *Cubism in Color: The Still Lifes of Juan Gris* for the Dallas presentation and *Color and Illusion: The Still Lifes of Juan Gris* for the Baltimore presentation, co-organized by The Baltimore Museum of Art and the Dallas Museum of Art.

The exhibition is supported by an indemnity from the Federal Council on the Arts and the Humanities.

Cubism in Color: The Still Lifes of Juan Gris is supported by the sponsors listed below. Additional support is provided by the Robert Lehman Foundation. The Dallas Museum of Art is supported, in part, by the generosity of DMA Members and donors, the citizens of Dallas through the City of Dallas Office of Arts and Culture, and the Texas Commission on the Arts.

PRESENTED BY

MAJOR SUPPORT

EXHIBITION SUPPORT

LOCAL SUPPORT

© 2021 Dallas Museum of Art

LIBRARY OF CONGRESS CATALOGING-IN-PUBLICATION DATA

Names: Myers, Nicole R., editor. | Rothkopf, Katherine, editor. | Brodbeck, Anna Katherine. | Cooper, Harry, 1959– | Esteban Leal, Paloma. | Baltimore Museum of Art, organizer, host institution. | Dallas Museum of Art, organizer, host institution.
Title: Cubism in color : the still lifes of Juan Gris / edited by Nicole R. Myers and Katherine Rothkopf ; with contributions by Anna Katherine Brodbeck, Christine Burger, Harry Cooper, Paloma Esteban Leal, Nicole R. Myers, Katherine Rothkopf.
Description: Dallas, Texas : Dallas Museum of Art, [2021] | "Published in conjunction with the exhibition entitled Cubism in Color: The Still Lifes of Juan Gris for the Dallas presentation and Color and Illusion: The Still Lifes of Juan Gris for the Baltimore presentation, co-organized by The Baltimore Museum of Art and the Dallas Museum of Art"—Colophon. | Includes bibliographical references and index.

Identifiers: LCCN 2020042542 | ISBN 9780300254228 (hardback)
Subjects: LCSH: Gris, Juan, 1887–1927—Exhibitions. | Still-life in art—Exhibitions. | Cubism—Spain—Exhibitions.
Classification: LCC N7113.G83 A4 2021 | DDC 709.04/032—dc23
LC record available at https://lccn.loc.gov/2020042542

ISBN 978-0-300-25422-8

DALLAS MUSEUM OF ART

Agustín Arteaga, The Eugene McDermott Director
Tamara Wootton Forsyth, The Marcus Rose Family Deputy Director
Sarah Schleuning, Interim Chief Curator and The Margot B. Perot Senior Curator of Decorative Arts and Design
Nicole R. Myers, The Barbara Thomas Lemmon Senior Curator of European Art
Joni Wilson-Bigornia, Director of Exhibitions and Interpretation
Eric Zeidler, Publications Manager
Christine Burger, Research Assistant

THE BALTIMORE MUSEUM OF ART

Christopher Bedford, Dorothy Wagner Wallis Director
Asma Naeem, The Eddie C. and C. Sylvia Brown Chief Curator

Katherine Rothkopf, The Anne and Ben Cone Memorial Director of the Ruth R. Marder Center for Matisse Studies and Senior Curator of European Painting and Sculpture
Laura Albans, Assistant Curator of European Painting and Sculpture
Steve Mann, Senior Director of Exhibitions and Program Alignment

PRODUCED BY LUCIA | MARQUAND, SEATTLE
www.luciamarquand.com
Edited by Martin Fox
"Juan Gris in Spanish Collections" by Paloma Esteban Leal translated from Spanish by David Auerbach
Designed by Thomas Eykemans
Typeset by Brynn Warriner in Sentinel and Slate
Proofread by Laura Lesswing
Indexed by Enid Zafran
Color management by iocolor
Printed and bound in China by Artron Art Group

CO-PUBLISHED BY

THE DALLAS MUSEUM OF ART
www.dma.org

THE BALTIMORE MUSEUM OF ART
www.artbma.org

DISTRIBUTED BY YALE UNIVERSITY PRESS
New Haven and London
www.yalebooks.com/art

Exhibition Schedule

Dallas Museum of Art
1717 North Harwood Street
Dallas, Texas, 75201
March 14–July 25, 2021

The Baltimore Museum of Art
10 Art Museum Drive
Baltimore, Maryland, 21218
September 12, 2021–January 9, 2022